Oil Paintings in Public Ownership in West Sussex

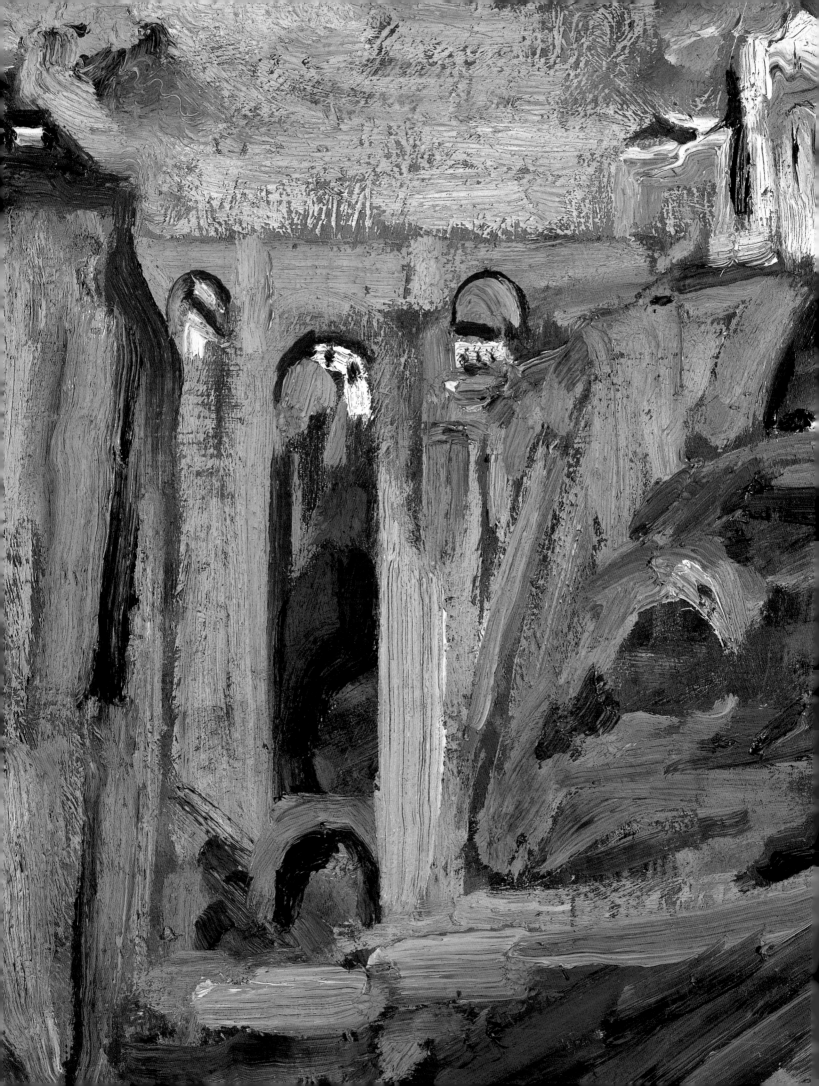

Oil Paintings in Public Ownership in West Sussex

The Public Catalogue Foundation

First published in 2005 by the Public Catalogue
Foundation, St Vincent House, 30 Orange Street,
London WC2 H7HH

© 2005 the Public Catalogue Foundation, registered
charity number 1096185

We wish to thank the individual artists and all the
copyright holders for their permission to reproduce
the works of art. Exhaustive efforts have been made
to locate the copyright owners of all the images
included within this catalogue and to meet their
requirements. Any omissions or mistakes brought
to our attention will be duly attended to and
corrected in future publications. Owners of
copyright in the paintings illustrated who have
been traced are listed in the Further Information
section.

Photographs of paintings are © the collections that
own them, except where otherwise acknowledged.

Forewords to each collection are © the respective
authors.

**The responsibility for the accuracy of the
information presented in this catalogue lies solely
with the holding collections. Suggestions that
might improve the accuracy of the information
contained in this catalogue should be sent to the
relevant collection (addresses p. 177–178) and
emailed to info@thepcf.org.uk.**

ISBN 1–904931–04–9 (hardback)
ISBN 1–904931–05–7 (paperback)

West Sussex photography:
www.ajphotographics.com

Designed by Jeffery Design, London

Distributed by the Public Catalogue Foundation, St
Vincent House, 30 Orange Street, London
WC2 H7HH
Telephone 020 7747 5936

**Printed and bound in the UK by Butler & Tanner
Ltd, Frome, Somerset**

Cover image:

Philpot, Glyn Warren 1884–1937
Henry Thomas (detail) 1934–1935
Pallant House Gallery (see p. 39)

Image opposite title page:

Bomberg, David 1890–1957
Ronda Bridge (detail) 1935
Pallant House Gallery (see p. 17)

Back cover images (from top to bottom):

Aitchison, Craigie Ronald John b.1926
Crucifixion IX 1963
Pallant House Gallery (see p. 12)

West, Francis b.1936
The Skaters 1972
Pallant House Gallery (see p. 46)

Oliver, Archer James 1774–1842
Susannah Holmes c.1825
Christ's Hospital Foundation (see p. 98)

Contents

THE PAINTINGS

Foreword

With the publication of the West Sussex catalogue, the third in the series, we are beginning to sense that the Foundation is becoming established. The value and quality of work are now plain for all to see: our readership and sales increase daily and more and more people (in particular curators) are aware of our work and its aims, and support them.

That, however, is not yet feeding through sufficiently to the funding side to allow us to feel sure-footed. It has proved harder than anticipated to raise money in West Sussex – a wealthy county. This is essentially because we lack the financial strength to invest properly in fundraising, and not for lack of potentially willing supporters. That West Sussex has been fully funded is due very largely to the work of Leslie Weller DL, as well as to West Sussex County Council, Charles Gregson (a trustee), the team at Russell New, and to Lady Emma and James Barnard who lent us Parham House for our launch. To all of them, and to the many other individuals and charitable trusts who have generously donated, our very real thanks.

A particular joy for me of this catalogue is the inclusion of Pallant House, where the intimacy of its gallery space and the personal and stimulating nature of Sir Colin St John Wilson's collection constantly reward the visitor. The collection of paintings is catalogued here in its entirety for the first time. Together with the cathedral, Pallant House makes Chichester a place of pilgrimage – and a safe place too, as the most excellent attention is to be had from the city's delightful doctor, Michael Gilbert, who happens not only to be a firm supporter of the Foundation's work, but my kind brother-in-law.

Nothing would have appeared in this catalogue without the cooperation of the curators of all the West Sussex collections, who have been uniformly helpful and supportive. I extend our thanks to them, as I do to the Mayor of Worthing, Emma Ball (curator of Worthing Museum and Art Gallery) and the supporters of the Save Worthing Museum campaign who helped keep that Museum open in the face of threatened closure earlier this year.

A special expression of thanks is due to Stella Sharp, our West Sussex county coordinator, whose diligence and careful, diplomatic work underlie everything contained in this catalogue. Also our thanks go to all the NADFAS Heritage Volunteers who so ably assisted Stella.

The erosion of the role of the national collection of oil paintings in our public life has been a tragedy that, I sense, is now beginning to be reversed. A headline in the Winter 2004 Royal Academy magazine found that in contemporary art shows "painting is back in vogue". It is wider than that though. The recent Rubens exhibition in Lille, the Titian in Edinburgh, the Sickert at Ashley Hall in Kendal, the Raphael at the National Gallery in London (to cite just a few), all demonstrate the powerful pull of well-displayed paintings, properly publicised, wherever they are located; and the substantial economic benefits for the towns, cities and regions that host them from the cultural tourism they generate. It makes absolutely good economic (and social) sense to promote art, especially in the regions. The Foundation's catalogues remind us just how rich a resource this nation owns in its galleries and how sensible it is, at every level, to exploit it.

Fred Hohler, Chairman

The Public Catalogue Foundation

The United Kingdom holds in its galleries and civic buildings arguably the greatest publicly owned collection of oil paintings in the world. However, an alarming four in five of these paintings are not on view. Whilst many galleries make strenuous efforts to display their collections, too many paintings across the country are held in storage, usually because there are insufficient funds and space to show them. Furthermore, very few galleries have created a complete photographic record of their paintings, let alone a comprehensive illustrated catalogue of their collections. In short, what is publicly owned is not publicly accessible.

The Public Catalogue Foundation, a registered charity, has three aims. First, it intends to create a complete record of the nation's collection of oil, tempera and acrylic paintings in public ownership. Second, it intends to make this accessible to the public through a series of affordable catalogues and, after a suitable delay, through a free Internet website. Finally, it aims to raise funds through the sale of catalogues in gallery shops for the conservation and restoration of oil paintings in these collections and for gallery education.

The initial focus of the project is on collections outside London. Highlighting the richness and diversity of collections outside the capital should bring major benefits to regional collections around the country. The benefits also include a revenue stream for conservation, restoration and gallery education, and the digitisation of collections' paintings, thereby allowing them to put the images on the Internet if they so desire. These substantial benefits to galleries around the country come at no financial cost to the collections themselves.

The project should be of enormous benefit and inspiration to students of art and to members of the general public with an interest in art. It will also provide a major source of material for scholarly research into art history.

Financial Supporters

The Public Catalogue Foundation would like to express its profound appreciation to the following organisations and individuals who have made the publication of this catalogue possible.

Donations of £5000 or more

Charles Gregson
Hiscox plc
Russell New

The Monument Trust
The Thistle Trust
West Sussex County Council

Donations of £1000 or more

Amberley Castle
Chichester District Council
David & Prue Hopkinson
John Rank
Leslie Weller
Lewis & Jacqueline Golden
Lord & Lady Egremont
Mr & Mrs Mark Burrell

Mr & Mrs Patrick Burgess
Mr James & Lady Emma Barnard
Mr S. J. D. Corsan
Roger & Jane Reed
The Bowerman Charitable Trust
The Hartnett Charitable Trust
The John S. Cohen Foundation
The Tanner Trust

Other Donations

Alys & Graham Ferguson Trust
Anthony & Stella Capo-Bianco
Bryan Bryan & Tessa Pascoe
Charles Pinney
Dr A. F. Hughes
Francis Baxendale
Frank Frame
Gilllian Harwood
Hugh Wyatt
Ian Frazer
J. A. T. Caulfield
John & Susan Mitchell
Julian & Fiona Smith
Kenneth Sharp
Lady Bailey
Lady Mary Mumford
Mark Scrase-Dickins
Martin Reed
Mr & Mrs John Godfrey
Mr & Mrs John Ross
Mr David Horner
Mr M. Heymann & Mrs A. M.
 Heymann

Mr R. & Lady Louisa Uloth Fitzhall
Mrs Christina J. Keith
Mrs Priscilla Richie
P. M. Luttman-Johnson
Peter Adorian
Peter Bottomley MP
Robert de Pass
Sir Brian & The Hon Lady Fiona
 Barttelot
T. S. Investments Ltd, Mrs Eleanor
 Brooks
The Blakenham Trust
The Bulldog Trust
The Duke of Richmond
The J. F. E. Smith Trust
Tim & Clare Ireland
Trees Power Family Charitable Trust
William Gibson
William Way (Wimbledon) Ltd
Wynkcoombe Trust

National Supporters

The Garfield Weston Foundation

Hiscox plc

National Sponsor

Christie's

Acknowledgements

The Public Catalogue Foundation would like to thank the individual artists and copyright holders for their permission to reproduce for free the paintings in this catalogue. Exhaustive efforts have been made to locate the copyright owners of all the images included within this catalogue and to meet their requirements. Copyright credit lines for copyright owners who have been traced, are listed in the Further Information section.

The Public Catalogue Foundation would like to express its great appreciation to the following organisations for their great assistance in the preparation of this catalogue:

Bridgeman Art Library
Flowers East
Marlborough Fine Art
National Association of Decorative and Fine Art Societies (NADFAS)
National Gallery, London
National Portrait Gallery, London
Royal Academy of Arts, London
Tate

The participating collections included in the catalogue would like to express their thanks to the following organisations which have so generously enabled them to acquire paintings featured in this catalogue:

Arts Council England
Friends of Pallant House
Heritage Lottery Fund (HLF)
MLA/V&A Purchase Grant Fund
National Art Collections Fund (the Art Fund)
National Heritage Memorial Fund (NHMF)

Catalogue Scope and Organisation

Medium and Support

The principal focus of this series is oil paintings. However, tempera and acrylic are also included as well as mixed media, where oil is the predominant constituent. Paintings on all forms of support (e.g. canvas, panel etc) are included as long as the support is portable. The principal exclusions are miniatures, hatchments or other purely heraldic paintings and wall paintings *in situ*.

Public Ownership

Public ownership has been taken to mean any paintings that are directly owned by the public purse, made accessible to the public by means of public subsidy or generally perceived to be in public ownership. The term 'public' refers to both central government and local government. Paintings held by national museums, local authority museums, English Heritage and independent museums, where there is at least some form of public subsidy, are included. Paintings held in civic buildings such as local government offices, town halls, guildhalls, public libraries, universities, hospitals, crematoria, fire stations and police stations are also included. Paintings held in central government buildings as part of the Government Art Collection and MoD collections are not included in the county-by-county series but should be included later in the series on a national basis.

Geographical Boundaries of Catalogues

The geographical boundary of each county is the 'ceremonial county' boundary. This county definition includes all unitary authorities. Counties that have a particularly large number of paintings are divided between two or more catalogues on a geographical basis.

Criteria for Inclusion

As long as paintings meet the requirements above, all paintings are included irrespective of their condition and perceived quality. However, painting reproductions can only be included with the agreement of the participating collections and, where appropriate, the relevant copyright owner. It is rare that a collection forbids the inclusion of its paintings. Where this is the case and it is possible to obtain a list of paintings, this list is given in the Paintings Without Reproductions section. Where copyright consent is refused, the paintings are also listed in the Paintings Without Reproductions section. All paintings in collections' stacks and stores are included, as well as those on display. Paintings which have been lent to other institutions, whether for short-term exhibition or long-term loan, are listed under the owner collection. In addition, paintings on long-term loan are also included under the borrowing institution when they are likely to remain there for at least another five years from the date of publication of this catalogue. Information relating to owners and borrowers is listed in the Further Information section.

Layout

Collections are grouped together under their home town. These locations are listed in alphabetical order. In some cases collections that are spread over a number of locations are included under a single owner collection. A number of collections, principally the larger ones, are preceded by curatorial forewords. Within each collection paintings are listed in order of artist surname. Where there is more than one painting by the same artist, the paintings are listed in order of collection accession number (inventory number). Where the artist is unknown and the school is given instead, paintings are listed in order of date first and then in order of collection accession number.

The few paintings that are not accompanied by photographs are listed in the Paintings Without Reproductions section.

There is additional reference material in the Further Information section at the back of the catalogue. This gives the full names of artists, titles and media if it has not been possible to include these in full in the main section. It also provides acquisition credit lines and information about loans in and out, as well as copyright and photographic credits for each painting. Finally, there is an index of artists' surnames.

Key to Painting Information

Almost all paintings are reproduced in the catalogue. Where this is not the case they are listed in the Paintings Without Reproductions section. Where paintings are missing or have been stolen, the best possible photograph on record has been reproduced. In some cases this may be black and white. Paintings that have been stolen are highlighted with a red border. Some paintings are shown with conservation tissue attached to parts of the painting surface.

Adam, **Patrick William** 1854–1929
Interior, Rutland Lodge: Vista through Open Doors 1920
oil on canvas 67.3 × 45.7
LEEAG.PA.1925.0671.LACF

Artist name This is shown as surname first. Where the artist is listed on the Getty Union List of Artist Names (ULAN), ULAN's preferred presentation of the name is always given. In a number of cases the name may not be a firm attribution and this is made clear. Where the artist name is not known, a school may be given instead. Where the school is not known, the painter name is listed as *unknown artist*. If the artist name is too long for the space, as much of the name is given as possible followed by (…). This indicates the full name is given at the rear of the catalogue in the Further Information section.

Painting title A painting followed by *(?)* indicates that the title is in doubt. Where the alternative title to the painting is considered to be better known than the original, the alternative title is given in parentheses. Where the collection has not given a painting a title, the publisher does so instead and marks this with an asterisk. If the title is too long for the space, as much of the title is given as possible followed by (…) and the full title is given in the Further Information section.

Medium and support Where the precise material used in the support is known, this is given.

Artist dates Where known, the years of birth and death of the artist are given. In some cases one or both dates may not be known with certainty, and this is marked. No date indicates that even an approximate date is not known. Where only the period in which the artist was active is known, these dates are given and preceded with the word *active*.

Execution date In some cases the precise year of execution may not be known for certain. Instead an approximate date will be given or no date at all.

Dimensions All measurements refer to the unframed painting and are given in cm with up to one decimal point. In all cases the height is shown before the width. Where the painting has been measured in its frame, the dimensions are estimates and are marked with (E). If the painting is circular, the single dimension is the diameter. If the painting is oval, the dimensions are height and width.

Collection inventory number In the case of paintings owned by museums, this number will always be the accession number. In all other cases it will be a unique inventory number of the owner institution. (P) indicates that a painting is a private loan. Details can be found in the Further Information section. The ✳ symbol indicates that the reproduction is based on a Bridgeman Art Library transparency (go to www.bridgeman.co.uk) or that the Bridgeman administers the copyright for that artist.

Facing page: Caulfield, Patrick, b.1936, *Juan Gris* (detail), 1963, Pallant House Gallery (p. 18)

THE PAINTINGS

Arundel Museum and Heritage Centre

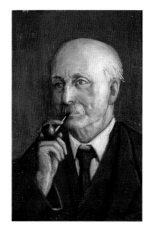

Ellis, Ralph
W. B. Ellis, Naturalist
oil on canvas 61 × 40
6

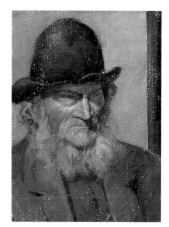

Ellis, Ralph
Portrait of a Countryman
oil on board 40 × 30
7

Ellis, Ralph
Arundel Cathedral from the River 1918?
oil on board 48 × 33
8

Ellis, Ralph
Seated Worker 1914
oil on board 39 × 25
9

Morris, D.
The Timber Wharf, Arundel 1899
oil on canvas 61 × 107
1

Ravenscroft, Frederick E. active 1891–1902
Old Mill by Swanbourne Lake 1891
oil on canvas 50 × 77
2

Ravenscroft, Frederick E. active 1891–1902
Arundel Castle from the Arun
oil on canvas 50 × 77
3

Ravenscroft, Frederick E. active 1891–1902
Arundel Castle from the Arun 1892
oil on canvas 50 × 77
4

Wilson, F.
View of Arundel 1877
oil on board 52 × 77
5

Wright, Helena
Corner of Maltravers Street and High Street
1867
oil on oak panel 27 × 35
10

Billingshurst Library

Jones, Oliver late 20th C
Path to St Mary's Church
acrylic on board 76.0 × 50.5
1

Chichester City Council

The Council House in Chichester, which dates from 1731, contains a wealth of artwork. In addition to the paintings shown here, the building houses a large collection of silverware, historic documents, antique furnishings and other artefacts relating to the city.

The oil paintings displayed in this catalogue have all been donated to the City of Chichester. The collection of paintings by the three Smith brothers, who were natives of Chichester, were presented to the city by Mrs A. W. F. Fuller in 1962. Much of the artwork is on public display in the Council House.

G. Clifford, Property Manager

Ashford, Faith
Chartres 1940
oil on canvas 28 × 34
DJ015

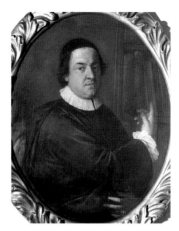

Bol, Ferdinand (attributed to) 1616–1680
Man in Black Doublet with White Ruff
oil on canvas 84 × 69
DJ104

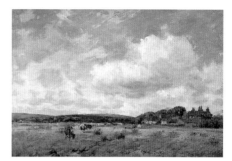

Charles, James 1851–1906
Sussex Downs
oil on canvas 39 × 58
DJ122

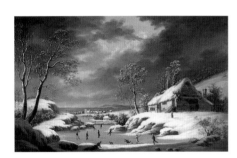

Gilbert, Joseph Francis 1792–1855
Winter Scene (Landscape with Village and Figures Skating) 1834
oil on canvas 79 × 125
DJ121

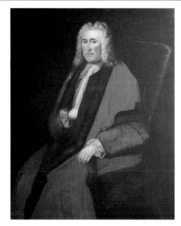

Hudson, Thomas (1701–1779) **or Jervas, Charles** (c.1675–1739) **(attributed to)**
John Costello, Mayor of Chichester, 1720
1720–1730
oil on canvas 124 × 98
DJ102

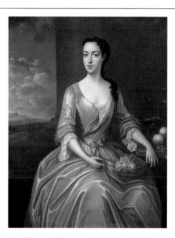

Hudson, Thomas (1701–1779) **or Jervas, Charles** (c.1675–1739) **(attributed to)**
Ann Costello, Daughter of John Costello
1720–1730
oil on canvas 119 × 44
DJ103

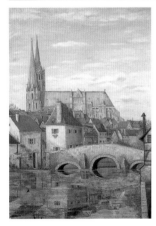

Marche
Chartres Cathedral wih Bridge over River 1960
oil on canvas 91 × 64
DJ132

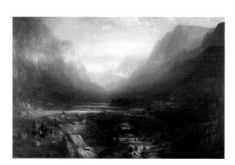

Müller, William James 1812–1845
Clearing after Rain, Pont Hoogan 1842
oil on canvas 99 × 152
DJ101

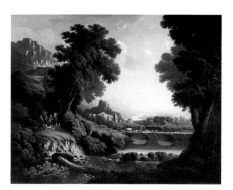

Pether, Abraham 1756–1812
River Landscape with Foreground Figures around a Fire, River and Bridge in Distance
oil on canvas 69 × 90
124

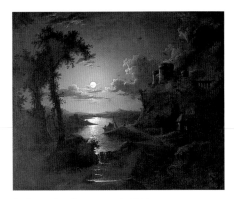

Pether, Abraham 1756–1812
Moonlit Estuary Scene
oil on canvas 62 × 75
DJ118

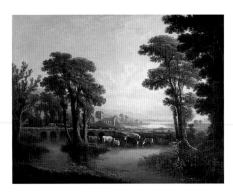

Pether, Abraham 1756–1812
River with Cattle Drinking, Ruined Church and Bridge
oil on canvas 69 × 89
DJ130

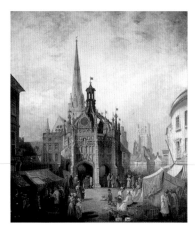

Pether, Henry 1800–1880
A View of Chichester Cross from East Street 1831
oil on canvas 90 × 77
DJ100

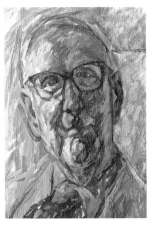

Riches, Elizabeth b.1931
The Late Eric Banks, Chichester, Town Clerk to Chichester (1936–1965 & 1974–1981) 1980?
oil on canvas 39.5 × 28.5
DJ009

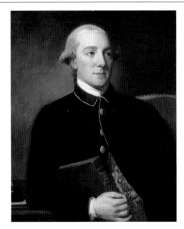

Romney, George 1734–1802
Harry Peckham Esq. Recorder of Chichester, 1785
oil on canvas 75 × 62
DJ108

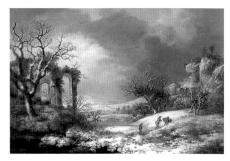

Smith, George 1714–1776
Winter Scene (Classical Ruins with Bridge in the Foreground and Figures with Horse)
oil on canvas 42 × 62
DJ119

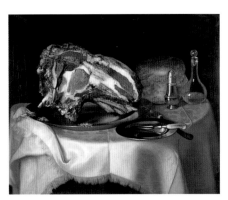

Smith, George 1714–1776
Still Life (Sirloin of Beef with Numerous Vessels and Utensils on a White Cloth)
oil on canvas 59 × 72
DJ120

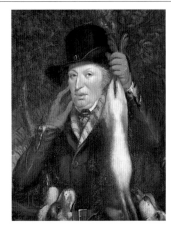

Smith, George 1714–1776
Man in Green Coat Holding a Hare with Four Hounds at his Feet
oil on canvas 90 × 70
DJ123

Smith, George 1714–1776
Wintry Scene with Burning Cottage in Foreground 1753
oil on canvas 70 × 90
DJ125

Smith, George 1714–1776
Rocky Shore Scene wih Ship Foundering 1752
oil on canvas 70 × 90
DJ126

Smith, John c.1717–1764
*Rural Scene with Cottage and Lake in
Foreground, Fishermen, Figures and Sheep*
oil on canvas 42 × 63
DJ127

Smith, John c.1717–1764
*River View with a Church in the Distance and
Figures in Foreground* 1755
oil on canvas 42 × 62
DJ129

Smith, William 1707–1764
*Winter Scene of a Cave in Foreground and Fire
with Figures Dancing* 1753
oil on canvas 43 × 53
DJ128

Smith, William (after) 1707–1764
*The Honourable James Brudenell, Recorder of
Chichester, MP for Chichester (1713–1715 &
1734–1746)* 1735
oil on canvas 74 × 62
DJ115

Smith, William (after) 1707–1764
*Charles, Second Duke of Richmond, KG, Mayor
of Chichester (1735)* 1735
oil on canvas 74 × 62
DJ116

unknown artist
Dr Henry King, Bishop of Chichester 1641
oil on canvas 75 × 52
DJ112

unknown artist early 17th C
*Said to be William Cawley, (MP, Founder of St
Bartholomew's Hospital, Chichester in 1626
and one of the Judges of King Charles I)* 1620
oil on oak board 56 × 43
DJ106

unknown artist late 17th C?
Man in Armour with White Ruff
oil on canvas 53 × 43
DJ107

unknown artist
Dr Edward Waddington, Bishop of Chichester
1724 1724–1731
oil on canvas 75 × 52
DJ113

unknown artist 18th C?
Sir Richard Farrington, Bt, Member for the City,
1714
oil on canvas 74 × 62
DJ109

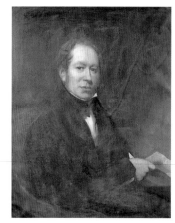

unknown artist
Seated Victorian Gentleman, Facing Half-Right
with Papers in Hand
oil on canvas 92.0 × 71.5
DJ002

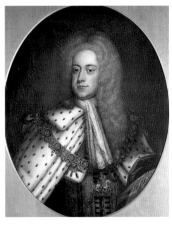

unknown artist
George II
oil on canvas 89 × 71
DJ110

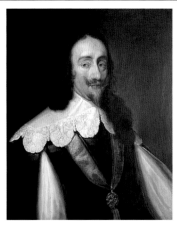

unknown artist
Charles I
oil on canvas 75 × 62
DJ111

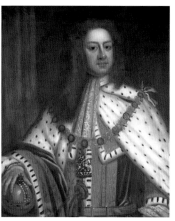

unknown artist
George I
oil on canvas 89 × 75
DJ114

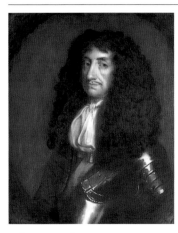

unknown artist
Charles II
oil on canvas 75 × 62
DJ117

Vizard, W. active 1886–1903
Peyton Temple Mackeson, MA (Oxen) JP, Hon.
Freeman of the City of Chichester, Mayor
(1901– 1904) 1903
oil on canvas 88 × 69
DH131

Chichester District Museum

Foulger, John
A Breezy Day in the Harbour, Chichester 1976
oil on card 17.6 × 21.6 (E)
7694

Jenner, Isaac Walter 1836–1901
The Mill Quay, Bosham 1882
oil on canvas 27.8 × 50.5
1171

Jennings, Audrey
Westgate at Twilight c.1955
oil on hardboard 27.0 × 37.7 (E)
2149

Malby, Walter Noah 1858–1892
Chichester Canal c.1884
oil on canvas 34.5 × 52.1 (E)
1172

Skelton, John 1923–1996
Slate Sculpture for Chichester Museum 1962
oil & pen on canvas 42.7 × 55.0
4528

Skelton, John 1923–1996
*Slate Sculpture for Chichester Museum, Symbol
of Discovery* 1962
oil & pen on canvas 56.8 × 19.5
4529

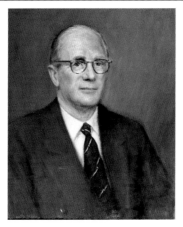

Swan, Robert John 1888–1980
Charles Ernest Shippam, President 1974
oil on canvas 59.5 × 49.5 (E)
7695

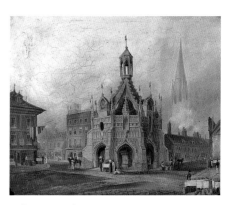

unknown artist
The Market Place at Chichester, Sussex
1810–1813
oil on canvas 42 × 52
7666

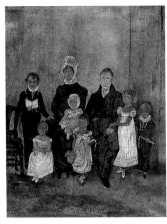

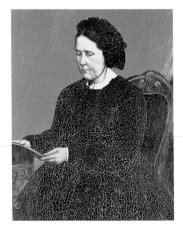

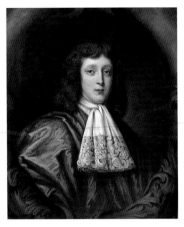

unknown artist
James Ewer Cutten and His Family c.1828
oil on canvas 45.2 × 37.0 (E)
7697

unknown artist
Sarah Cutten 1850–1860s
oil on canvas 47 × 38
7698

unknown artist
Oliver Whitby (after a painting attributed to Mary Beale) 1887?
oil on canvas 74.5 × 62.0 (E)
4969

unknown artist
The Grange, Tower Street, Chichester c.1922
oil on hardboard 44 × 74
4560

unknown artist
Hurrah for Shippams 1954
oil on canvas 76.3 × 65.7
7223

Watts, Roland active 1940–1960
Chichester from Donnington, Summer 1950 1950
oil on hardboard 28.1 × 35.7
4065

Chichester Festival Theatre

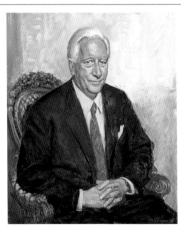

Hailstone, Bernard 1910–1987
Leslie Evershed-Martin, Founder of Chichester Festival Theatre 1978
oil on canvas 99.0 × 86.3
1 (P)

Chichester Library

Towell, W. K.
Tower Street, Chichester c.1900
oil on canvas 49 × 38

Fishbourne
Roman Palace

Baker, Evelyn active c.1960–2004
*Spiral Vine Tendril Border on Late First
Century Mosaic* mid-1960s
acrylic on card 42.5 × 53.3
1

Baker, Evelyn active c.1960–2004
Third Century Duplex Knot Mosaic mid-1960s
acrylic on card 40.5 × 30.8
2

Baker, Evelyn active c.1960–2004
*Mid-Second Century Cupid on a Dolphin
Mosaic* mid-1960s
acrylic on card 99.2 × 99.2
3

Pallant House Gallery

Pallant House Gallery is a remarkable hybrid: one of the country's most important collections of modern British art in a Queen Anne town house, dating from 1712, with a contemporary wing designed by Long & Kentish in association with Colin St John Wilson. The Gallery owes its inception to what Walter Hussey (1909–1985), the Dean of Chichester from 1955–1977, described as his 'blackmail': that if Pallant House, one of the finest buildings in Chichester, were to be restored as a gallery he would leave his art collection to the city. In 1982, after a programme of sensitive restoration, this grade one listed building, which had been used as council offices since 1919, was opened to the public as a gallery with the Hussey Collection displayed in the fine historic interiors.

The artworks in the Hussey Collection range from Old Master prints and drawings by Albrecht Dürer, Giovanni Bernini, Thomas Gainsborough, Rembrandt van Rijn, Giulio Romano and Jean Antoine Watteau to Modern artworks by Duncan Grant, Barbara Hepworth, John Minton, Henry Moore, Pablo Picasso, Ceri Richards, Matthew Smith, Christopher Wood and many others. Significantly, Hussey was not only a collector but also a patron of the arts, leading the post-war renaissance in church patronage. As vicar of St Matthew's in Northampton he had commissioned a sculpture of the Madonna and Child from Henry Moore and a crucifixion from Graham Sutherland, and subsequently at Chichester he commissioned an altarpiece from Sutherland, a tapestry for the High Altar from John Piper, a stained glass window from Marc Chagall, furnishings from the sculptor Geoffrey Clarke, vestments from Ceri Richards and various musical commissions including the moving *Rejoice in the Lamb* by Benjamin Britten and the *Chichester Psalms* by Leonard Bernstein. Hussey became friends with many of these artists and as a result, the collection contains many studies and artworks that relate to his various commissions, such as Sutherland's painting *Christ Appearing to Mary Magdalen* and *Crucifixion* and John Piper's *Air Motif from Chichester Cathedral Tapestry*.

In 1985 an independent charitable trust was established to take over the running of the gallery from the Chichester District Council. The success of the original gallery attracted more bequests, loans and donations, most notably the Kearley Bequest through the National Art Collections Fund in 1989. Charles Kearley was a property developer, racehorse owner and hotelier, who began collecting in the late thirties in order to decorate a bare apartment in Kensal House, a progressive Modernist housing development designed by the architect Maxwell Fry. His collection complements Hussey's, but broadens its scope with examples of international modern art by artists such as Paul Cézanne, Sam Francis, Paul Klee, Le Corbusier, Fernand Léger, Jean Metzinger and Gino Severini, whose *Danseuse No.5* is one of the masterpieces of Italian Futurist art. Kearley mainly bought from dealers or at auctions, allowing himself an annual budget of about £700 for the purchase of works of art. An early purchase was John Piper's *Redland Park Congregational Church, Bristol*, an important example of Piper's work for the War Artist's Advisory Committee during World War II. During the next few years this was joined by works by Mark Gertler, Paul Nash, Ben Nicholson and J. B. Yeats and many others, some bought on the advice of the art critic R. H. Wilenski.

The Norman Lucas Bequest in 1995 brought further artworks by artists including Jean Dufy, Ivon Hitchens, Henry Lamb and studio ceramics by Bernard Leach, and at the same time the gallery was bequeathed the Geoffrey Freeman Collection of Bow Porcelain, an exemplary collection of over 300 pieces of eighteenth century bone china. The Gallery's collection also includes some significant historic paintings, such as the sixteenth century heraldic panels of the 'Heroines of Antiquity' by Lambert Barnard from Amberley Castle on long-term loan from Chichester District Council, which are rare examples of English Pre-Reformation painting, and a fine collection of eighteenth century landscape and still life paintings by the Smith Brothers of Chichester (George, William and John). Special mention should be made of the group of paintings by Ivon Hitchens (1893–1979), who lived and worked in the South Downs from 1940 until his death, which includes the remarkable Curved Barn, Hitchens' earliest painting in a public collection, which was presented by the artist before his death. A recent acquisition through the National Art Collections Fund is Hitchens' vibrant Matisse-inspired Flowers. In 1997 the German Jewish émigré artist Hans Feibusch (1898–1998) presented the contents of his studio to the gallery, which included canvases, studies, drawings and sculptures. Feibusch had been included in Hitler's exhibition of Degenerate Art in 1937 and besides important commissions from George Bell, Bishop of Chichester he worked as a painter of religious murals in many churches in London and across the south of England.

With these growing collections it became clear in the mid-1990s that the gallery was rapidly running out of space and the decision was made to build a new wing to make the building and collections more accessible to all. The new wing houses seven galleries opening off a long central hall with natural lighting from above, a prints and drawings room, education studio workshop, art reference library, bookshop and café. The courtyard garden is designed by Christopher Bradley-Hole, who has won the gold medal at the Chelsea Garden Show on a number of occasions. The new gallery also houses the collection of Professor Sir Colin St John Wilson and his wife M. J. Long, who approached Pallant House Gallery as a possible home for their unrivalled art collection in the early 1990s. The Wilson Collection (part-permanent gift through the National Art Collections Fund and part extended loan) is made up of over 500 paintings, drawings, prints and sculptures and includes masterpieces of British 20th century art such as Michael Andrews' Colony Room, Peter Blake's The Beatles 1962, David Bomberg's Last Self Portrait, Patrick Caulfield's Juan Gris and Richard Hamilton's Swingeing London '67.

Colin St John Wilson (Sandy to his friends) is the architect of the British Library and was Professor of Architecture and Fine Art at Cambridge University from 1975 until 1989, and is still Professor Emeritus. He describes his art collecting as a 'lifelong addiction', which began after he received a £35 pay-off on demobilisation from the navy in 1945. Like Hussey, Wilson has enjoyed friendships with many of the artists, including Peter Blake, Prunella Clough, Richard Hamilton and Eduardo Paolozzi, some as a result of his involvement with the Institute of Contemporary Arts in London and his association with the Independent Group (1952–1955). He has been portrayed by a number of artists including Michael Andrews, William Coldstream, David Hockney, Howard Hodgkin, R. B. Kitaj and the sculptor Celia Scott, and he has written about the working methods of Andrews and Coldstream in The Artist at Work. In addition to the iconic examples of British Pop Art, the collection

has strong holdings of twentieth century figurative painting by artists including Walter Sickert, David Bomberg, Frank Auerbach, Peter de Francia and Victor Willing. Significantly, preparatory studies are often represented as well as the finished works, as in the case of Sickert's *Jack Ashore*, Bomberg's *The Southeast Corner, Jerusalem* and Michael Andrew's sublime last painting *Thames Painting: The Estuary*.

With the addition of the Wilson Collection, Pallant House Gallery has become what might be called a 'collection of collections', providing an overview of modern British art, albeit through the individual tastes and concerns of the different collectors. The gallery's collection continues to grow, in a range of media, through a programme of artist's residencies and commissions, which have recently included the photographer Joy Gregory, the jeweller Wendy Ramshaw, the painter Paul Huxley, the multimedia artists Langlands & Bell and the landscape artist Andy Goldsworthy, and through the generosity of private donors, art charities and funding bodies such as the National Art Collections Fund, the Resource/Victoria and Albert Purchase Grant Fund, the Museums Libraries and Archives Council, the Arts Council England and, not least, the Friends of Pallant House.

Simon Martin, Assistant Curator

Adler, Jankel 1895–1949
Reclining Nude 1940s
oil on board 30.5 × 63.5
CHCPH 1422 (P)

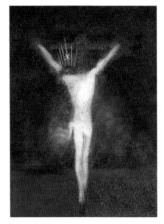

Aitchison, Craigie Ronald John b.1926
Crucifixion IX 1963
oil on canvas 25 × 20
CHCPH 1007 (P)

Andrews, Michael 1928–1995
Study for 'Colony Room' 1962
oil on board 31.4 × 48.0
CHCPH 1015

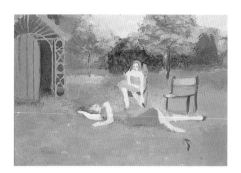

Andrews, Michael 1928–1995
Two Girls in the Garden 1957
oil on board 30.5 × 40.6
CHCPH 1040 (P)

Andrews, Michael 1928–1995
Thames Painting: The Estuary (Mouth of the Thames) 1994–1995
oil and mixed media on canvas 219.8 × 189.1
CHCPH 1091

Andrews, Michael 1928–1995
Colony Room I (The Colony Room) 1962
oil on board 120.0 × 182.8
CHCPH 1215

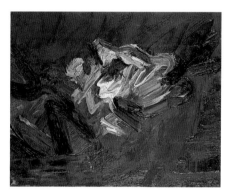

Andrews, Michael 1928–1995
Study of a Head for a Group of Figures (Study of a Head with Green Turban) 1967
oil on board 21.5 × 16.5
CHCPH 1419 (P)

Armstrong, John 1893–1973
The Open Door 1930
oil on canvas 89.2 × 77.5
CHCPH 1654 (P)

Auerbach, Frank Helmuth b.1931
Reclining Head of Gerda Boehm 1982
oil on canvas 41.5 × 51.0
CHCPH 0054

Auerbach, Frank Helmuth b.1931
To the Studios 1977
oil on board 45.5 × 51.0
CHCPH 0098

Auerbach, Frank Helmuth b.1931
Oxford Street Building Site c.1960
oil on board 55 × 40
CHCPH 1052 (P)

Auerbach, Frank Helmuth b.1931
Camden Palace 2000
oil on board 10 × 10
CHCPH 1095

Auerbach, Frank Helmuth b.1931
Reclining Model in the Studio I 1963
oil on board 61.0 × 77.5
CHCPH 1421 (P)

Barker, Kit 1916–1988
Gathered Reeds, Grande Brière 1969
oil on canvas 50 × 96
CHCPH 0882

Barker, Kit 1916–1988
Llanmadoc, Gower 1965
oil on canvas 51.0 × 86.3
CHCPH 0891

Barnard, Lambert c.1490–1567
Semiramis, from the Amberley Castle 'Heroines of Antiquity' (Amberley Queens) c.1526
oil & tempera on canvas 115 × 86
CHCPH 0738 a (P)

Barnard, Lambert c.1490–1567
Lampedo, from the Amberley Castle 'Heroines of Antiquity' (Amberley Queens) c.1526
oil & tempera on canvas 115 × 86
CHCPH 0738 b (P)

Barnard, Lambert c.1490–1567
Menalippe, from the Amberley Castle, 'Heroines of Antiquity' (Amberley Queens) c.1526
oil & tempera on canvas 115 × 86
CHCPH 0738 c (P)

Barnard, Lambert c.1490–1567
Hippolyta, from the Amberley Castle 'Heroines of Antiquity' (Amberley Queens) c.1526
oil & tempera on canvas 115 × 86
CHCPH 0738 d (P)

Barnard, Lambert c.1490–1567
Zenobia, from the Amberley Castle 'Heroines of Antiquity' (Amberley Queens) c.1526
oil & tempera on canvas 115 × 86
CHCPH 0738 e (P)

Barnard, Lambert c.1490–1567
Sinope, from the Amberley Castle 'Heroines of Antiquity' (Amberley Queens) c.1526
oil & tempera on canvas 115 × 86
CHCPH 0738 f (P)

Facing page: Sutherland, Graham Vivian, 1903–1980, *Datura Flowers* (detail), 1957, Pallant House Gallery (p. 44)

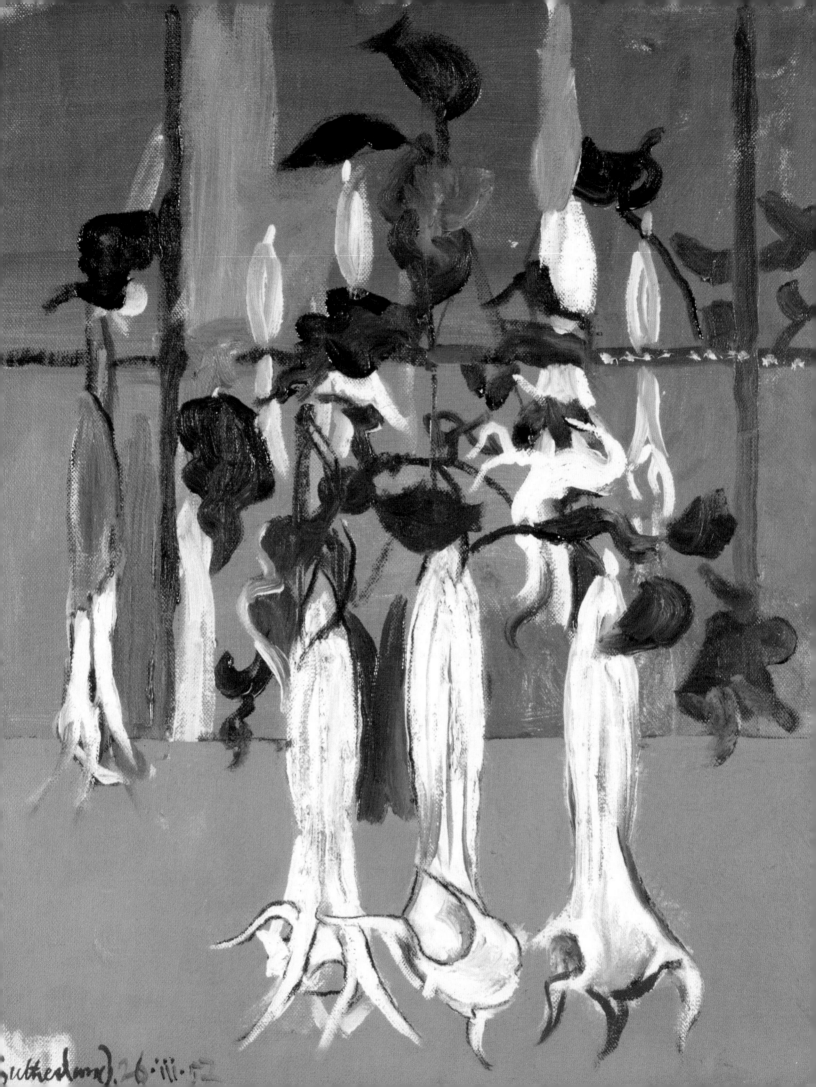

Barnard, Lambert c.1490–1567
*Thamoris, from the Amberley Castle 'Heroines
of Antiquity' (Amberley Queens)* c.1526
oil & tempera on canvas 115 × 86
CHCPH 0738 g (P)

Barnard, Lambert c.1490–1567
*Cassandra, from the Amberley Castle 'Heroines
of Antiquity' (Amberley Queens)* c.1526
oil & tempera on canvas 115 × 86
CHCPH 0738 h (P)

Bell, Leland 1922–1991
Two Nudes 1980s
acrylic on canvas on board 55.2 × 42.9
CHCPH 1231

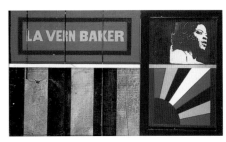

Bell, Leland 1922–1991
Butterfly Group 1980s
acrylic on canvas on board 25.3 × 66.0
CHCPH 1424

Bell, Vanessa 1879–1961
Angelica 1934
oil on hardboard 13 × 13
CHCPH 1017-1 (P)

Blake, Peter b.1932
La Vern Baker 1961–1962
oil on wood & mirror glass 52.0 × 87.6
CHCPH 1008 (P)

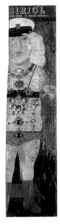

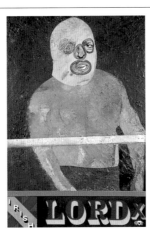

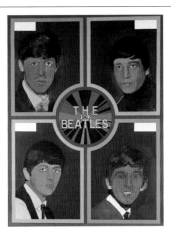

Blake, Peter b.1932
Siriol, She-Devil of Naked Madness 1957
oil & collage on panel 74.9 × 21.6
CHCPH 1009 (P)

Blake, Peter b.1932
Irish Lord X 1963
oil on canvas 54.5 × 39.0
CHCPH 1051 (P)

Blake, Peter b.1932
The Beatles 1962 1963–1968
cryla on hardboard 122 × 91
CHCPH 1073

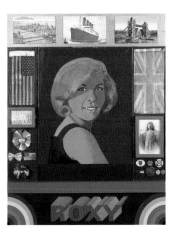

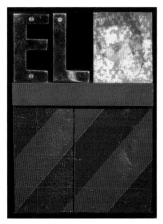

Blake, Peter b.1932
Girls with Their Hero 1959
cryla on board 134 × 125
CHCPH 1232

Blake, Peter b.1932
Roxy Roxy 1965–1983
cryla & collage on hardboard 66.0 × 55.1
CHCPH 1425 (P)

Blake, Peter b.1932
EL 1961
lipstick, collage & oil paint on wood
29.6 × 21.0
CHCPH 1427 (P)

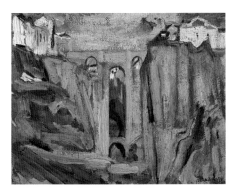

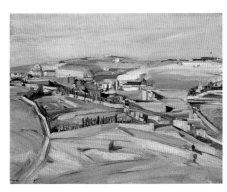

Bomberg, David 1890–1957
Ronda Bridge 1935
oil on panel 31.5 × 40.5
CHCPH 0337

Bomberg, David 1890–1957
The Southeast Corner, Jerusalem (Palestinian Landscape) 1926
oil on canvas 51 × 66
CHCPH 0818

Bomberg, David 1890–1957
The Last Landscape (Tajo and Rocks, Ronda) 1956
oil on canvas 71.0 × 91.5
CHCPH 1057 (P)

Bomberg, David 1890–1957
Last Self Portrait 1956
oil on canvas 76.0 × 63.5
CHCPH 1233

Bomberg, David 1890–1957
Interior of a Peasant House, Kolonia 1923
oil on canvas 40.5 × 50.5
CHCPH 1237

Bomberg, David 1890–1957
Talmudist 1953
oil on canvas 76.2 × 63.6
CHCPH 1241

Bomberg, **David** 1890–1957
Soliloquy Noonday Sun, Ronda 1954
oil on canvas 89 × 79
CHCPH 1430 (P)

Bomberg, **David** 1890–1957
Self Portrait 1923
oil on card 29 × 29
CHCPH 1431 (P)

Bomberg, **David** 1890–1957
Self Portrait (Recto: 'The Man') 1937
oil on board 61.0 × 50.8
CHCPH 1439 (P)

Bomberg, **David** 1890–1957
The Man (Verso: 'Self Portrait') 1937
oil on board 61.0 × 50.8
CHCPH 1439 (P)

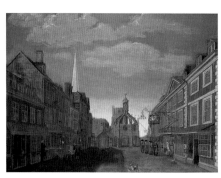

British School 18th C
East Street, Chichester 1715
oil on canvas 84 × 113
CHCPH 0318 (P)

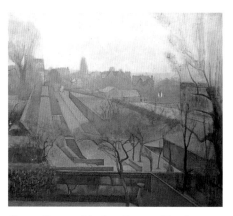

Carter, **Bernard Arthur Ruston (Sam)**
b.1909
University College School, Hampstead from the Artist's Studio Window (...) 1971
oil on board 111.5 × 122.5
CHCPH 1448 (P)

Caulfield, **Patrick** b.1936
Coloured Still Life 1967
acrylic on board 56 × 89
CHCPH 1010 (P)

Caulfield, **Patrick** b.1936
Juan Gris 1963
household paint on board 122 × 122
CHCPH 1055

Caulfield, **Patrick** b.1936
Kellerbar 1997
acrylic on canvas 76.8 × 61.6
CHCPH 1069 (P)

Caulfield, Patrick b.1936
Pipe on Table 2000
oil on board 7.5 × 7.5
CHCPH 1098

Caulfield, Patrick b.1936
Still Life with Figs 1964
oil on board 122.0 × 152.4
CHCPH 1242

Caulfield, Patrick b.1936
Landscape with Birds 1963
gloss paint on board 122 × 122
CHCPH 1243

Caulfield, Patrick b.1936
View of the Chimneys 1964
oil on canvas 122.0 × 243.8
CHCPH 1244

Caulfield, Patrick b.1936
Reserved Table 2000
acrylic on canvas 183 × 190
CHCPH 1245

Caulfield, Patrick b.1936
Study for the British Library Tapestry (Pause on the Landing) 1993
acrylic on board 61.6 × 76.8
CHCPH 1441 (P)

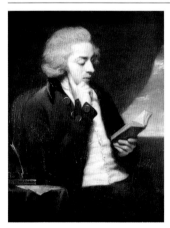

Chandler, John Westbrooke (attributed to)
1764–1804/1805
Portrait of a Young Gentleman Reading (Young Burke)
oil on canvas 91 × 74
CHCPH 0278

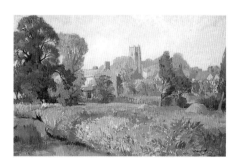

Chorley, Adrian b.1906
Monks Eleigh, Suffolk 1949
oil on canvas 40.5 × 57.0
CHCPH 1123

Clough, Prunella 1919–1999
Disused Land 1999
oil on canvas 132 × 122
CHCPH 1054

Clough, Prunella 1919–1999
Brown Wall 1964
oil on canvas 111 × 101
CHCPH 1078

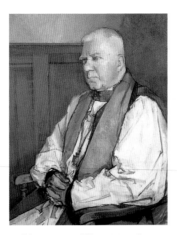

Coldstream, William Menzies 1908–1987
Dr Bell, Bishop of Chichester 1954
oil on canvas 89.4 × 70.0
CHCPH 0742/ T00074 🐝

Coldstream, William Menzies 1908–1987
Westminster IX 1982
oil on canvas 34.3 × 29.2
CHCPH 1012 (P) 🐝

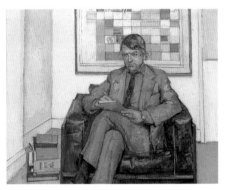

Coldstream, William Menzies 1908–1987
Colin St John Wilson 1982–1983
oil on canvas 101.6 × 127.0
CHCPH 1048 (P) 🐝

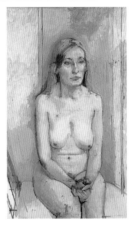

Coldstream, William Menzies 1908–1987
Seated Nude 1972–1973
oil on canvas 101.0 × 61.6
CHCPH 1050 🐝

Coldstream, William Menzies 1908–1987
The Opera House, Rimini, Interior (Bomb Damaged Theatre, Italy) c.1944
oil on canvas 81.6 × 59.7
CHCPH 1070 🐝

Coldstream, William Menzies 1908–1987
View across Frognal Lane 1971
oil on canvas 72.6 × 50.0
CHCPH 1256 🐝

Coldstream, William Menzies 1908–1987
View from Kitchen Window, Cannon Hill (Emmanuel Church) 1947
oil on canvas 65.0 × 53.7
CHCPH 1445 (P) 🐝

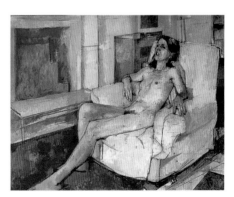

Coldstream, William Menzies 1908–1987
Seated Nude 1973–1974
oil on canvas 101.6 × 127.0
CHCPH 1446 (P) 🐝

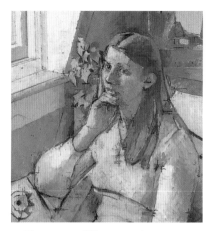

Coldstream, William Menzies 1908–1987
Girl Reflecting 1977
oil on canvas 45.7 × 45.7
CHCPH 1447 (P)

Collins, Cecil 1908–1989
Fête gallante 1951
oil on canvas 82.5 × 122.0
CHCPH 1660 (P)

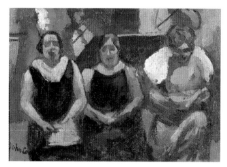

Cooper, John L. G. 1894–1943
Three Prima Donnas 1934
oil on hardboard 12.6 × 18.0
CHCPH 1017-2 (P)

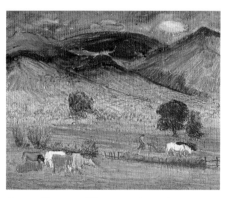

Coxon, Raymond James 1896–1997
Cumberland 1934
oil on board 10.4 × 13.0
CHCPH 1017-3 (P)

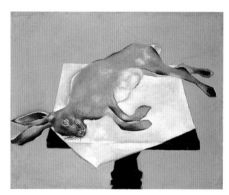

Craxton, John b.1922
Hare on a Table 1944–1946
oil on board 51.0 × 63.4
CHCPH 1029 (P)

Creffield, Dennis b.1931
Petworth: South End from East 1991–1992
oil on canvas 76.2 × 86.4
CHCPH 1263

Cunningham, Vera 1897–1955
Susannah and the Elders 1934
oil on canvas board 13.5 × 17.8
CHCPH 1017-4 (P)

de Francia, Peter b.1921
A Diary of our Times (Triptych)
oil on canvas 183 × 140
CHCPH 1271a

de Francia, Peter b.1921
A Diary of our Times (Triptych)
oil on canvas 183 × 140
CHCPH 1271b

de Francia, Peter b.1921
A Diary of our Times (Triptych)
oil on canvas 183 × 140
CHCPH 1271c

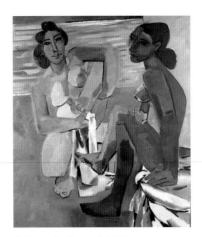

de Francia, Peter b.1921
Two Nudes 1973
oil on canvas 178 × 152
CHCPH 1276

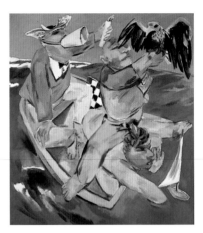

de Francia, Peter b.1921
Ship of Fools c.1972
oil on canvas 76.3 × 54.5
CHCPH 1277

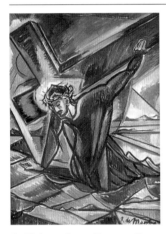

de Maistre, Leroy Leveson Laurent Joseph
1894–1968
Christ Falls the First Time c.1947
oil on canvas 41.4 × 31.1
CHCPH 1180

Donagh, Rita b.1939
Overhead 2000
oil on canvas 6.5 × 15.5
CHCPH 1102

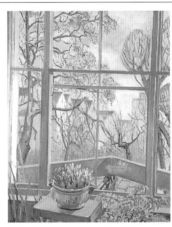

Donaldson, Marysia active 1937–1959
Promise (A Window in Hampstead) c.1937
oil on canvas 76.4 × 36.6
CHCPH 1124

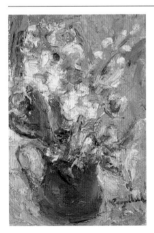

Engelbach, Florence 1872–1951
Crocus and Stocks 1934
oil on canvas 17.8 × 12.7
CHCPH 1017-5 (P)

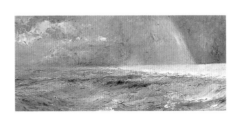

Eurich, Richard Ernst 1903–1992
Chesil Beach 1979
oil on board 25.4 × 45.1
CHCPH 0105

Evans, Merlyn Oliver 1910–1973
The Lock
oil on canvas 154 × 128
CHCPH 1661 (P)

Fedden, Mary b.1915
The Yellow Truck 1960
oil on board 50 × 30
CHCPH 0105

Fedden, Mary b.1915
Still Life with Artichoke 1972
oil on canvas 50.5 × 61.0
CHCPH 0929

Feibusch, Hans 1898–1998
Narcissus 1946
oil on canvas 61.0 × 91.5
CHCPH F.001

Feibusch, Hans 1898–1998
Rotes Tor, Taormina
oil on canvas 56.0 × 76.2
CHCPH F.246

Feibusch, Hans 1898–1998
Roemische Tempel
oil on canvas 49.5 × 89.5
CHCPH F.247

Feibusch, Hans 1898–1998
Untitled (Meditteranean Landscape) 1949
oil on canvas 49.5 × 90.0
CHCPH F.257

Feibusch, Hans 1898–1998
Untitled (Wooded Landscape) 1944/1948
oil on canvas 51 × 90
CHCPH F.258

Feibusch, Hans 1898–1998
Landscape Study: Talnyva
oil on canvas 51.0 × 91.5
CHCPH F.259

Feibusch, Hans 1898–1998
Untitled (Still Life of Bust, Candle, Vase and Shell) 1935
oil on canvas 53.0 × 73.5
CHCPH F.262

Feibusch, Hans 1898–1998
The Grey Cloud (Four Mourning Figures in a Crucifixion Scene) 1987
oil on canvas 152.2 × 151.5
CHCPH F.265

Feibusch, Hans 1898–1998
Descent into Hell (Hollensturs 2) 1985
oil on canvas 152.6 × 96.8
CHCPH F.266

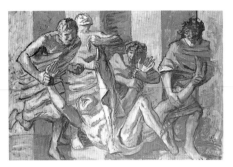

Feibusch, Hans 1898–1998
Homage to Poplinsee 1985
oil on canvas 107.5 × 155.0
CHCPH F.267

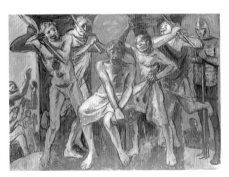

Feibusch, Hans 1898–1998
The Flagellation 1985
oil on canvas
CHCPH F.268

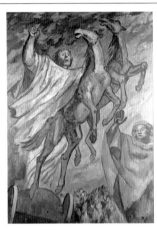

Feibusch, Hans 1898–1998
Elijah's Ascension 1990
oil on canvas 182.5 × 131.1
CHCPH F.269

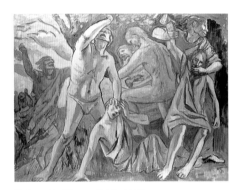

Feibusch, Hans 1898–1998
Strife 1988
oil on canvas 135 × 176
CHCPH F.271

Feibusch, Hans 1898–1998
Miraculous Draft of Fishes 1969
oil on canvas 155.5 × 189.0
CHCPH F.272

Feibusch, Hans 1898–1998
Men and Satyrs Dancing 1954
oil on canvas 131 × 145
CHCPH F.273

Feibusch, Hans 1898–1998
Guardian Angels 1961
oil on board 212 × 119
CHCPH F.275

Feibusch, Hans 1898–1998
Study for the Bishop's Chapel Mural, Chichester
1953
oil on canvas 224 × 119
CHCPH F.276

Feibusch, Hans 1898–1998
Untitled (Study, Men and Satyrs)
oil on canvas 151.5 × 220.0
CHCPH F.277

Feibusch, Hans 1898–1998
Landscape with Large Terracotta Jars
oil on canvas 51.0 × 76.2
CHCPH F.278

Feibusch, Hans 1898–1998
Untitled Scene (Adam and Eve) 1964
oil on canvas 122.0 × 63.8
CHCPH F.279

Feibusch, Hans 1898–1998
Untitled (Study of Reclining Female Nude with Blue Wrap) 1989
oil on canvas 61.6 × 91.5
CHCPH F.281

Feibusch, Hans 1898–1998
Untitled (Study of Roman Bust, Fruit, Leaves and Drape) 1980
oil on canvas 51.5 × 91.7
CHCPH F.283

Feibusch, Hans 1898–1998
Untitled (Still Life of Head, Wreath, Shell, Fruit and Candle) 1980
oil on canvas 51.2 × 91.3
CHCPH F.284

Feibusch, Hans 1898–1998
Untitled (Landscape with Woman in an Olive Grove)
oil on canvas 51.0 × 76.5
CHCPH F.285

Feibusch, Hans 1898–1998
Untitled (Study of Three Turtles Swimming with Fish) 1950
oil on canvas 50.7 × 91.5
CHCPH F.286

Feibusch, Hans 1898–1998
Untitled (Gloucestershire Landscape, Evening)
1987
oil on canvas 50.6 × 76.2
CHCPH F.288

Feibusch, Hans 1898–1998
Taormina, Sicily 1949
oil on canvas 56 × 76
CHCPH F.289

Feibusch, Hans 1898–1998
*Untitled (Still Life of Candle, Bowl of Apples
and Vase of Bergenia)* 1980
oil on canvas 50.7 × 91.4
CHCPH F.291

Feibusch, Hans 1898–1998
*Untitled (Still Life of Candle, Drape, Apples and
Shell)*
oil on canvas 51 × 91
CHCPH F.292

Feibusch, Hans 1898–1998
Still Life with Head 1980
oil on canvas 50 × 91
CHCPH F.295

Feibusch, Hans 1898–1998
Dream Flight 1971
oil on canvas 92.4 × 136.6
CHCPH F.296

Feibusch, Hans 1898–1998
Untitled (Two Females)
oil on canvas
CHCPH F.298

Feibusch, Hans 1898–1998
At the Feet of Christ on the Cross
oil on board 91.6 × 122.2
CHCPH F.301

Feibusch, Hans 1898–1998
The Huck (A Meditteranean Landscape) 1984
oil on canvas 51 × 91
CHCPH F.303

Feibusch, Hans 1898–1998
Olive Grove
oil on canvas
CHCPH F.304

Feibusch, Hans 1898–1998
Untitled (Still Life of Candle, Marrow, Squashes and Bucket) 1942
oil on canvas 50.7 × 71.0
CHCPH F.305

Feibusch, Hans 1898–1998
Still Life (Fish and Candle)
oil on canvas 51 × 92
CHCPH F.306

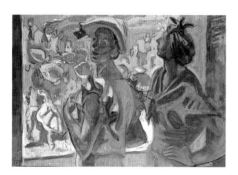

Feibusch, Hans 1898–1998
Untitled (Study of Two Women in an Aquarium) 1951
oil on canvas 76 × 102
CHCPH F.307

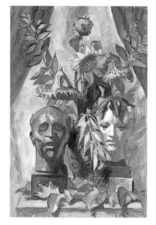

Feibusch, Hans 1898–1998
Untitled (Still Life of Sunflowers with Two Heads) 1982
oil on canvas 91.5 × 61.2
CHCPH F.308

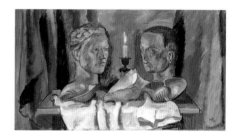

Feibusch, Hans 1898–1998
Untitled (Still Life of Two Heads, Three Shells and a Candle) 1980
oil on canvas 51.7 × 92.0
CHCPH F.309

Feibusch, Hans 1898–1998
Gloucester Landscape 'Wye' 1987
oil on canvas 50.7 × 76.5
CHCPH F.310

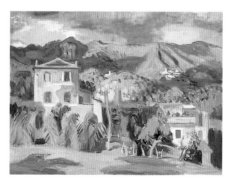

Feibusch, Hans 1898–1998
Cloud Shadows
oil on canvas 61.0 × 81.6
CHCPH F.311

Feibusch, Hans 1898–1998
Untitled (Tobias and the Angel) 1953
oil on canvas 166.5 × 92.0
CHCPH F.315

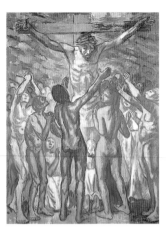

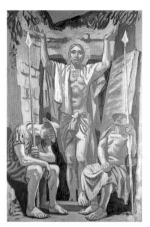

Feibusch, Hans 1898–1998
The Old Gods 1953
oil on canvas 91.5 × 152.2
CHCPH F.1753

Feibusch, Hans 1898–1998
Crucifixion 1986
oil on canvas 182 × 136
CHCPH F.1754

Feibusch, Hans 1898–1998
Resurrection 1969
oil on canvas 217.5 × 142.0
CHCPH F.1755

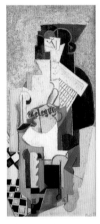

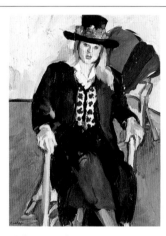

Filla, Emil 1882–1953
Homme assis tenant un journal 1920
oil and sand on canvas 78.3 × 36.5
CHCPH 0588

Finer, Stephen b.1949
Sir Morris Finer 1999
oil on canvas 60 × 50
CHCPH 1121

Fisher, Sandra 1947–1994
*Cosima in a Black Hat (Spender's
Granddaughter)* 1992
oil on canvas 40 × 30
CHCPH 1279

Freud, Lucian b.1922
Unripe Tangerine 1946
oil on board 8.9 × 8.9
CHCPH 1013 (P)

Gertler, Mark 1892–1939
Near Swanage 1916
oil on board 24.0 × 36.2
CHCPH 0965

González, Pedro b.1927
Untitled Abstract of Figures 1985
acrylic on canvas 93.8 × 83.5
CHCPH 0624

Gore, Spencer 1878–1914
The Garden Path, Garth House 1910
oil on canvas 41.0 × 50.8
CHCPH 0265

Gotlib, Henryk 1890–1966
Fireside Nude 1940s
oil on canvas 76.4 × 50.5
CHCPH 1126

Grant, Duncan 1885–1978
Bathers by the Pond 1920–1921
oil on canvas 50.5 × 91.5
CHCPH 0061

Grant, Duncan 1885–1978
Rosamund Lehmann 1974
oil on canvas 61.2 × 51.0
CHCPH 0976

Grant, Duncan 1885–1978
Still Life 1934
oil on board 8.9 × 10.7
CHCPH 1017-7 (P)

Greaves, Derrick b.1927
Flower Piece 1969
oil & acrylic on canvas 76.2 × 152.4
CHCPH 0067

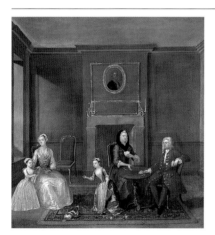

Hamilton, Gawen 1697–1737
The Rawson Conversation Piece c.1730
oil on canvas 80.0 × 74.6
CHCPH 0831

Hamilton, Richard b.1922
Swingeing London '67 1967–1968
oil & relief silkscreen on photo and board
60.8 × 79.5
CHCPH 1047

Hamilton, Richard b.1922
Hers in a Lush Situation 1958
oil, cellulose, metal foil & collage on panel
81 × 122
CHCPH 1281

Hamilton, Richard b.1922
Respective 1951
oil on hardboard 91.5 × 122.0
CHCPH 1459 (P)

Hayden, Henri 1883–1970
Cubist 1919 1919
oil on canvas 27.1 × 35.0
CHCPH 0577

Hayter, Stanley William 1901–1988
Composition (Matin serrisant une…) 1934
oil on sculpted board 8.9 × 10.2
CHCPH 1017-8 (P)

Hayter, Stanley William 1901–1988
Composition (Leda) 1934
oil on sculpted board 8.9 × 10.2
CHCPH 1017-9 (P)

Henderson, Nigel 1917–1985
Black Landscape 1960
collaged photographs and paint on board
92 × 89
CHCPH 1287

Hillier, Tristram Paul 1905–1983
La truite aux pommes vapeurs 1934
oil on panel 9.2 × 12.9
CHCPH 1017-11 (P)

Hillier, Tristram Paul 1905–1983
Marine 1934
oil on wood composite 10.3 × 12.9
CHCPH 1017-12 (P)

Hitchens, Ivon 1893–1979
Curved Barn (The Barn) 1922
oil on canvas 66 × 98
CHCPH 0078

Hitchens, Ivon 1893–1979
November Revelation 1973
oil on canvas 44 × 103
CHCPH 0079

Hitchens, Ivon 1893–1979
Sussex River, Near Midhurst 1965
oil on canvas 51 × 117
CHCPH 0109

Hitchens, Ivon 1893–1979
Distant Hills, Light on Dark and Dark through Light 1968
oil on canvas 39 × 85
CHCPH 0357

Hitchens, Ivon 1893–1979
Red Centre 1972
oil on canvas 59.8 × 72.5
CHCPH 0591

Hitchens, Ivon 1893–1979
Blue Shadows 1940
oil on canvas 51.8 × 104.3
CHCPH 0599

Hitchens, Ivon 1893–1979
House among Trees
oil on canvas 45.5 × 50.6
CHCPH 0883

Hitchens, Ivon 1893–1979
A Memory of Chichester from Old Hunston 1975
oil on board 57 × 154
CHCPH 0957 (P)

Hitchens, Ivon 1893–1979
Woodland Scene with Two Woodsmen
oil on canvas 38.0 × 83.5
CHCPH 0958 (P)

Hitchens, Ivon 1893–1979
Early Winter Walk 1965
oil on canvas 48.5 × 74.5
CHCPH 0959 (P)

Hitchens, Ivon 1893–1979
Woodland Path and Grey Trees c.1949
oil on canvas 40.6 × 74.2
CHCPH 0960 (P)

Hitchens, Ivon 1893–1979
Downland Farm Near Heyshott
oil on canvas 45.7 × 76.0
CHCPH 0961 (P)

Hitchens, Ivon 1893–1979
Weir
oil on canvas 41 × 79
CHCPH 0962 (P)

Hitchens, Ivon 1893–1979
Spring Mood 1934
oil on board 15.3 × 18.0
CHCPH 1017-10 (P)

Hitchens, Ivon 1893–1979
Flowers 1942
oil on canvas 61.0 × 56.3
CHCPH 1195

Hodgkin, Howard b.1932
The Visit 1963
oil on hardboard 51 × 58
CHCPH 1011 (P)

Hodgkin, Howard b.1932
Granchester Road 1975
oil on wood 124.5 × 145.0
CHCPH 1056 (P)

Hodgkin, Howard b.1932
End of the Tunnel 2000
oil on card 11 × 13
CHCPH 1104

Hodgkins, Frances 1869–1947
Spanish Peasants 1934
oil on plywood 15.4 × 12.8
CHCPH 1017-14 (P)

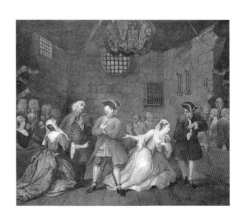

Hogarth, William 1697–1764
The Beggar's Opera, Act III 1729
oil on canvas 47.0 × 53.4
CHCPH 1001 (P)

Holt, Lilian 1898–1983
Spirit of Ronda, Andalucia 1955
oil on canvas 90 × 120
CHCPH 1290

Houthuesen, Albert Anthony 1903–1979
Ravine 1970
acrylic on board 40.6 × 59.9
CHCPH 1076

Huxley, Paul b.1938
After Mutis Mutandis 2000
acrylic on paper 10 × 10
CHCPH 1113

Hyman, Timothy b.1946
The Man in the Moon, Myddleton Square
1988–1990
oil on canvas 48.3 × 48.3
CHCPH 1335

Iden, Peter b.1945
Autumn Light, Near Bepton c.1990
oil on canvas 46 × 56
CHCPH 1210

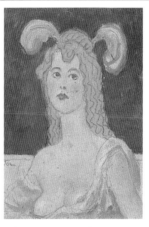

John, Augustus Edwin 1878–1961
Arabella 1934
oil on canvas 17.7 × 12.7
CHCPH 1017-15 (P) 🏵

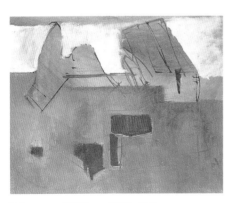

Johnstone, William 1897–1981
Landscape (Scottish Landscape)
oil on canvas 63.5 × 76.3
CHCPH 0614

Kitaj, R. B. b.1932
Books and Ex-Patriot c.1970
oil on wood 73.7 × 22.2
CHCPH 1066 (P)

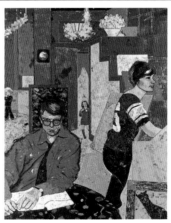

Kitaj, R. B. b.1932
The Architects 1981
oil on canvas 153.0 × 122.2
CHCPH 1077 (P)

Kitaj, R. B. b.1932
Michael Andrews as a Thames Bargeman 1999
oil on canvas 10.3 × 9.5
CHCPH 1106

Kitaj, R. B. b.1932
Priest, Deckchair and Distraught Woman 1961
oil on canvas 127.0 × 101.6
CHCPH 1291

Kitaj, R. B. b.1932
Specimen Musing of a Democrat 1961
oil and collage on canvas 102.0 × 127.5
CHCPH 1292

Kitaj, R. B. b.1932
Self Portrait 1965
oil on canvas 25.4 × 35.6
CHCPH 1293

Kitaj, R. B. b.1932
The Harold J. Laski Field Day 1966–1967
oil on canvas 152.4 × 152.4
CHCPH 1468 (P)

Kitaj, R. B. b.1932
An Untitled Romance 1961
oil and collage on canvas 61 × 43
CHCPH 1470 (P)

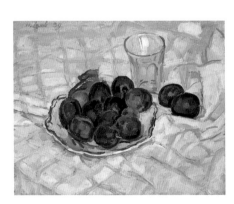

Lamb, Henry 1883–1960
Plums on a Dish 1939
oil on canvas 41 × 51
CHCPH 0887

Lancaster, Mark b.1938
Post-Warhol Souvenir Marilyn (7–17 Nov. 1987) 1987
oil on canvas 30.5 × 25.4
CHCPH 1016 (i)

Lancaster, Mark b.1938
Post-Warhol Souvenir Marilyn (10–12 Nov. 1987) 1987
oil on canvas 30.5 × 25.4
CHCPH 1016 (ii)

Facing page: Hunt, William Holman, 1827–1910, *Bianca* (detail), 1869, Worthing Museum and Art Gallery (p. 147)

Lancaster, Mark b.1938
Post-Warhol Souvenir Marilyn (16–17 Oct. 1987) 1987
oil on canvas 30.5 × 25.4
CHCPH 1016 (iii)

Lancaster, Mark b.1938
Post-Warhol Souvenir Marilyn (30 Sept. 1987) 1987
oil on canvas 30.5 × 25.4
CHCPH 1016 (iv)

Lancaster, Mark b.1938
Jamestown Red and Green 2000
oil on resin panel 10.0 × 9.8
CHCPH 1106

Lancaster, Mark b.1938
Cambridge Red and Green 1968
liquitex on canvas 173 × 173
CHCPH 1294

Lancaster, Mark b.1938
Study for Cambridge Eight 1968
liquitex on canvas 35.5 × 35.5
CHCPH 1295

Lancaster, Mark b.1938
Cambridge Eight 1968
liquitex on canvas 172 × 172
CHCPH 1471 (P)

Lancaster, Mark b.1938
New York: 7–14th Street Series 1972
aquatec & graphite on canvas 86.4 × 127.0
CHCPH 1472 (P)

Lancaster, Mark b.1938
Study for New York 1972
aquatec & graphite on canvas
CHCPH 1473 (P)

Lancaster, Mark b.1938
Early Two-Part Canvas
liquitex on canvas 71.2 × 41.0
CHCPH 1475 (P)

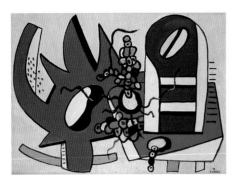

Léger, Fernand 1881–1955
L'engrenage rouge (Nature mort en rouge et bleu) 1939
oil on canvas 49.2 × 64.2
CHCPH 0592

Lemmen, Georges 1865–1916
Beach at Heyst c.1891
oil on canvas 17.0 × 24.8
CHCPH 0562

Lewis, Morland 1903–1943
Carmarthen Bay 1937
oil on canvas 51 × 60
CHCPH 0323 🐝

Marr, Leslie b.1922
Cirque de Navacelles
oil on canvas 76.2 × 69.9
CHCPH 1331

MacBryde, Robert 1913–1966
Apples on Paper
oil on board 30.0 × 39.5
CHCPH 0578

Medley, Robert 1905–1994
Despolio 1985
oil on canvas 76 × 51
CHCPH 1296

Meninsky, Bernard 1891–1950
On the Beach - Spanish Bathers 1936
oil on canvas 15.2 × 30.5
CHCPH 1332

Meteyard, Thomas Buford 1865–1928
Winter Scituate, Massachusetts 1890s
oil on canvas 37.3 × 55.0
CHCPH 0606

Metzinger, Jean 1883–1956
L'echaffaudage
oil on canvas 27.2 × 35.2
CHCPH 0115

Metzinger, Jean 1883–1956
Le village c.1914
oil on canvas 37.3 × 45.3
CHCPH 0563

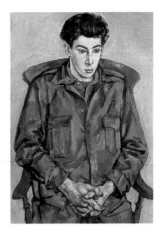

Minton, John 1917–1957
David Tindle as a Boy 1952
oil on canvas 35.8 × 25.4
CHCPH 0115

Morris, Cedric Lockwood 1889–1982
French Partridge 1934
oil on panel 8.9 × 12.2
CHCPH 1017-17 (P)

Muche, Georg 1895–1987
Komposition in vier Akzenten 1920
oil on canvas 59.4 × 45.7
CHCPH 0974 (P)

Nash, John Northcote 1893–1977
The Lake, Chicknell 1952
oil on canvas 63 × 76
CHCPH 0321

Nash, Paul 1889–1946
Dead Spring 1929
oil on canvas 48.5 × 40.0
CHCPH 0601

Nash, Paul 1889–1946
Landscape Composition (Objects in Relation)
1934
tempera on hardboard 13.0 × 15.5
CHCPH 1017-19 (P)

Nash, Paul 1889–1946
Composition (Design for Today) 1934
tempera on hardboard 12.8 × 8.9
CHCPH 1017-20 (P)

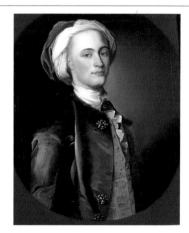

Nazzari, Bartolomeo 1699–1758
Richard Peckham c.1740
oil on canvas 73 × 63
CHCPH 0092

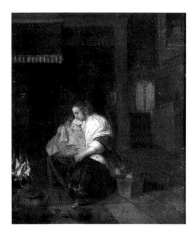

Netscher, Caspar (follower of) 1639–1684
The Dutch Mother c.1700
oil on canvas 28.0 × 24.7
CHCPH 0528

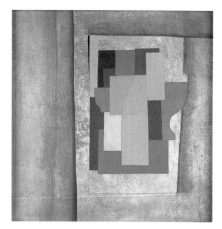

Nicholson, Ben 1894–1982
1946 (still life - cerulean) 1946
oil on canvas over board 61.5 × 63.0
CHCPH 0596

Oulton, Thérèse b.1953
Hermetic Definitions No.1 1985
oil on canvas 50.8 × 61.3
CHCPH 0953

Philpot, Glyn Warren 1884–1937
Henry Thomas 1934–1935
oil on canvas 52.5 × 36.4
CHCPH 0705

Piper, John 1903–1992
Air Motif (Design for Chichester Cathedral Tapestry) 1966
oil on panel 122.3 × 58.1
CHCPH 0124

Piper, John 1903–1992
Redland Park Congregational Church, Bristol 1940
oil on canvas 61.4 × 51.3
CHCPH 0595

Rees, Michael b.1962
Scapegoat 1996/1997
oil on board 25.4 × 20.3
CHCPH 1314

Rees, Michael b.1962
Bog Woman 1996/1997
oil on board 25.4 × 20.3
CHCPH 1315

Reinganum, Victor 1907–1995
Children Skipping 1939
oil & gouache on board 22.5 × 30.5
CHCPH 0893

Richards, Ceri Geraldus 1903–1971
Passing Train in a Landscape 1942
oil on canvas 50.6 × 61.0
CHCPH 0128

Richards, Ceri Geraldus 1903–1971
Rape of the Sabines (Saudade) 1949
oil on canvas 111.5 × 142.0
CHCPH 0129

Richards, Ceri Geraldus 1903–1971
La cathédrale engloutie II 1960
oil on canvas 42 × 42
CHCPH 0268

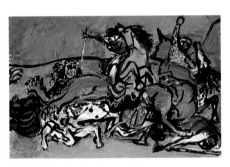

Richards, Ceri Geraldus 1903–1971
The Lion Hunt (after Eugène Delacroix) 1963
oil on canvas 25.7 × 35.8
CHCPH 0965

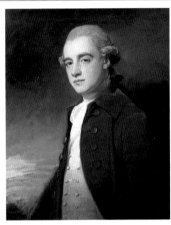

Romney, George 1734–1802
Henry Gough, Baron Calthorpe 1779
oil on canvas 71.5 × 64.0
CHCPH 1092 (P)

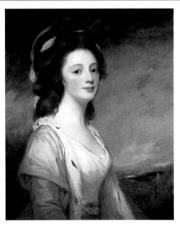

Romney, George 1734–1802
Lady Gough 1783
oil on canvas 76.5 × 64.3
CHCPH 1093 (P)

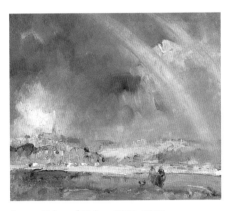

Seago, Edward Brian 1910–1974
The Rainbow after 1945
oil on board 22.2 × 27.1
CHCPH 01913 (P)

Self, Colin b.1941
*Waiting Women and 2 Nuclear Bombers
(Handley Page Victors)* 1962–1963
oil on board 112 × 183
CHCPH 1320

Self, Colin b.1941
At the Party (Hunt Ball) 1962
oil on board 24 × 32
CHCPH 1487 (P)

Severini, Gino 1883–1966
Danseuse No.5 1915/1916
oil on canvas 93.3 × 74.0
CHCPH 0594

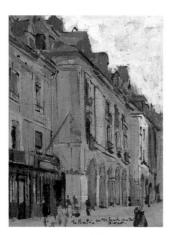

Sickert, Walter Richard 1860–1942
Les arcades de la poissonerie, quai Duguesne, Dieppe c.1900
oil on board 19.5 × 15.7
CHCPH 0147

Sickert, Walter Richard 1860–1942
Hubby and Wilson Steer - A Sketch c.1911
oil on canvas 41.0 × 33.5
CHCPH 0576

Sickert, Walter Richard 1860–1942
Jack Ashore c.1912
oil on canvas 36.8 × 28.0
CHCPH 0819

Sickert, Walter Richard 1860–1942
Hotel de Commerce, Dieppe
oil on canvas 60.0 × 71.3
CHCPH 0907 (P)

Sickert, Walter Richard 1860–1942
Chagford Across Fields 1915
oil on canvas 46.5 × 72.5
CHCPH 0908 (P)

Sickert, Walter Richard 1860–1942
La rue Picquet, Dieppe
oil on canvas 65 × 39
CHCPH 0909 (P)

Sickert, Walter Richard 1860–1942
Pulteney Bridge, Bath c.1917
oil on canvas 49.3 × 61.0
CHCPH 0910 (P)

Sickert, Walter Richard 1860–1942
St Jacques, rue Picquet
oil on canvas 66.5 × 54.3
CHCPH 0911 (P)

Sickert, Walter Richard 1860–1942
*Gwen Ffrangcon-Davies in 'The Lady With a
Lamp'* c.1932–1934
oil on canvas 122.0 × 68.6
CHCHP 1072

Smith, George 1714–1776
Winter Landscape c.1765
oil on canvas 43.8 × 64.2
CHCPH 0332

Smith, George 1714–1776
Winter Landscape with Two-Arched Bridge
oil on canvas 31.2 × 43.5
CHCPH 0980 (P)

Smith, George 1714–1776
*Farmhouse with Cattle in Mountainous
Landscape*
oil on canvas 31.8 × 44.0
CHCPH 0981 (P)

Smith, George 1714–1776
Cocking Millpond
oil on canvas 45.8 × 63.4
CHCPH 0982 (P)

Smith, George 1714–1776
The Watermill (Sullington, Near Storrington)
oil on canvas 57.5 × 79.5
CHCPH 0988 (P)

Smith, George (1714–1776) **& Smith, John**
(c.1717–1764)
The Shepherd, Evening
oil on canvas 30.5 × 35.2
CHCPH 0978 (P)

Smith, George (1714–1776) **& Smith, John**
(c.1717–1764)
The Shepherd, Morning
oil on canvas 30.6 × 35.2
CHCPH 0979 (P)

Smith, Matthew Arnold Bracy 1879–1959
Landscape Near Cagnes c.1935
oil on canvas 53 × 64
CHCPH 0065

Smith, Matthew Arnold Bracy 1879–1959
Flowers and Mixed Fruit c.1927
oil on canvas 53 × 32
CHCPH 0149

Smith, Matthew Arnold Bracy 1879–1959
Portrait of a Lady 1938/1939
oil on board 60.7 × 50.8
CHCPH 0600

Smith, Matthew Arnold Bracy 1879–1959
Reclining Nude (Vera) 1924
oil on canvas 49.5 × 64.0
CHCPH 0990

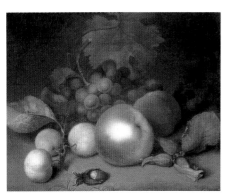

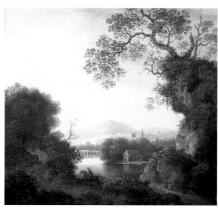

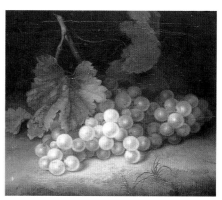

Smith, William 1707–1764
Still Life with Grapes, Peaches and Plums 1763
oil on canvas 30.2 × 35.8
CHCPH 0977 (P)

Smith, William 1707–1764
Landscape with Horsemen 1763
oil on canvas 45 × 49
CHCPH 0983 (P)

Smith, William 1707–1764
Still Life of Grapes 1763
oil on canvas 31.0 × 35.7
CHCPH 0984 (P)

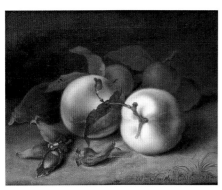

Smith, William 1707–1764
Still Life of Peaches, Plums and Cobnuts 1762
oil on canvas 31.0 × 35.7
CHCPH 0985 (P)

Smith, William 1707–1764
Still Life of Peaches, Grapes and Cobnuts 1757
oil on canvas 30.5 × 35.6
CHCPH 0986 (P)

Smith, William 1707–1764
A Shepherd and Shepherdess in a Landscape
1757
oil on canvas 44.2 × 57.7
CHCPH 0987 (P)

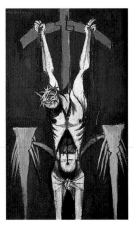

Stokes, Adrian Durham 1902–1972
Landscape
oil on canvas 63.5 × 76.2
CHCPH 1316

Stokes, Adrian Durham 1902–1972
Nude 1967–1968
oil on canvas 73.7 × 54.6
CHCPH 1317

Sutherland, Graham Vivian 1903–1980
Crucifixion 1947
oil on board 65 × 40
CHCPH 0155

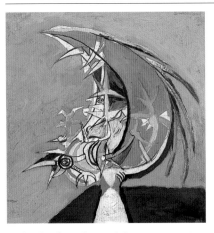

Sutherland, Graham Vivian 1903–1980
Thorn Head 1947
oil on canvas 40.9 × 40.9
CHCPH 0156

Sutherland, Graham Vivian 1903–1980
Track Junction in the South of France 1950
oil on canvas 29.0 × 24.5
CHCPH 0157

Sutherland, Graham Vivian 1903–1980
Landscape in the South of France c.1950
oil on canvas 90.0 × 69.5
CHCPH 0158

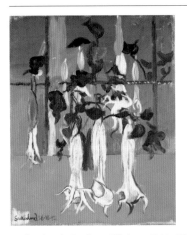

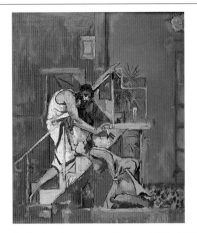

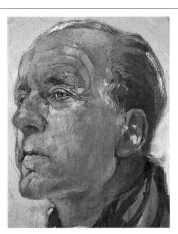

Sutherland, Graham Vivian 1903–1980
Datura Flowers 1957
oil on canvas 55 × 45
CHCPH 0159

Sutherland, Graham Vivian 1903–1980
Christ Appearing to Mary Magdalen (Noli me tangere) 1961
oil on canvas 64 × 53
CHCPH 0160

Sutherland, Graham Vivian 1903–1980
Walter Hussey 1965
oil on canvas 54.3 × 32.0
CHCPH 0161

Tilson, Joe b.1928
Triptych No.3A 1960
oil on canvas 30.8 × 77.0
CHCPH 0322

Tilson, Joe b.1928
Small Geometry No.1 1964
acrylic on wood relief 54.5 × 54.5
CHCPH 1089

Tilson, Joe b.1928
1–5 (The Senses) 1963
acrylic on wood relief 233.0 × 152.4
CHCPH 1490 (P)

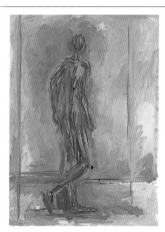

Tilson, Joe b.1928
Maltese Cross Cut-Out 1952
oil on wood 30.5 × 30.5
CHCPH 1491 (P)

Tindle, David b.1932
Bonfire 1975
tempera on panel 32.8 × 33.8
CHCPH 0706 (P)

Turnbull, William b.1922
Walking Figure (Man) 1950
oil on canvas 69 × 51
CHCPH 1323

Wadsworth, Edward Alexander 1889–1949
Composition on a Pink Background 1934
tempera on gessoed panel 14.0 × 16.5
CHCPH 1017-23 (P)

Wadsworth, Edward Alexander 1889–1949
Conversation 1934
tempera on gessoed panel 9.0 × 12.7
CHCPH 1017-24 (P)

Webb, Marjorie 1903–1978
Sutherland Sunset
oil on board 51.5 × 61.0
CHCPH 0710

West, Francis b.1936
Study for the Last Judgement 1971
oil on canvas 134 × 100
CHCPH 1671 (P)

West, Francis b.1936
The Skaters 1972
oil on canvas 117 × 149
CHCPH 1672 (P)

West, Francis b.1936
The Last Judgement 1972
oil on canvas
CHCPH 1673 (P)

Whaite, H. Clarence 1895–1978
Spring, Farringford 1948
oil on canvas 50.8 × 61.0
CHCPH 1075

Williamson, Harold Sandys 1892–1978
Church and People 1948
oil on board 19 × 30
CHCPH 0324

Willing, Victor 1928–1988
Judge 1982
oil on canvas 250 × 200
CHCPH 1325

Willing, Victor 1928–1988
Night 1978
oil on canvas 228 × 315
CHCPH 1328

Willing, Victor 1928–1988
Swing 1978
oil on canvas 183 × 152
CHCPH 1493 (P)

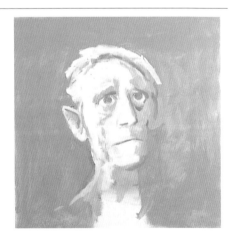

Willing, Victor 1928–1988
Self Portrait at 70 1987
oil on canvas 56 × 56
CHCPH 1495 (P)

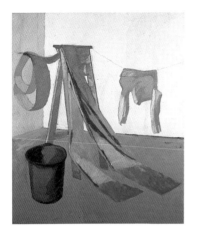

Willing, Victor 1928–1988
Painting with Stepladder 1976
oil on canvas 183 × 152
CHCPH 1496 (P)

Wood, Christopher 1901–1930
Lemons in a Blue Basket 1922
oil on canvas 44 × 62
CHCPH 0269

Yeats, Jack Butler 1871–1957
The Ox Mountains 1944
oil on hardboard 23.4 × 36.7
CHCPH 0571

Royal Military Police Museum

The Military Police have been acquiring paintings since the 19th century. The collection contains a number of excellent portraits of colonel commandants, which is increased each time a colonel commandant retires. The collection also continues to commission paintings of operational theatres, such as the 2003 conflict in Iraq, which is due for completion in 2005. The artists are varied and show a range of abilities. Some are serving or ex-Royal Military Policemen, and others are professional artists and portrait painters. The portrait of Queen Elizabeth was commissioned in 1977 to mark her becoming Colonel-in-Chief of the Royal Military Police and is painted by Leonard Boden.

Colonel J. H. Baber, Regimental Secretary, Royal Military Police

Ademollo, Carlo 1825–1911
Colonel Becky in Prison 1860 1884
oil on canvas 126 × 188
53

Billingham, P. P.
Redcap Portrait 1993
oil on wood 38.0 × 28.5
19

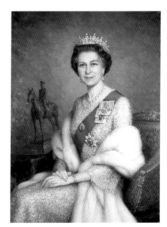

Boden, Leonard 1911–1999
HRH Queen Elizabeth 1977
oil on canvas 95 × 73 (E)
52

Boughey, Arther
General Miles Dempsey 1970
oil on canvas 75 × 49
4

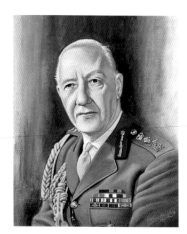

Boughey, Arther
General Geoffrey Baker 1971
oil on canvas 59.0 × 49.5
5

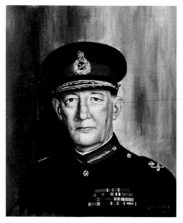

Boughey, Arther
Field Marshal James Cassels 1970
oil on canvas 59.0 × 49.5
6

Boughey, Arther
General Cecil Blacker 1976
oil on canvas 74 × 59
7

Fordyce
Major Narbir Thupa 1964
oil on wood 54 × 45
8

Howard, Ken b.1932
Centenary of Royal Military Police 1977
acrylic on canvas 88 × 120 (E)
18 ❀

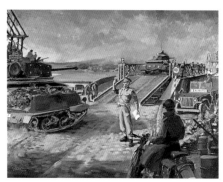

Hutchins, (Colonel) P. E.
Europe, 1945 1968
oil on canvas 70 × 99
3

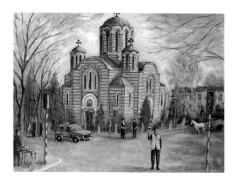

Kevic
Kosovo 1998
acrylic on wood 52 × 70
14

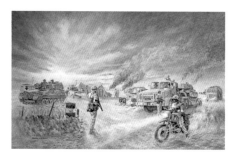

Kitchen, Michael S. late 20th C
First Gulf War c.1992
oil on canvas 60 × 90
15

Kitchen, Michael S. late 20th C
Northern Ireland
oil on canvas 60 × 90
16

Kitchen, Michael S. late 20th C
Falklands
oil on canvas 60 × 90
17

Leach, M. C.
Checkpoint Charlie 1973
oil on canvas 58.5 × 69.0
20

Potter, James
Lieutenant Colonel Christopher Wallace,
Colonel Commandant of Royal Military Police
Regiment 1998
oil on canvas 60 × 64
1

Potter, James
Bosnia 2000
acrylic on canvas 105 × 143 (E)
12

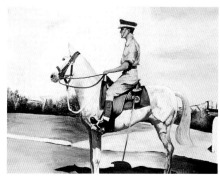

Sargeant
Lieutenant Colonel Frank Baggley on a Horse
1973
oil on wood 42 × 52
13

unknown artist
Slavic Building 1997
oil on wood 54.0 × 40.5
51

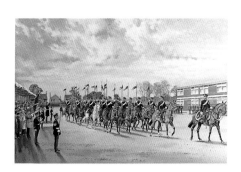

Wanklyn, Joan
Disbandment Parade 1994
oil on canvas 59.0 × 89.5
2

Wragg, Stephan 20th C
Red Cap Tree
oil on canvas 70 × 90
9

Wragg, Stephan 20th C
The TP Near Casino
oil on canvas 70 × 90
10

Wragg, Stephan 20th C
Gathering Prisoners before San Felice
oil on canvas 70 × 90
11

Royal West Sussex
NHS Trust

Dudgeon, Gerry b.1952
Mughal Blues 2000
acrylic on canvas 76 × 87
9

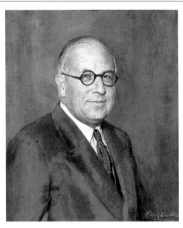

Eastman, Frank S. b.1878
Richard Henty
oil on canvas 59 × 49
8

Hunkin, Sally 20th C
Echos
acrylic on canvas 59.0 × 67.5
3

Hunkin, Sally 20th C
The Road
acrylic on canvas 59.5 × 74.0
4

Purchase, Hugo & Purchase, Nigel
Goodwood
acrylic on canvas 100 × 243
1

Purchase, Nigel
Cricket Match 2003
2

unknown artist 20th C
Flowers I
5

unknown artist 20th C
Flowers II 1954
7

Woodward, L. 20th C
Richard Paine, Chairman (1993–2001)
oil on canvas 60.0 × 49.8
6

University College Chichester, Otter Gallery

The Background to the Bishop Otter Collection

The impetus behind the creation of the Bishop Otter Art Collection stems from the experience of the 1939–1945 war. The contents of most London galleries were transferred to safer parts of the country for storage. To compensate, the Committee for the Encouragement of Music and the Arts (CEMA) was set up in 1940 with a remit to organise travelling exhibitions of original paintings in town halls and works canteens. It was intended to be a sign that, even in the midst of war, the government recognised the value of art for national morale. In 1945 John Maynard Keynes persuaded the government to convert CEMA into the Arts Council of Great Britain, with a mission to encourage the expansion of the arts. In a 1945 broadcast he said: "We look forward to a time when the theatre and concert hall and the art gallery will be a living element in everyone's upbringing, and regular attendance at the theatre and concerts a

part of organised education." This post-war emphasis on social improvement and the integration of the arts with education was the pervasive intellectual background for the creation of the Bishop Otter Art Collection.

The Establishment of the Collection

Bishop Otter College was founded in 1839, but had acquired few original works of art prior to 1945. In 1947 Eleanor Hipwell, the Head of Art, began the collection when she bought three pictures for the college from an exhibition at the Victoria & Albert Museum. One of these is a watercolour, by Michael Rothenstein called *Figure Holding Autumn Leaves*.

In 1950, a new Principal, Miss K. E. Murray, whose family background gave her a profound belief in the civilising effects of the arts and the value of living with original pictures, wrote to Bishop Bell of Chichester about the development of a collection of original paintings: "We feel that it is very important that students who are going to teach in all grades of primary and secondary modern schools, and who come, for the most part, from rather ordinary homes without much cultural background, should be helped from the surroundings we give them in college to form standards of their own. We take them to exhibitions in London and elsewhere as far as possible, but this is not the same thing as living with good examples of contemporary art, and given material, I think the college has a contribution to make here in the education of public taste." In 1949, Miss Murray had been joined by Sheila McCririck as the new head of art. She became a major collaborator in buying pictures for the collection.

The Development of the Collection

In 1950 the principal allocated £100 for the purchase of new original works of art. This was not insignificant, but was not adequate to buy enough original pictures to build up a collection. The story of how this was done and the growth of the collection, which was to include some of the finest examples of 20th century British art by Epstein, Frost, Heron, Hitchens, Lanyon, Moore, Piper, Spencer, Scott, Sutherland, Nash, and Wallis, is a remarkable example of persistence and serendipity (see Brighton, T. (Ed), *150 Years: The Church Colleges in Higher Education*, 1989, WSIHE).

An early acquisition was *Autumn Stream* by Ivon Hitchens, who followed the romantic tradition of landscape painting, using vibrant colours; predominantly purples and yellows. It is an excellent example of the artist's most typical work. "I am trying to understand the 'aesthetic truth' of my subjects . . . If the work is untrue it is valueless – but the kind of truth I see may be a bit different . . . What I see and feel I try to reduce to patches and lines of pigment which have an effect of nature in terms of a relationship of all the parts", said Hitchens. Soon after, a small bronze maquette of a seated figure was purchased from Henry Moore. The original maquette was unfortunately stolen, but was replaced by a similar Moore bronze, which remains one of the centrepieces of the collection. In 1951 a group of staff and students visited Graham Sutherland in his studio and purchased the gouache *Entrance to a Lane*, which is an abstract representation of a lane at Sandy Haven in Pembrokeshire, and is a later version of a painting at the Tate with the same title.

Acquisition Policy

While the educational aims of the collection were clear and widely supported, the purchasing policy, as well as some individual acquisitions, often came in for severe criticism. This was based on a negative view of the value of abstract or modern styles to the educational purpose of the college. A view existed in the Bishop Otter College Council (the governing body) that the educational function of reproductions of Victorian historical or didactic art could be more easily understood. These views surfaced among students, staff and members of the council. When Patrick Heron's *Black and White* was bought in 1956, it caused considerable controversy. It is a stark composition of black abstract forms on a white canvas. Council member Jeffrey Cumberlege, former publisher to the Oxford University Press, wrote: "The danger in acquiring an affection for such a picture is the danger of acquiring a taste for a hundred per cent proof gin – a glass of sherry becomes tasteless! It's easy to become an addict." He expressed concern about student reactions to the picture, feeling that students might run the risk of seeing, "…how easy it is to become an artist, and any knowledge of good drawing will be considered a waste of time." However, Bishop Bell, Dean Hussey and other members of the council voted to continue to support the acquisition policy and, in November 1957, Bell wrote: "How glad I am that the council expressed their approval of the policy of artistic challenge and how much I rejoice in that decision."

Another abstract picture purchased about this time also originated from Cornwall. This was Peter Lanyon's *Green Mile*. This large vertical painting forms part of a group of five works known as the *Saint Just Triptych*, which has the *Green Mile* as one of the wings. It is a suggestion of space and Cornish scenery. Patches of grey, black lines, an intimation of the sea and the dark green of the Cornish landscape all allude to the countryside that Lanyon loved. He said: "I paint very thin, tall vertical paintings sometimes. This may be because I am fond of climbing cliffs, and I find them very tall and thin. It is just a matter of doing paintings that are not visual paintings so much, but are related to some physical experience."

The growth of the collection owed much to support from Bishop Bell (Chairman of the Council) and Dean Walter Hussey, himself a leading patron of the arts. Hussey eventually left his pictures and sculptures to Chichester, where they are now housed in the notable collection of Pallant House Gallery.

The Mitre Gallery and the Otter Gallery

Throughout the 1950s and 1960s as the collection grew, it was still displayed around the college for the benefit of staff and students. However, this optimistic and unworldly policy of unsecured display could not survive the increasing monetary value of the pictures, and there were occasional thefts. The Mitre Gallery was opened to display pictures securely in 1990, as part of the College's 150th anniversary celebrations. In 1998, the building of a new Learning Resources Centre provided the opportunity to incorporate a splendid new replacement gallery at its heart. It was opened by Lord Dearing and named the Otter Gallery, in honour of Bishop William Otter (1768–1840). It marks a new phase in the life of the permanent collection, as well as displaying visiting exhibitions of contemporary art to the college community and the people of the region.

Dr Brian Rigby, Honorary Curator

Bain, **Peter** b.1927
Painting
oil on panel 91.5 × 91.5
26

Ballard, **Kenneth**
Irises
oil on canvas 76 × 92
308

Barnden, **Bruce** b.1925
Chalk Pit
oil on hardboard 65 × 80
27 🐝

Bernard, **Barbara**
Jon 1977
oil on canvas 32 × 33
28

Blow, **Sandra** b.1925
Painting
oil on canvas 137.2 × 122.0
29

Bond, **Julian**
Grey Day 1968
oil on canvas 82.5 × 67.3
30

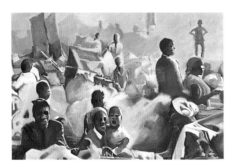

Bradley, **Michael**
Refugee Camp 1980
oil on board 96 × 131
302

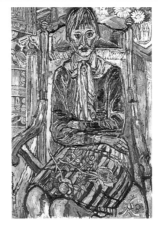

Bratby, **John Randall** 1928–1992
Girl with a Rose in Her Lap 1960
oil on canvas 122.0 × 86.3
31 🐝

Bray, **Jill**
Red and Brown Abstract
oil on canvas 56 × 31
181

Facing page: King, Yeend, 1855–1924, *Early Autumn* (detail), Worthing Museum and Art Gallery (p. 148)

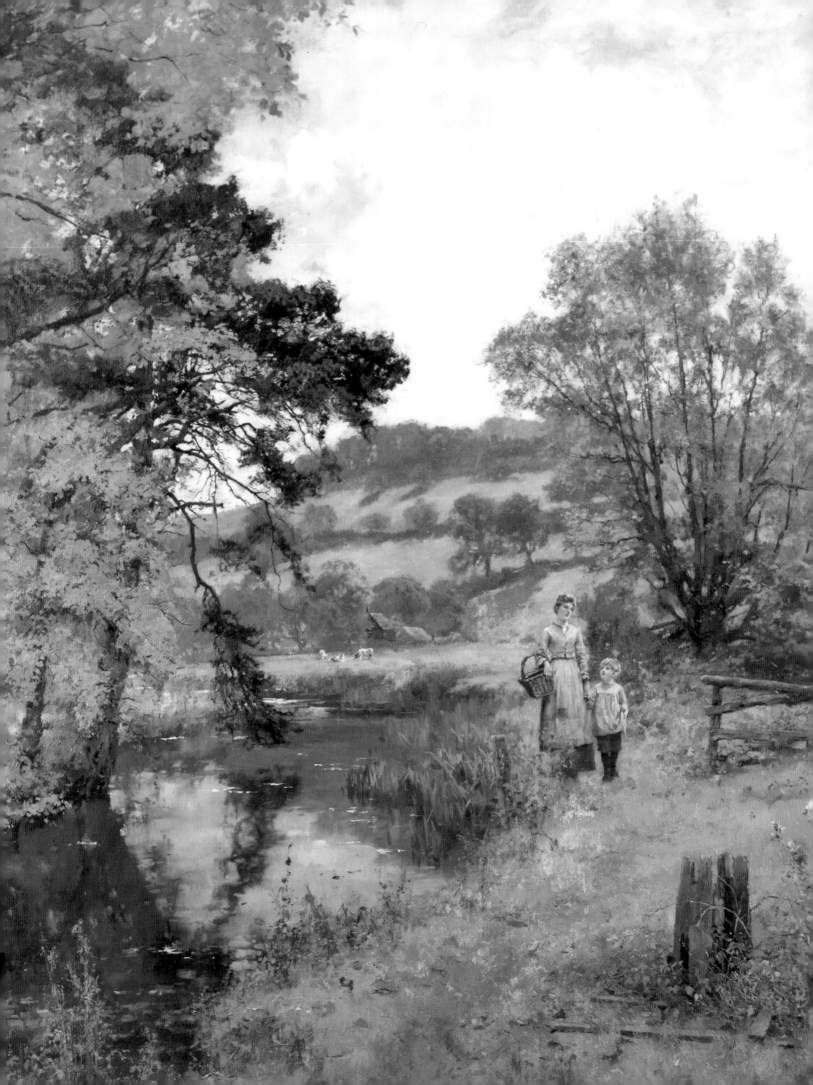

Burns, William 1921–1972
Small Harbour
oil on board 60.0 × 63.5
32

Clifford, Geoffrey
Double Portrait 1965
oil on board 81.0 × 61.5
33

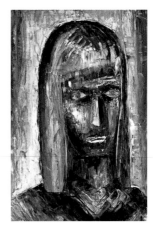

Duffin, Gillian
Head of a Girl 1966
oil on board 91 × 61
34

Elsey, Dick
Still Life No.2 1971
oil on board 60 × 48
35

Enwonwu, Ben 1921–1994
Monotony 1948
oil on canvas 91 × 71
36 🐝

Eurich, Richard Ernst 1903–1992
Solent Angler 1975
oil on canvas 59 × 60
37 🐝

Fedden, Mary b.1915
Still Life with Two Oranges 1965
oil on canvas 53 × 64
38 🐝

Feiler, Paul b.1918
Boats and Sea
oil on canvas 87.5 × 90.8
39 🐝

Fernee, Kenneth b.1926
Shadows and Lights - Evening
oil on hardboard 71 × 91
40

Flint, Rhona
Mum and Dad 2002
oil on canvas 80 × 95
304

Freestone, Ian
Lying Figure 1966
oil on board 38.5 × 122.0
41

Frost, Terry 1915–2003
Red Painting October 62/May 63 1962–1963
oil on canvas 152 × 122
42

Gasking, Elspeth
Trees 1965
oil on board 50.5 × 71.5
43

Gavin, James b.1928
Corrida 2
oil on canvas 167 × 183
44 🐝

Gear, William 1915–1997
White Features 1958
oil on canvas 122.0 × 81.3
45

Gear, William 1915–1997
Black Figures 1957
oil on canvas 81.3 × 122.0
46

Ginns, Greg
Landscape Planes 2001
oil on canvas 76 × 122
303

Goodwin, Elaine
Philip
oil on board 91 × 121
47

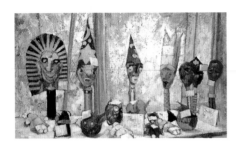

Greig, Rita b.1918
Kings, Wizards and Other Creatures 1974
oil on board 44 × 73
48

Harris, Jane b.1956
Boats 1975 1975
oil on paper 76.5 × 51.0
50

Harris, Norma
Study in Blue
oil on paper 38 × 44
51

Hayward, Peter active from 1960s
Painting 1968 1968
oil on board 122.5 × 184.0
54

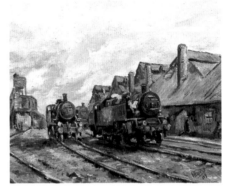

Hayward, Peter active from 1960s
Two Trains
oil on board 26 × 30
305

Hayward, Peter active from 1960s
Railway Station
oil on board 41 × 51
306

Heron, Patrick 1920–1999
Black and White: April 1956 1956
oil on canvas 127.0 × 101.5
55

Hitchens, Ivon 1893–1979
Autumn Stream mid-1940s
oil on canvas 59.0 × 108.5
56

Hitchens, John b.1940
Flowers in a Shore Window 1968
oil on canvas 50.8 × 91.5
57

Hoad, Simon
Pink Painting 1966
oil on canvas 78 × 74
58

Howell, Christopher
Sussex Trees 1965
oil on board 61 × 122
61

Humphreys, David b.1937
Landfall 1968
oil on board 45 × 39
62

Hunt, Eileen
Apples 1972
oil on board 37 × 33
63

Jenkins, Paul
Geoffrey 1968
oil on board 31 × 31
64

John, Stephen
When Comes the Day 1977
acrylic and oil on canvas 210 × 136
107

King, Carolanne
Shell and Sea Mat on Shingle 1979
oil on canvas board 25 × 35
65

Lanyon, Peter 1918–1964
The Green Mile 1952
oil on masonite 158.7 × 49.5
66

Le Goupillot, Richard
Painting 1973 1973
oil on canvas 91.5 × 168.0
67

Lees, Stewart b.1926
The Exact Patch
acrylic on board 70 × 75
1

Liddell, Peter b.1954
Beck Falls 1
acrylic 69 × 71
2

Lock, Priscilla
Chimneys
oil on board 64 × 50
68

Lord, Tim
John 1956
oil on board 76.5 × 53.5
69

Martin, Bob
Winter Morning - Del Quay 1972
oil on board 91.5 × 122.5
70

Mather, Sally
Nets 1957
oil on board 40 × 50
71

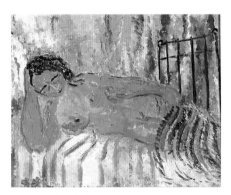

McCririck, Sheila 1916–2001
Nude 1947 1947
oil on canvas 52 × 62
72

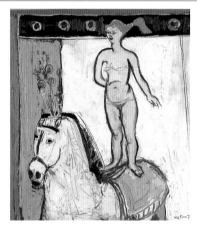

Mellon, Eric James b.1925
Circus Horse and Rider 1971
oil on board 66.5 × 61.0
73

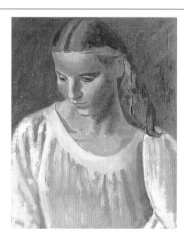

Meninsky, Bernard 1891–1950
Portrait
oil on canvas 61 × 50
74

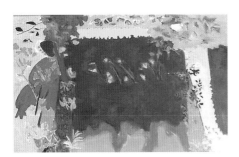

Michie, David Alan Redpath b.1928
Patterned Garden 1972
oil on canvas 67 × 112
75 🐝

Moffatt, Heather
'My God, my God, why hast Thou forsaken me?'
oil on canvas 92.0 × 42.5
77

Mohanti, Prafulla
Painting
oil on canvas 71 × 91
78

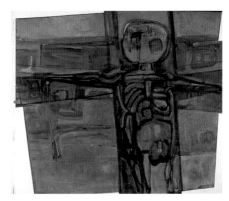

Murray, Andrew b.1917
Young Footballers at Newlyn, Cornwall 1971
oil on canvas 46.0 × 56.5
79

Murray, Fay
Daisies 1971
oil on board 84 × 64
80

Naylor, Albert b.1932
Crucifixion 1970
oil on board 104 × 122
81

Oliver-Jones, Robert
Three Men
oil on board 107 × 122
301

Patel, Jenny
Orange Figure 1974
oil on canvas board 40.5 × 50.5
82

Patten, John
Trees in Snow 1965
oil on board 50.5 × 62.0
83

Peckham, Laura
Introspective 1 1988
acrylic 94 × 125
3

Pescott, Ann
Evening at Kingley Vale 1972
oil on canvas 46 × 92
84

Pettrie, Les
The Breeze 1972
oil on canvas 46 × 92
85

Redgrave, William 1903–1986
Tiger, Tiger 1957
oil on paper 45 × 69
87

Scott, William George 1913–1989
Harbour 1950–1951
oil on canvas 57 × 99
89

Sentence, Bryan
Me 1972
oil on canvas 61 × 46
90

Simcock, Jack b.1929
Cottages, Mow Copp II 1959 1959
oil on hardboard 46 × 76
92

Smith, Larry
Chaplin
oil on board 75 × 91
93

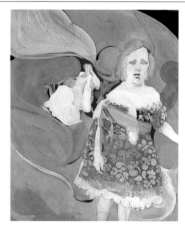

Stanshall, Vivian 1943–1995
Speranza Regards Her Son
oil on board 87 × 74
94

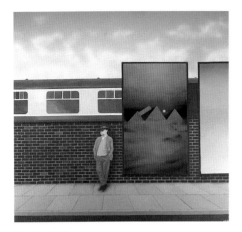

Stark, Andrew
*Man on Drab Pavement next to Exotic
Advertising Hoarding* 1980
acrylic on canvas 138 × 142
307

Stern, Bernard b.1920
Boy with Blue Hat
oil on canvas 76 × 102
95

Stern, Bernard b.1920
Musical Notes
oil on canvas 160 × 100
96

Topping, Gillian
Tumbling 1977
acrylic on canvas 64 × 69
4

Tremlett, Irene
Hanging On
oil on paper 76.5 × 51.0
99

Tucker, Jane
Portrait
oil on canvas 60.5 × 46.0
100

unknown artist
Seven Figures
oil on canvas 183 × 183
300

Wallis, Alfred 1855–1942
Boat (Fishing Lugger at Sea) 1994
oil on paper 16 × 21
101

Walton, Frank b.1905
Prophet Abstract
oil on board 57.5 × 81.0
102

Webb, Marjorie 1903–1978
Aubergines and Fish
oil on board 51 × 61
103

Wicks, Claire
Despondency 1976
oil on paper 76.5 × 51.0
104

Williams, Cherry
Singleton 1969
oil on board 59.5 × 90.0
105

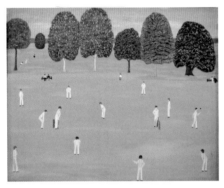

Williams, John
The Cricket Match 1972
oil on canvas 58.0 × 76.5
106

West Sussex County Council

Codd, Michael b.1938
North Park Furnace, Fernhurst c.1994
acrylic on board 52 × 78
WSCC.01

Codd, Michael b.1938
Devil's Jumps, Treyford, Barrow Cemetery c.1996
acrylic on board 50 × 74
WSCC.02

Codd, Michael b.1938
Church Norton Mound, Norman Castle 1997
acrylic on board 60 × 103
WSCC.03

Codd, Michael b.1938
*Wealden Iron Industry: Iron Ore Extraction -
Minepits, Charcoal Burning, Coppicing and
Cording* c.1997–1998
acrylic on board 53 × 75
WSCC.04

Codd, Michael b.1938
*Portsmouth to Arundel Canal at Hunston,
Bullion Shipment* c.1998
acrylic on board 55 × 75
WSCC.05

Codd, Michael b.1938
*Portsmouth to Arundel Canal: Ford Lock and
Pumping Station* c.1998
acrylic on board 55 × 76
WSCC.06

Codd, Michael b.1938
West Grinstead Wharf (Baybridge Canal)
c.1998
acrylic on board 55 × 76
WSCC.07

Codd, Michael b.1938
Bines Bridge, River Adur c.1998
acrylic on board 55 × 76
WSCC.08

Codd, Michael b.1938
Wealden Hammer Pond 1998
acrylic on board 53 × 75
WSCC.09

Codd, Michael b.1938
Wealden Hammer Forge 1999
acrylic on board 53 × 75
WSCC.10

Codd, Michael b.1938
Balcombe Viaduct 1999
acrylic on board 50 × 90
WSCC.11

Codd, Michael b.1938
Boxgrove Palaeolithic Site (Diptych) 2000
acrylic on board 53 × 75
WSCC.12

Codd, Michael b.1938
Boxgrove Palaeolithic Site (Diptych) 2000
acrylic on board 53 × 75
WSCC.13

Codd, Michael b.1938
Shoreham Fort 2002
acrylic on board 55 × 76
WSCC.14

Codd, Michael b.1938
Rifleman, Sussex Artillery Volunteers 2002
acrylic on board 40 × 30 (E)
WSCC.15

Codd, Michael b.1938
Tote Copse Castle, Aldingbourne 2002
acrylic on board 55 × 76
WSCC.16

West Sussex Record Office

The West Sussex Record Office exists to acquire, preserve and make records relating to the history of West Sussex available for public consultation. The collections at Chichester include a large selection of prints, drawings photographs and postcards. Although it is not the record office's policy to collect paintings and works of art, inevitably a number of such items have been deposited in Chichester. The most notable of these is a collection of engravings, drawings and sculptures by Eric Gill. Although not extensive, the paintings in the record office – many of which are portraits – include some of merit and others with interesting literary and artistic associations.

The two portraits of William Hayley have descended through the Mason family to the present day. In one he is writing his book on the life of William Cowper and in the other he is presenting a bible to William Hayley Mason, his

godson, in front of the tomb of Cowper in Dereham Church, Norfolk. The collection also contains a fine portrait of William Huntington, which came from the Providence Chapel in Chichester, as well as a portrait of Coventry Patmore by C. H. B. Jaques. Also of special interest is a portrait of the three Smith Brothers of Chichester, who were well-known 18th century landscape and still life painters, by William Shayer, as well as a fine painting of East Street market in Chichester by Joseph Francis Gilbert.

Timothy J. McCann, Assistant County Archivist, West Sussex Record Office

British (English) School early 19th C
William Huntington
oil on canvas 91 × 71
PD2705

Field, Yvonne
Bernard Vick 1980s
acrylic on canvas 49.5 × 30.0
PD2714

Gilbert, Joseph Francis 1792–1855
East Street Market, Chichester c.1813
oil on canvas 40.6 × 59.2
F/PD478

Holman, Thomas & Holman, William
Map of Woodmancote and Albourne 1768
oil on board 116.8 × 205.7
Acc3885

Jaques, C. H. B.
Coventry Patmore
oil on canvas 108 × 78
PD2166

Jennings, Audrey
Francis William Steer 1961
oil on canvas 61.0 × 50.8
PD2043

Romney, George (attributed to) 1734–1802
William Hayley
oil on canvas 39 × 33
PD2353

Romney, George (attributed to) 1734–1802
William Hayley
oil on canvas 38 × 28
PD2354

Shayer, William 1788–1879
Smith Brothers of Chichester
oil on canvas 63 × 45
F/PD471

Tilman
West Grinstead Church Exterior c.1975
oil on board 91.2 × 121.9
PD2031

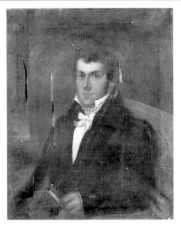

unknown artist
Charles Jaques c.1841
oil on canvas 88.9 × 63.0
PD2163

unknown artist
Ann Jaques c.1841
oil on canvas 74.9 × 52.1
PD2164

unknown artist
Charles Jaques c.1841
oil on canvas 60.5 × 49.5
PD2165

unknown artist
View from Pitshill, Tillington 1864
oil on canvas 35.6 × 38.1
F/PD161

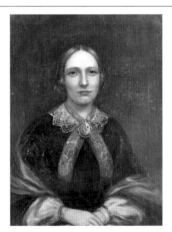

unknown artist
Lady Augusta Maxse
oil on canvas 39.5 × 29.0
Acc3364/a

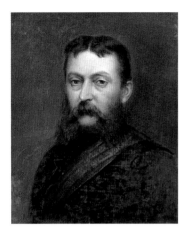

unknown artist
Sir Henry Berkeley Fitzhardinge Maxse
oil on canvas 32 × 27
Acc3364/b

unknown artist
Sir Alexander Ferrier
oil on canvas 95 × 79
Acc3874

unknown artist
Sir Robert Turing
oil on canvas 108 × 78
Acc3874

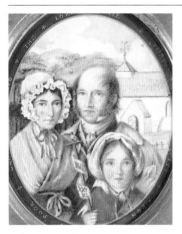

unknown artist
East Marden Clothing Fund
oil on canvas 49.5 × 30.0
F/PD467

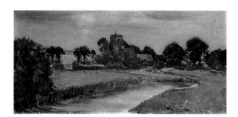

unknown artist
Felpham Church Exterior
oil on canvas 17.5 × 35.6
PD1345

Crawley Library

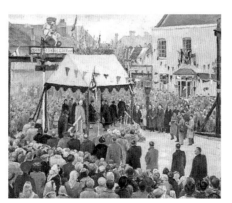

Burr, Victor 1908–1993
Visit of Princess Elizabeth to Crawley 1950
oil on canvas 55 × 66
1

Crawley Museum Centre

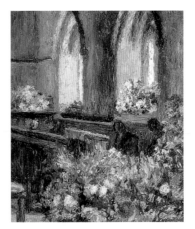

Burr, Victor 1908–1993
Harvest Festival (St John the Baptist Church, Crawley)
oil on canvas 53.3 × 43.2
1

Cuckfield Museum

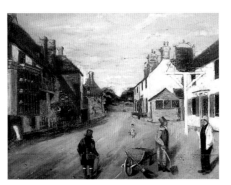

Anscombe, Joseph d.1869
South Street, Cuckfield c.1846
oil on panel 32 × 41
B2003-689

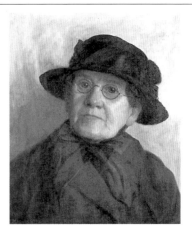

Gray, M.
Nurse Stoner 1937
oil on canvas 34 × 29
P51

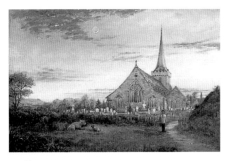

Ruff, George 1826–1903
Afterglow 1872
oil on canvas 30 × 45
B2003-690

Ruff, George 1826–1903
Harvest Time 1883
oil on panel 12.5 × 26.0
B2003-691

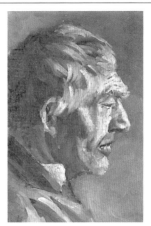

unknown artist
Profile of Gentleman c.1900
oil on canvas 25.5 × 18.0
P71

Chequer Mead Theatre and Art Centre Trust

East Grinstead Millennium Mural

The East Grinstead Millennium Mural was conceived by Ken Averill, Chairman of the East Grinstead Millennium Committee, designed by artist Bill Lehan and executed on a series of panels by a team of painters and craftsmen ranging from amateur to professional, from four years old to well into pensionable age. The subject of the mural is the history of East Grinstead from the dawn of time to 2000 years after the birth of Christ.

Chequer Mead initially said that they would be willing to have it mounted in their restaurant for one year, but five years on, it is still there. There was enough room to mount 29 panels, but to cover such a vast span of time with only 29 boards meant that one or two things had to be left out, so it was decided to show the more picturesque events. Each painter or team of painters was given a master drawing as a working brief and they were asked to follow the intention of the drawing closely, but with freedom to use their own style. Everybody was issued with a 244 cm by 122 cm white painted panel, as well as pots of cadmium red, cadmium yellow, oxford blue, black and white emulsion paint, and the instruction to go and get on with it. The choice of colours gave an enormous range of tones, but all the panels have a degree of colour harmony. They were painted by pupils of three schools, about an equal quantity of men and women, a solitary schoolboy, a calligrapher, a quilting society, an embroidery society, a specialist painter and decorator, five photographers and two children aged four and six who wanted to know what they were going to be paid!

Even with a drawing to work from, everyone managed to stamp their own individuality on their work. There were over 100 people working on the mural and they all delivered on time, achieving a masterpiece of mutual co-operation and good planning. Our thanks go to all the artists, to the people who did the research, the 'heavy gang' who erected the panels high overhead, and to Chequer Mead for the provision of the ever-open coffee pot to keep them going. We also thank those generous people who sponsored many of the paintings, the money from which went towards new lighting to show the mural to its best advantage.

Every panel has something special about how it came to be chosen, or a tale about its commission, design or research. Of particular interest is the panel representing East Grinstead's 1999 May Fair. We would have liked a snapshot of the entire fair, but, as this was not possible, we had five photographers take as many head-and-shoulders photographs as they could in ten minutes. The best were chosen as being a fair sample of the people there. If it were possible for this to have been done 750 years ago at the 1247 May Fair, and if we had the only copy, it would now be a national treasure.

Bill Lehan, Artist

IN THE BEGINNING
THERE WERE ONLY
TREES···

East Grinstead Millennium Mural Team
In the Beginning There Were Only Trees 1999
emulsion on panel 244 × 122
1

···THEN A HOVEL

East Grinstead Millennium Mural Team
…Then Only a Hovel 1999
emulsion on panel 244 × 122
2

East Grinstead Millennium Mural Team
The Romans Just Missed Us 1999
emulsion on panel 244 × 122
3

THE ROMANS
JUST MISSED US

GREENSTEDE
STARTS TO FORM

East Grinstead Millennium Mural Team
Greenstede Starts to Form 1999
emulsion on panel 244 × 122
4

700 - ish
CHURCH NAMED
AFTER ST SWITHUN

East Grinstead Millennium Mural Team
700-ish Church Named after St Swithun 1999
emulsion on panel 244 × 122
5

1086 WE ARE IN THE
DOMESDAY BOOK

East Grinstead Millennium Mural Team
1086 We Are in the Domesday Book 1999
emulsion on panel with fabric and wood
244 × 122
6

1220's HIGH STREET
LAID OUT

East Grinstead Millennium Mural Team
1220s High Street Laid Out 1999
emulsion on panel 244 × 122
7

1247 and 1516 ROYAL
CHARTER FOR SPRING
AND AUTUMN FAIRS

East Grinstead Millennium Mural Team
*1247 and 1516 Royal Charter for Spring and
Autumn Fairs* 1999
emulsion on panel with wood 244 × 122
8

1490's - 1800's
WEALDEN IRON
INDUSTRY

East Grinstead Millennium Mural Team
1490s–1800s Wealden Iron Industry 1999
emulsion on panel and wood 244 × 122
9

**1556 MARTYRS
BURNT AT THE STAKE**

East Grinstead Millennium Mural Team
1556 Martyrs Burnt at the Stake 1999
emulsion on panel with wood and rope
244 × 122
10

**1572 GRANTED
SEAL FOR TOWNE OF
ESTGRINSTEED**

East Grinstead Millennium Mural Team
1572 Granted Seal for Towne of Estgrinstead
1999
emulsion on panel 244 × 122
11

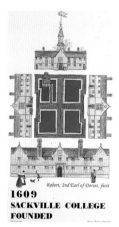

**1609
SACKVILLE COLLEGE
FOUNDED**

East Grinstead Millennium Mural Team
1609 Sackville College Founded 1999
emulsion on panel 244 × 122
12

**1683 CHURCH
STRUCK BY
LIGHTNING**

East Grinstead Millennium Mural Team
1683 Church Struck by Lightning 1999
emulsion on panel 244 × 122
13

**1717 INTRODUCTION
OF THE
TURNPIKE TOLLS**

East Grinstead Millennium Mural Team
1717 Introduction of the Turnpike Tolls 1999
emulsion on paper with wood 244 × 122
14

**1750 THE
COACHING INDUSTRY**

East Grinstead Millennium Mural Team
1750 The Coaching Industry 1999
emulsion on panel 244 × 122
15

**1854 St MARGARET'S
CONVENT FOUNDED**

East Grinstead Millennium Mural Team
1854 St Margaret's Convent Founded 1999
emulsion on panel 244 × 122
16

**1855 RAILWAY TO
THREE BRIDGES
OPENED**

East Grinstead Millennium Mural Team
1855 Railway to Three Bridges Opened 1999
emulsion on panel 244 × 122
17

**1863 FIRST
FIRE BRIGADE
FORMED**

East Grinstead Millennium Mural Team
1863 First Fire Brigade Formed 1999
emulsion on panel 244 × 122
18

East Grinstead Millennium Mural Team
1884 Greenwich Meridian Established 1999
emulsion on panel 244 × 122
19

East Grinstead Millennium Mural Team
1908 First East Grinstead Scout Troop Founded
1999
emulsion on panel 244 × 122
20

East Grinstead Millennium Mural Team
1940 McIndoe's Burns Unit at QV hospital
1999
emulsion on panel 244 × 122
21

East Grinstead Millennium Mural Team
1943 Whitehall Cinema Destroyed by Enemy Action 1999
emulsion on panel 244 × 122
22

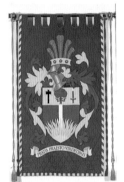

East Grinstead Millennium Mural Team
1954 Granted a Coat of Arms 1999
textile and emulsion on panel 244 × 122
23

East Grinstead Millennium Mural Team
1962 Town Twinning Founded 1999
emulsion on panel with wood 244 × 122
24

East Grinstead Millennium Mural Team
1970s Office Buildings Change Town's Character 1999
emulsion on panel with wood 244 × 122
25

East Grinstead Millennium Mural Team
1999 Monday 3 May Visitors to the 'Lions' May Fayre' 1999
photographs on panel with emulsion
244 × 122
26

East Grinstead Millennium Mural Team
1999 East Grinstead Millennium Logo 1999
emulsion on panel with wood 244 × 122
27

Facing page: Piper, John, 1903–1992, *Redland Park Congregational Church, Bristol* (detail) 1940, Pallant House Gallery (p. 39)

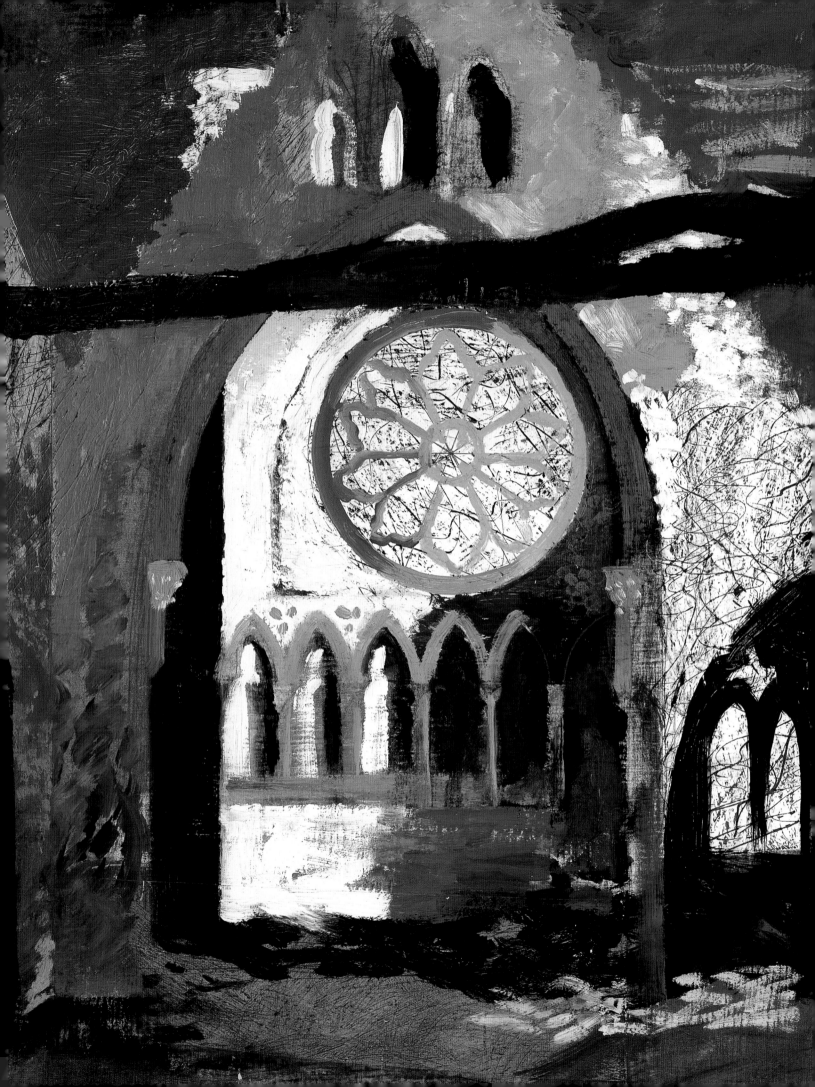

East Grinstead Millennium Mural Team
Anno Domini MM 1999
acrylic on MDF board 222 × 243 (E)
28 and 29

Rix, Anne-France b.1973
The Bigger Picture 1999
acrylic on panel 120 × 120 (E)
30

unknown artist
title unknown
acrylic on panels 70 × 89 (E)
31

East Grinstead
Town Council

Collison, Edward c.1920–2001
East Court at Springtime
oil on canvas 50 × 75
2

Lane, Bill
Street Market Railway Approach, East Grinstead 1989
oil on canvas 44.0 × 59.7
4

Moss, William George active 1814–1838
East Grinstead from the Lewes Old Road 1838
oil on canvas 41.0 × 51.5
3

Tupholme-Barton, Nicola
Queen Elizabeth II, Golden Jubilee 2002
oil on canvas 100.5 × 125.5
1

unknown artist 20th C?
Alfred Wagg
oil on canvas 59.5 × 49.5
5

East Grinstead Town Museum

Collison, Edward c.1920–2001
Red Lion at Chelwood Gate c.1970
oil on canvas 29.5 × 40.7
EGRTM 955.1

Collison, Edward c.1920–2001
Set Fair c.1970
oil on canvas 39.8 × 50.4
EGRTM 955.2

Collison, Edward c.1920–2001
Southwark Bridge c.1970
oil on canvas 44.5 × 60.0
EGRTM 955.3

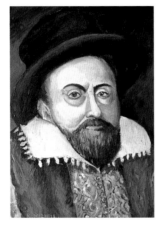

Michell, Ronald 1916–1991
Robert Sackville, Second Earl of Dorset 1976
oil on hardboard 36 × 27 (E)
EGRTM 956

Pepper, William Reynolds d.1886
*East Grinstead High Street Looking West to
Middle Row* 1880
oil on panel 27 × 45 (E)
EGRTM 135.3

Pepper, William Reynolds d.1886
Great Walking Fête 1881
oil on card 16 × 22
EGRTM 135.4

Pepper, William Reynolds d.1886
*An Obstructionist 'Cloture' That Didn't Come
off* 1882
oil on card 16 × 20
EGRTM 135.5

Pepper, William Reynolds d.1886
Public Rights of Way 1882
oil on card 21 × 26
EGRTM 135.6

Pepper, William Reynolds d.1886
The Fable of the Hare, the Turtle and the Fox
c.1880
oil on card 22 × 26
EGRTM 135.7

Sawyer, F. E. late 19th C
East Grinstead from the Old Lewes Road (copy after William George Moss)
oil on canvas 20 × 26
EGRTM 152

Ullmann, Thelma Beatrice c.1915–c.1999
Backyard of Crown Hotel Looking East c.1960
oil on hardboard 56.0 × 42.6
EGRTM 190.2

unknown artist
High Street at Junction with London Road
c.1880
oil on panel 24 × 40 (E)
EGRTM 135.2

Hassocks Parish Council

Deschamps, A.
Hotel de ville, Montmirail 2002
oil on canvas 54 × 65

Princess Royal
Hospital Arts
Project

Edwards, Trudie
Garden Scene with Waterlilies and Bridge
oil on board 120 × 325
3

Gray, Anthony John b.1946
Squares, Lines, Circles and Rainbows 1991
oil on canvas 122 × 122
4

Gray, Anthony John b.1946
Squares, Lines, Circles and Rainbows 1991
oil on canvas 122 × 122
5

Gray, Anthony John b.1946
Squares, Lines, Circles and Rainbows 1991
oil on canvas 122 × 122
6

Gray, Anthony John b.1946
Squares, Lines, Circles and Rainbows 1991
oil on canvas 122 × 122
7

Gray, Anthony John b.1946
*Surreal Painting - Women's Faces with Birds,
Blue Sky and Clouds*
oil on canvas 100.0 × 152.5
9

Gray, Anthony John b.1946
Circles within Squares
oil on canvas 122 × 152
10

Gray, Anthony John b.1946
Geometric Diamonds over Snowy Mountains
oil on canvas 63 × 63
11

Gray, Anthony John b.1946
Geometric Diamonds over Snowy Mountains
oil on canvas 63 × 63
12

Holmes Pickup, M.
Landscape
oil on canvas 75 × 62
16

Parrott, Bill
Jack and Jill Windmill
oil on canvas 85 × 155
2

Phillips, K. K.
Poppies
oil on canvas 122 × 122
13

Sanderson, Elizabeth
Impression of Sidmouth
oil on canvas 49 × 59
14

Tetley, P. I. D.
Chalk Pit on the Downs
oil on canvas 49 × 75
1

unknown artist
Winter Lake
oil on canvas 76.5 × 94.0
15

Henfield Museum

Burleigh, Veronica 1909–1998
Threshing c.1930
oil on canvas 76 × 101
PB1221

Gordon, J.
Congregational Chapel, Henfield c.1875
oil on canvas 31 × 41
1204

Gordon, J. (attributed to)
Windmill Lane, Henfield c.1896
oil on canvas 59 × 69
1274

Gray, Rosa 1868–1958
Cottage by Road
oil on canvas 25 × 36
88/20/P1334

Green, Robert
From Barrow Hill, Henfield c.1950
oil on canvas applied to card 35 × 43
PB1214

Holden, Bertha 1911–1999
*The Health Centre from Cagefoot Lane,
Henfield* 1975
oil on board 26 × 36
PB1171

Milne, Malcolm 1887–1954
Primeval Henfield 1951
acrylic on cardboard 56 × 76
PB1183

Milne, Malcolm 1887–1954
Henfield High Street, 1850 AD 1951
acrylic on cardboard 56 × 76
PB1184

Milne, Malcolm 1887–1954
Henfield, 1500 AD 1951
acrylic on cardboard 56 × 76
PB1185

Milne, Malcolm 1887–1954
Henfield, 1000 AD 1951
acrylic on cardboard 56 × 76
PB1186

Russell, M.
The Cat House, Henfield 1882
oil on canvas 30 × 46
PB1209

Squire, Harold 1881–1959
Clay Pits, Dorset 1924
oil on wood 33 × 41
PB1164

unknown artist
High Street, Henfield c.1880
oil on cardboard 36 × 50 (E)
PB1211

unknown artist
Cottage Garden, Henfield c.1918
oil on wood 13 × 18
PB1190

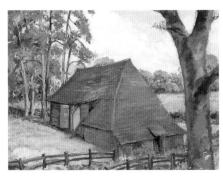

unknown artist
Backsettown Barn, Henfield c.1964
oil on canvas applied to card 30 × 41
PB1195

unknown artist 20th C
A Cottage Kitchen
oil on cardboard 23 × 31
PB1173

Christ's Hospital Foundation

King Edward VI founded Christ's Hospital (used in the sense of 'hospitality') in 1552 to take poor children from the streets of London and provide them with shelter and education. The school was one of three royal hospitals founded towards the end of the boy-king's reign. They were to address the plight of the poor, whose situation had been exacerbated by his father's closure of the city's monasteries. St Thomas' Hospital was founded for attending to the sick, Bridewell Hospital for giving shelter and sustenance to beggars, and Christ's Hospital for educating and caring for the 'fatherless children and other poor men's children'. Edward gave the former Grey Friars' Monastery in Newgate to the school, which continued there until overcrowding and poor conditions caused a move to the clean air of Horsham in 1902.

Commonly known as the 'Bluecoat School' or more frequently 'CH' by those closest to it, the distinctive uniform of a blue 'Housey' coat was established very early in the school's existence and is still worn today. With the founding aid of the City of London in 1552 the school flourished and soon began to send scholars to the universities. The charitable nature of the school attracted benefactors who admired the 'rags to riches' achievements of many former pupils, who, through education, achieved fame and fortune in public life, commerce and the professions. These benefactors gave legacies, property, money and valuable items such as silver and artworks to the school, building a substantial endowment that provides income through which the school finances its charitable mission even today.

Neither civil war nor plague, nor even the Great Fire of London, which claimed a large number of the school's buildings, could stop the onward progress of Christ's Hospital. Samuel Pepys, as Secretary to the Admiralty and as a Governor, was largely instrumental in persuading Charles II to found the Royal Mathematical School within Christ's Hospital to help redress the shortage of navigators skilled in mathematics and navigation on merchant and naval ships. Something of a golden age for the school followed in the second half of the 18th century and early 19th century, when it boasted such pupils as Samuel Taylor Coleridge, Charles Lamb and James Leigh Hunt. Many other pupils migrated to the colonies and helped found settlements which prospered in America, the West Indies and India. During Victoria's reign, the school attracted the interest of the Queen, who invited pupils to Windsor to display their artworks and who purchased the most appealing pictures. The school also attracted interest from many successful businessmen who ensured a continuing source of gifts and legacies that helped build Christ's Hospital's permanent endowment.

In the 20th century, Christ's Hospital continued to transform pupils' lives and many of its 'Old Blues' became household names, including Edmund Blunden (notable poet of the First World War era), Barnes Wallis (inventor of the Dam Buster's bouncing bomb), Constant Lambert (composer), Bernard Levin (critic, writer and television personality), Michael Stewart (Foreign Secretary) Sir Colin Davis (conductor) and many other actors, writers, academics, sportsmen, television personalities and eminent individuals.

Throughout nearly 450 years of social and economic change, Christ's Hospital has remained true to its founding principles and now provides high quality boarding education for children who, but for Christ's Hospital, would not have the chance in life that their potential deserves. A balanced pupil population is a feature of the school, and children are admitted from all walks of life. About 500 boys and 350 girls between the ages of 11 and 18 are in the school. The overriding principle of the admissions procedure is to help those with need, whatever that need may be. The income from the endowment ensures that any child can apply to attend Christ's Hospital who is academically at about the national average level or above as measured by their Key Stage Two SATs results.

Unlike other boarding schools, Christ's Hospital does not earn the majority of its income from fees paid by parents. The endowment income funds about 85 percent of costs; 20 percent of parents pay nothing towards their children's schooling and another 20 percent pay less than the costs of feeding their child. The rest pay an amount that is scaled according to their income. The governing Council of Almoners actually restricts the number of children taken whose parents are able to pay full fees.

Christ's Hospital art collection is extensive, with some 250 works in a variety of media and all hanging. Foremost among these is the great Verrio, measuring over 5 by 26 metres, which dominates one wall of the dining hall, flanked by two outstanding portraits of the young Queen Victoria and Prince Albert, painted to commemorate the Queen's visit to the school in 1845 by Sir Francis Grant PRA. In the chapel, 16 vast paintings in egg tempera by Frank Brangwyn add, by their brilliance and lightness of colour, to the awe-inspiring vault of the interior. The library has, at its eastern end, the 'Charter painting' evoking a ceremony by which Edward presented the 1553 Royal Charter to Christ's Hospital. This painting is faced at the western end by a picture of Charles II, founder of the Royal Mathematical School, attributed to Laroon. The governors, often aided by subscriptions, commissioned all these paintings. Many others were the result of gift or legacy. They all add to the unique atmosphere within this historical and most charitable of schools.

Tony Hogarth-Smith, Administration Officer

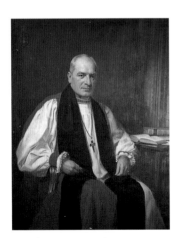

Ayoub, Moussa active 1903–1940
The Right Reverend Edmund Courtenay Pearce, DD
oil on canvas 126 × 100 (E)
2

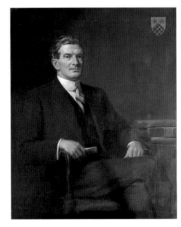

Ayoub, Moussa active 1903–1940
Mervyn Boecher Davie 1930
oil on canvas 121.9 × 91.4 (E)
60

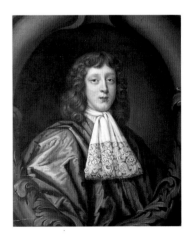

Beale, Mary (attributed to) 1633–1699
Oliver Whitby
oil on canvas 73.8 × 61.0 (E)
94

Beresford, **Frank Ernest** 1881–1967
John Rose 1935
oil on canvas 59.6 × 49.6 (E)
112

Bowness, **William** 1809–1867
John Guy Webster as a Christ's Hospital Boy
oil on canvas 80.3 × 59.3
165

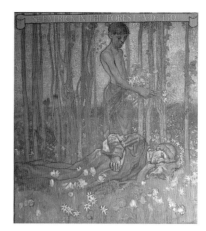

Brangwyn, **Frank** 1867–1956
St Patrick in the Forest c.1920
tempera on canvas 228 × 227 (E)
211

Brangwyn, **Frank** 1867–1956
St Alban Martyr c.1920
tempera on canvas 228.0 × 405.5 (E)
212

Brangwyn, **Frank** 1867–1956
St Augustine at Ebbsfleet c.1920
tempera on canvas 228.0 × 405.5 (E)
213

Brangwyn, **Frank** 1867–1956
*St Aidan, Bishop of North Cumbria, 635 AD
Training Boys at Lindisfarne* c.1920
tempera on canvas 228.0 × 405.5 (E)
214

Brangwyn, **Frank** 1867–1956
*St Wilfred, First Bishop of Selsey Teaching the
South Saxons, 681 AD* c.1920
tempera on canvas 228.0 × 405.5 (E)
215

Brangwyn, **Frank** 1867–1956
*William Caxton Printing Bibles at Westminster,
1476 AD* c.1920
tempera on canvas 228.0 × 405.5 (E)
216

Brangwyn, **Frank** 1867–1956
*John Eliot Giving Bibles to the Mohicans, 1660
AD* c.1920
tempera on canvas 228.0 × 405.5 (E)
217

Brangwyn, **Frank** 1867–1956
'Let the people praise thee O God, let all the people praise thee' c.1920
tempera on canvas 228.0 × 405.5 (E)
218 🐝

Brangwyn, **Frank** 1867–1956
'Peter standing up with the eleven lifted up his voice and spake' c.1920
tempera on canvas 228.0 × 405.5 (E)
219 🐝

Brangwyn, **Frank** 1867–1956
The Martyrdom of St Stephen c.1920
tempera on canvas 228.0 × 405.5 (E)
220 🐝

Brangwyn, **Frank** 1867–1956
The Men Led Saul by the Hand and Brought him to Damascus c.1920
tempera on canvas 228.0 × 405.5 (E)
221 🐝

Brangwyn, **Frank** 1867–1956
St Paul Shipwrecked c.1920
tempera on canvas 228.0 × 405.5 (E)
222 🐝

Brangwyn, **Frank** 1867–1956
The Arrival of St Paul at Rome c.1920
tempera on canvas 228.0 × 405.5 (E)
223 🐝

Brangwyn, **Frank** 1867–1956
The Conversion of St Augustine at Milan, 387 AD c.1920
tempera on canvas 228.0 × 405.5 (E)
224 🐝

Brangwyn, **Frank** 1867–1956
St Ambrose Training the Choir at his Church in Milan, 385 AD c.1920
tempera on canvas 228.0 × 405.5 (E)
225 🐝

Brangwyn, **Frank** 1867–1956
St Columba Landing at Iona c.1920
tempera on canvas 228 × 227 (E)
226 🐝

British (English) School early 17th C
Dame Mary Ramsay
oil on canvas 116 × 93 (E)
228

British (English) School 17th C
Edward VI
oil on canvas 124 (E)
77

British (English) School mid-17th C
William Gibbon, Treasurer (1662)
oil on canvas 79.5 × 66.5 (E)
83

British (English) School mid-17th C
John Fowke
oil on canvas 73.8 × 63.0 (E)
87

British (English) School
Thomas Parr of Lisbon, Merchant c.1790
oil on canvas 135.0 × 99.1 (E)
167

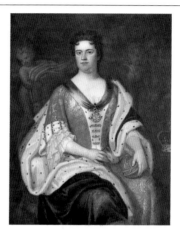

British (English) School early 18th C
Queen Anne
oil on canvas 101.6 × 76.2 (E)
68

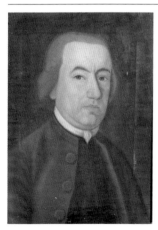

British (English) School early 18th C
Portrait of a Gentleman said to be Thomas Parr
oil on canvas 40.8 × 30.2 (E)
162

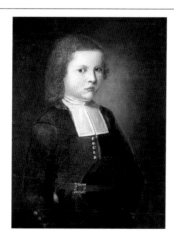

British (English) School early 18th C
Portrait of a Christ's Hospital Boy
oil on canvas 64.7 × 48.7 (E)
176

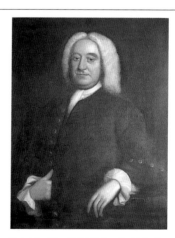

British (English) School 18th C
James Hodgson, FRS
oil on canvas 89.5 × 69.2 (E)
174

British (English) School early 19th C
*William Walker Wilby of Windmill House
(1770–1842)*
oil on canvas 73.7 × 61.0 (E)
129

British (English) School 19th C
Susannah Holmes
oil on canvas 228.6 × 147.3 (E)
70

British (English) School 19th C
S. T. Coleridge
oil on canvas 91.4 × 61.0 (E)
160

British (English) School 19th C
Edward Thornton
oil on canvas 73.0 × 59.3 (E)
163

British (English) School 19th C
Edward Pitts
oil on canvas 60.0 × 44.6 (E)
179

British (English) School early 20th C
Reverend Arthur William Upcott
oil on canvas 91.4 × 61.0 (E)
39

British (English) School early 20th C
Frederick Wilby of Stortford Park (1849–1925)
oil on canvas 73.7 × 61.0 (E)
132

British (English) School early 20th C
Sir John Pound
oil on canvas 165.1 × 134.6 (E)
229

British (English) School early 20th C
Sir Henry Vanderpant
oil on canvas 60.0 × 49.5 (E)
286

British (English) School 20th C
William Hamilton Fyfe
oil on canvas 121.9 × 91.4 (E)
38

British (English) School
Miss M. Robertson
oil on canvas 121.9 × 61.0 (E)
47

British (English) School
Sir John Savory
oil on canvas 101.6 × 76.2 (E)
51

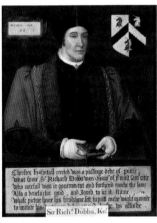

British (English) School
*Richard Dobbs, Lord Mayor of London
(1551–1552)*
oil on panel 103 × 78 (E)
86

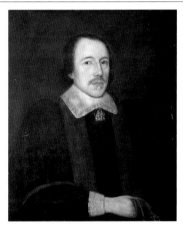

Brown, Mather 1761–1831
Richard Clark
oil on canvas 126.0 × 100.5 (E)
89

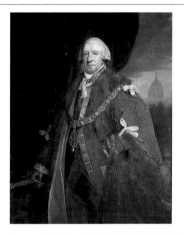

Brown, Mather (attributed to) 1761–1831
Sir John William Anderson
oil on canvas 139.0 × 111.5 (E)
90

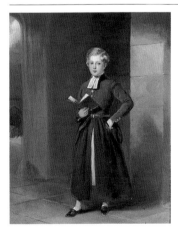

Carpenter (school of) early 19th C
Portrait of Christ's Hospital Boy
oil on canvas 61.5 × 49.6 (E)
205

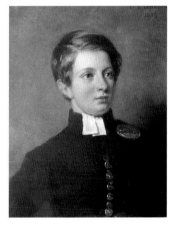

Carpenter, William 1818–1899
George Atkinson 1839
oil on panel 23.7 × 19.0 (E)
181

Chamberlin, Mason (attributed to) active
c.1786–1826
Mrs Le Keux
oil on canvas 88.8 × 68.2 (E)
5

Chinnery, George 1774–1852
Captain Charles Shea (Died 1866)
oil on canvas 23.5 × 19.1 (E)
156

Clarke, George Frederick 1823–1906
William Foster White (after John Prescott Knight)
oil on canvas 80.5 × 64.6 (E)
21

Closterman, John (attributed to) 1660–1711
Daniel Colwall
oil on canvas 122.2 × 99.7 (E)
102

Collier, John 1850–1934
Herbert William Walmisley 1912
oil on canvas 141.0 × 101.5 (E)
10

Collier, John 1850–1934
Portrait of Unknown Soldier 1921
oil on canvas 89.7 × 69.5 (E)
11

Cooper, Alfred Egerton 1883–1974
HRH Henry Duke of Gloucester Receiving His Charge as President, 14 April 1937 1937
unvarnished oil on canvas 74.5 × 111.0 (E)
23

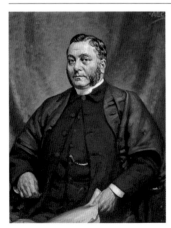

Cooper, Alfred Egerton 1883–1974
Reverend Richard Lee, Headmaster
oil on canvas 91.4 × 61.0
40

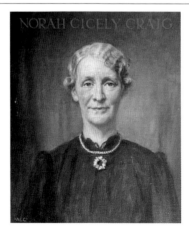

Cooper, Alfred Egerton 1883–1974
Miss Norah Cicely Craig
oil on canvas 61.0 × 50.8
46

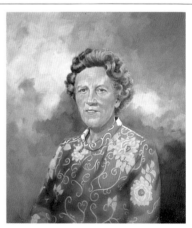

Cooper, Alfred Egerton 1883–1974
Miss D. West
oil on canvas 91.4 × 61.0 (E)
48

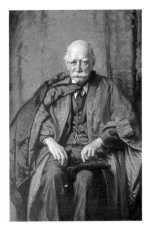

Cooper, Alfred Egerton 1883–1974
Sir Oliver Lodge
oil on canvas 121.9 × 76.2 (E)
54

Cooper, Alfred Egerton 1883–1974
Joseph James Brown 1937
oil on canvas 121.9 × 91.4 (E)
61

Cooper, Alfred Egerton 1883–1974
Charles Wilfred Thompson 1950s
oil on canvas 121.9 × 91.4 (E)
62

Cooper, Alfred Egerton 1883–1974
Sir Barnes Wallis
oil on panel? 116.8 × 91.4 (E)
64

Cooper, Alfred Egerton 1883–1974
Barnes Wallis 1930
oil on canvas 50.8 × 39.4 (E)
164

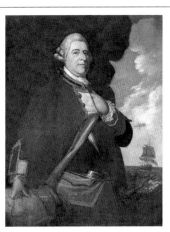

Cosway, Richard 1742–1821
Admiral Michael Everitt 1773?
oil on canvas 124.2 × 99.0 (E)
158

Critz, John de the elder (style of)
1551/1552–1642
Wolston Dixey, President (1590–1593)
oil on canvas 127.0 × 101.5 (E)
84

Crowe, Eyre 1824–1910
Christ's Hospital Children in London Quad
1877
oil on canvas 17.5 × 24.5 (E)
204

Dahl, Michael I (attributed to)
1656/1659–1743
Thomas Lockington
oil on canvas 124.8 × 99.0 (E)
9

91

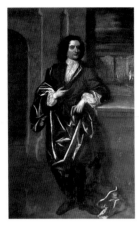

Dahl, Michael I (circle of) 1656/1659–1743
William Garway
oil on canvas 243.8 × 147.3 (E)
55

Daniell, William 1769–1837
*Sea Battle between a French Squadron and
Ships of the East India Company*
oil on canvas 92.7 × 198.1 (E)
76

Daniell, William 1769–1837
*The Action of Commodore Dance and the
Comte de Linois off the Straits of Malacca,15
February 1804*
oil on canvas 92.7 × 198.1 (E)
78

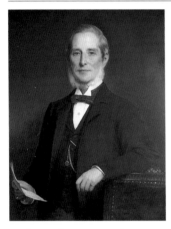

Dicksee, Thomas Francis 1819–1895
Matthius Sidney Smith Dipnall 1890
oil on canvas 90.0 × 69.2 (E)
27

Edwards, Peter Douglas b.1955
*Susan Mitchell, Treasurer (1996–2002) and Her
Husband John* 2002
oil on canvas 198.1 × 101.6 (E)
305

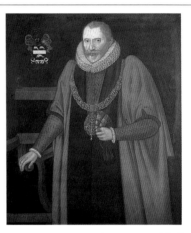

Geeraerts, Marcus the younger (circle of)
1561–1635
Sir John Leman
oil on canvas 101.6 × 91.4 (E)
171

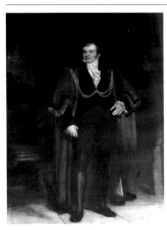

Grant, Francis 1803–1878
William Thompson
oil on canvas 294.6 × 203.2 (E)
32

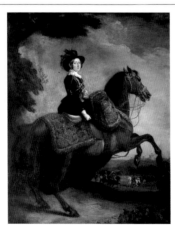

Grant, Francis 1803–1878
HM Queen Victoria 1845/1846
oil on canvas 274.3 × 218.4 (E)
42

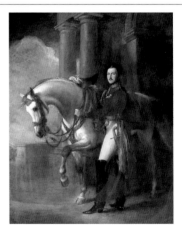

Grant, Francis 1803–1878
HRH Prince Albert
oil on canvas 274.3 × 218.4 (E)
44

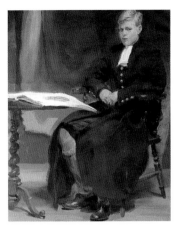

Gray, Douglas Stannus 1890–1959
A Christ's Hospital Boy Studying c.1920
oil on canvas 54.5 × 44.5 (E)
206

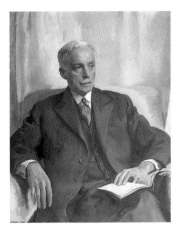

Green, Kenneth 1905–1986
Thomas Edward Limmer 1932
unvarnished oil on canvas 90.0 × 69.5 (E)
28

Green, Kenneth 1905–1986
Oswald Lael Flecker 1955
oil on canvas 121.9 × 91.4 (E)
37

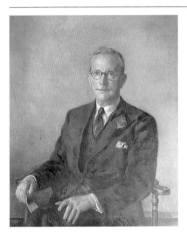

Green, Kenneth 1905–1986
Reginald Edgeley Oldfield 1957
oil on canvas 121.9 × 91.4 (E)
63

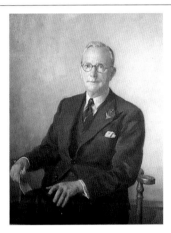

Green, Kenneth 1905–1986
R. E. Oldfield, Treasurer (1945–1957) 1957
oil on canvas 109.2 × 86.4 (E)
230

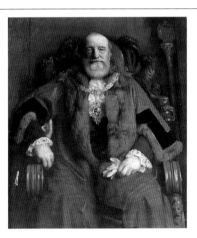

Hacker, Arthur 1858–1919
Sir Walter Vaughan Morgan 1901
oil on canvas 139.7 × 110.5 (E)
67

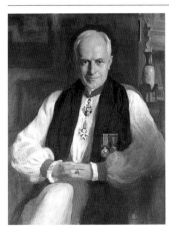

Hardy, Benjamin
Ernest Harold Pearce 1932
oil on canvas 101.6 × 76.2 (E)
53

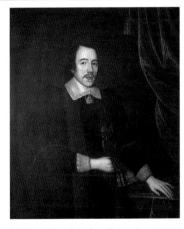

Hayls, John (circle of) active 1651–1679
Thomas Barnes
oil on canvas 114.1 × 91.3 (E)
172

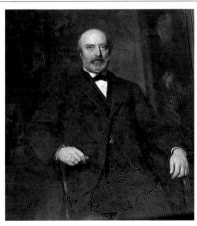

Herkomer, Hubert von 1849–1914
John D. Allcroft, Treasurer, (1873–1891) 1884
oil on canvas 124.5 × 99.3 (E)
227

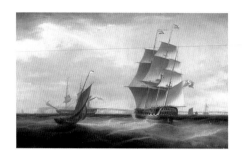

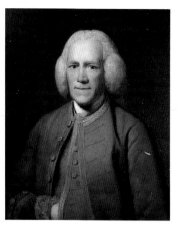

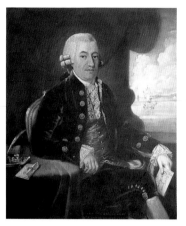

Higgins or R. Scott (Captain)
The Ship 'Thomas Grenville' c.1860s
oil on canvas 82.6 × 133.4 (E)
75

Highmore, Joseph (circle of) 1692–1780
John Smith
oil on canvas 73.2 × 61.0 (E)
7

Highmore, Joseph (circle of) 1692–1780
Reverend Edmund Tew
oil on canvas 124.5 × 99.1 (E)
168

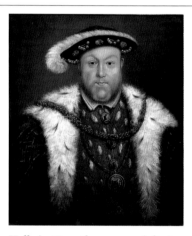

Hindman, John (attributed to) 18th C
Portrait of a Pupil of Christ's Hospital
oil on canvas 44.1 × 34.7 (E)
177

Hodgson, E. S.
Christ's Hospital from the Treasurer's Garden
c.1900
oil on canvas 58.7 × 48.7 (E)
210

Holbein, Hans the younger (after)
1497/1498–1543
Henry VIII
oil on canvas 74 × 62 (E)
30

Hunt, Gerard Leigh 1858–after 1928
James Leigh Hunt
oil on canvas 106.7 × 86.3 (E)
14

Hunt, Richard active 1640–1642
Thomas Singleton 1642
oil on canvas 72.5 × 63.0 (E)
82

Hyndman, Arnold active 1921–1932
Frederick Augustus White 1921
oil on canvas 121.9 × 91.4 (E)
59

Facing page: Hitchins, Ivon, 1893–1979, *Flowers in Hot Sun* (detail), 1975, Worthing Museum and Art Gallery (p. 146)

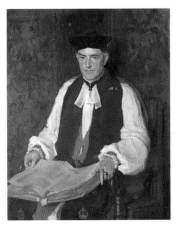

Hyndman, Arnold active 1921–1932
The Right Reverend E. H. Pearce
oil on canvas 124.5 × 99.1 (E)
170

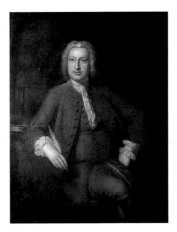

Hysing, Hans (attributed to) 1678–1753
Thomas Birch
oil on canvas 125.0 × 100.5 (E)
4

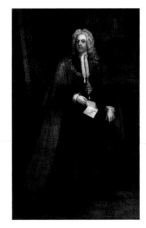

Hysing, Hans (attributed to) 1678–1753
Sir Francis Child (Died 1740)
oil on canvas 243.8 × 147.3 (E)
31

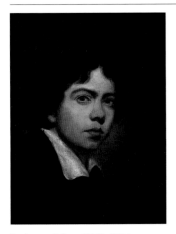

Jackson, John 1778–1831
Portrait said to be of James Henry Leigh Hunt,
Aged 18
oil on canvas 44.5 × 33.7 (E)
161

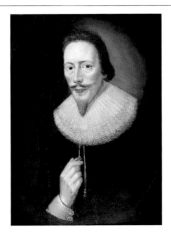

Janssens van Ceulen, Cornelis (follower of)
1593–1661
Richard Young
oil on panel 64.1 × 49.5 (E)
91

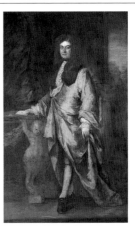

Kneller, Godfrey (attributed to) 1646–1723
Josiah Bacon
oil on canvas 243.8 × 147.3 (E)
57

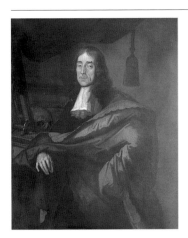

Kneller, Godfrey (attributed to) 1646–1723
Thomas Stretchley, 1692
oil on canvas 124.5 × 99.1 (E)
169

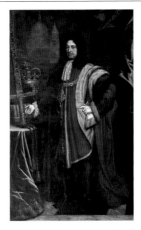

Kneller, Godfrey (circle of) 1646–1723
Sir Francis Child (Died 1713)
oil on canvas 243.8 × 147.3 (E)
33

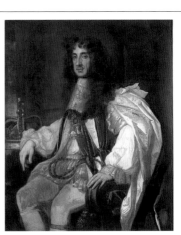

Kneller, Godfrey (circle of) 1646–1723
Charles II
oil on canvas 228.6 × 147.3 (E)
71

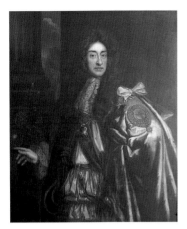

Kneller, Godfrey (studio of) 1646–1723
James II
oil on canvas 124 × 101 (E)
29

Knight, John Prescott 1803–1881
The Duke of Cambridge c.1860s
oil on canvas 269.2 × 177.8 (E)
56

**Knight, P. or Pickersgill, Henry William
(1782–1875)**
Richard Hotham Pigeon
oil on canvas 269.2 × 177.8 (E)
45

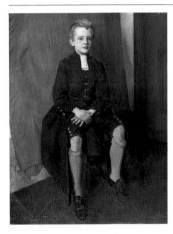

Lambert, George Washington 1873–1930
*Constant Lambert as a Christ's Hospital
Schoolboy* 1916
oil on canvas 124.5 × 91.4 (E)
118

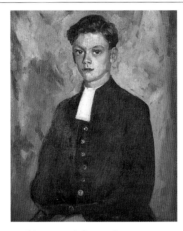

Larking, Patrick Lambert 1907–1981
*Portrait of a Christ's Hospital Boy (G. J. L.
Crewdson)*
oil on canvas 62.2 × 57.0 (E)
209

Laroon, Marcellus I (attributed to)
1653–1702
Charles II
oil on canvas 375.9 × 297.2 (E)
108

Lawrence, Joseph (circle of) early 19th C?
Thomas Wilby
oil on canvas 74.5 × 61.0 (E)
26

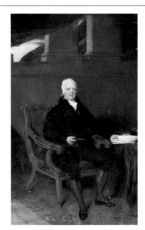

Lawrence, Thomas 1769–1830
James Palmer, Treasurer (1798–1824)
oil on canvas 228.6 × 147.3
41

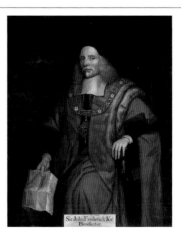

Lely, Peter (circle of) 1618–1680
Sir John Frederick, Kt
oil on canvas 122.2 × 99.7 (E)
99

Logsdail, William 1859–1944
Edward Logsdail as Christ's Hospital Scholar
1904
oil on canvas 182.9 × 61.0 (E)
69 🐝

Luxmoore, Ben 20th C
Interior of Christ's Hospital Chapel
unvarnished oil on canvas 66.8 × 44.5 (E)
136

Luxmoore, Ben 20th C
Christ's Hospital Boys Running in Avenue
unvarnished oil on canvas 34.7 × 49.0 (E)
142

Luxmoore, Ben 20th C
Ben Waters
oil on canvas 77.5 × 51.8 (E)
203

Luxmoore, Ben 20th C
Portrait of a Christ's Hospital Boy
oil on canvas 41.9 × 58.4 (E)
298

Myles, Frank
Mr Keymer 1878
oil on canvas 60 × 50 (E)
131

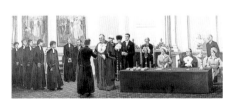

Nelson, Edmund b.1910
The Presentation of the Lord Mayor's Bounty
1977
oil on canvas 59.2 × 147.5 (E)
111

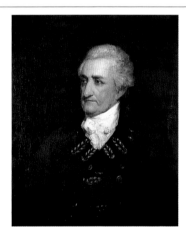

Northcote, James (attributed to) 1746–1831
Commodore Sir Nathaniel Dance
oil on canvas 74.4 × 61.0 (E)
6

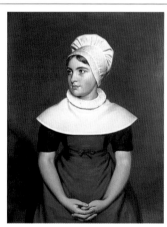

Oliver, Archer James 1774–1842
Susannah Holmes c.1825
oil on canvas 88.9 × 68.6 (E)
208

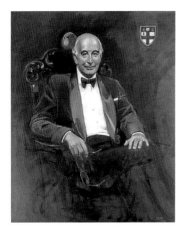

Palmer, Margaret b.1922
James Forbes 1991
oil on canvas 121.9 × 91.4 (E)
74

Palmer, Margaret b.1922
Richard Nicholls 1998
unvarnished oil on canvas 107.8 × 82.0 (E)
95

Pannett, Juliet b.1911
Sir David Hay Newsome
oil on canvas 121.9 × 91.4 (E)
35

Pannett, Juliet b.1911
Miss E. M. Tucker
oil on canvas 91.4 × 61.0 (E)
49

Pannett, Juliet b.1911
Miss J. Morrison 1987
oil on canvas 91.4 × 61.0 (E)
50

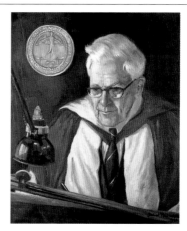

Pannett, Juliet b.1911
Sir Barnes Wallis
oil on canvas 61.0 × 50.8 (E)
231

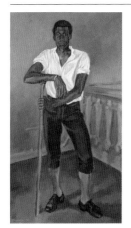

Parmenter, Susan
Sean Davis 1981
oil on canvas 80.5 × 44.6 (E)
199

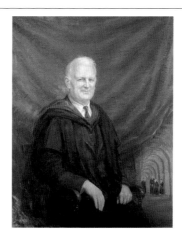

Ramos, Theodore b.1928
Clarence Milton Edward Seaman
oil on canvas 121.9 × 91.4 (E)
36

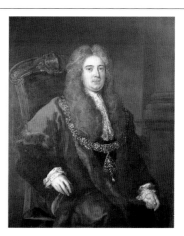

**Richardson, Jonathan the elder (attributed
to)** 1665–1745
Sir Francis Forbes
oil on canvas 124 × 100 (E)
8

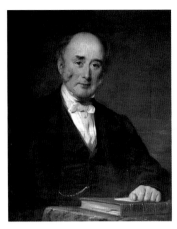

Richmond, George 1809–1896
William Gilpin 1859
oil on canvas 80.5 × 64.6 (E)
20

Rigby, Harold Ainsworth active 1904–1915
A Classical Scene
oil on canvas 59.5 × 44.8 (E)
304

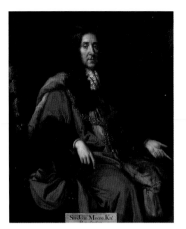

Riley, John (attributed to) 1646–1691
Sir John Moore
oil on canvas 122.2 × 99.7 (E)
97

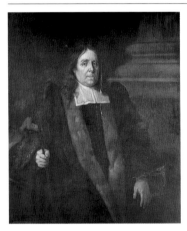

Riley, John (attributed to) 1646–1691
John Morris
oil on canvas 122.2 × 99.7 (E)
102a

Rubbra, Benedict b.1938
Angus Ross, Treasurer (1970–1976) c.1975
oil on canvas 121.9 × 91.4 (E)
72

Rubbra, Benedict b.1938
Richard Poulton, Headmaster (1987–1997)
1998
oil on canvas 121.9 × 91.4 (E)
80

Scott, Robert 1771–1841
The 'Buckinghamshire' off the 'Asses' Ears',
China Sea, December 1833 1834
oil on canvas 82.6 × 135.9 (E)
79

Scrots, Guillim (circle of) active 1537–1553
Edward VI, Founder of Christ's Hospital
oil on canvas 99 × 71 (E)
22

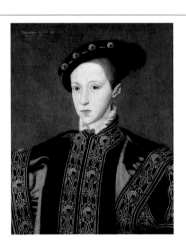

Scrots, Guillim (circle of) active 1537–1553
Edward VI c.1560
oil on panel 58.5 × 48.2 (E)
85

Facing page: Pether, Henry, 1800–1880, *A View of Chichester Cross from East Street* (detail), 1831, Chichester City Council (p. 4)

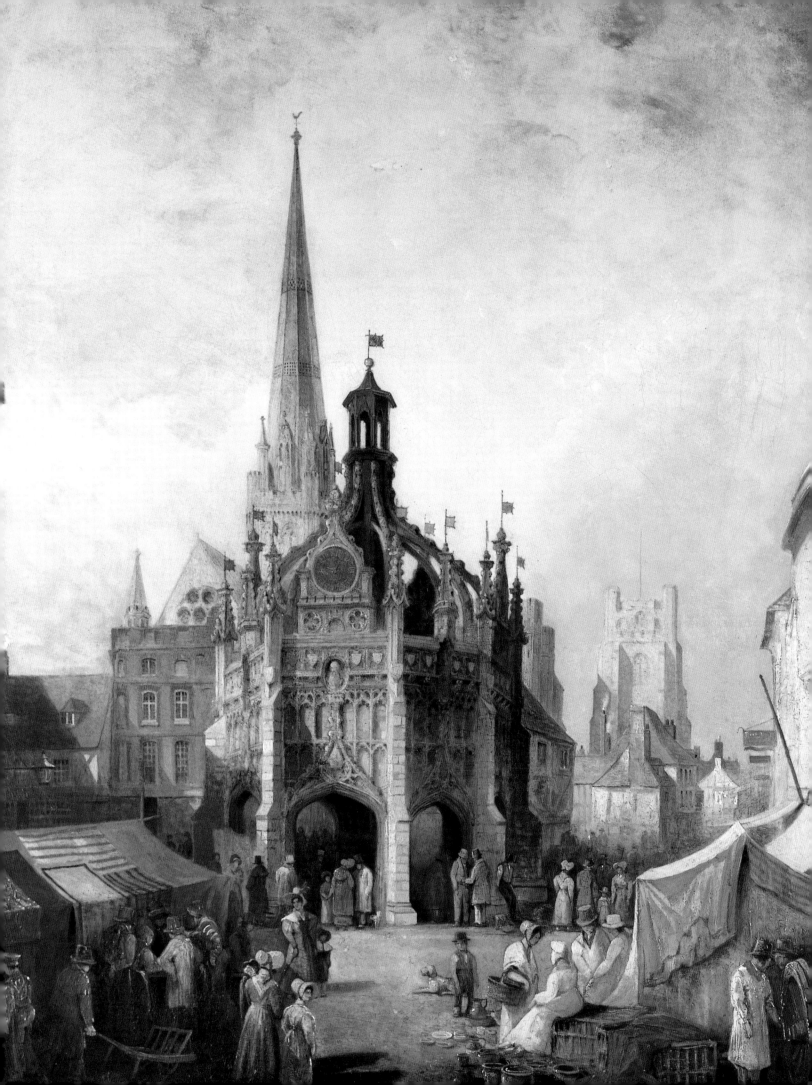

Shee, Martin Archer 1769–1850
Thomas Poynder Junior, Treasurer (1824–1835)
oil on canvas 121.7 × 91.7 (E)
66

Smee, Michael b.1946
Professor Jack Morpurgo 1989
oil on canvas 70 × 60 (E)
306

Speed, Harold 1872–1957
Lieutenant Colonel T. H. Boardman 1918
oil on canvas 75.2 × 62.0 (E)
240

Tayler, Edward E. active 1915–1935
Portrait of a Naval Officer 1915
oil on canvas 76.2 × 48.3 (E)
287

unknown artist
A Remarkable Occurrence in the Life of Brook Watson (copy of John Singleton Copley) 1778
oil on canvas 177.8 × 223.5 (E)
1

unknown artist
General View of Christ's Hospital c.1820 c.1820
oil on canvas 71.2 × 114.5 (E)
196

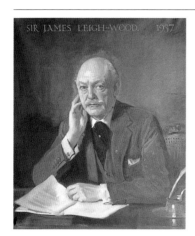

unknown artist
Sir James Leigh-Wood 1937
oil on canvas 121.9 × 91.4 (E)
58

unknown artist 20th C
Sir Edward Ernest Cooper
oil on canvas 121.9 × 91.4 (E)
52

unknown artist
John Thackeray
oil on canvas 110 × 84 (E)
3

unknown artist
Thomas Nixson
oil on canvas 74.2 × 61.3 (E)
12

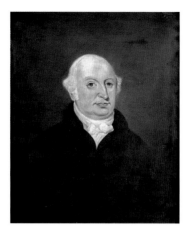

unknown artist
Portrait of an Unknown Gentleman
oil on canvas 58.0 × 48.5 (E)
13

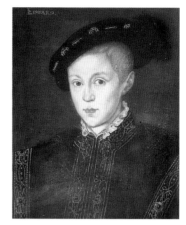

unknown artist
Edward VI
oil on board 16.2 × 14.2 (E)
15

unknown artist
Henry Stone
oil on canvas 122.2 × 99.7 (E)
96

unknown artist
Presentation of Royal Charter by Edward VI
oil on canvas 396.2 × 823.0 (E)
109

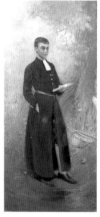

unknown artist
Christ's Hospital Boy
oil on canvas 60.0 × 29.6 (E)
113

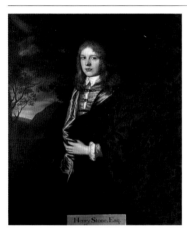

unknown artist
Sir Christopher Clitherow
oil on canvas 123.7 × 91.1 (E)
119

unknown artist
Thomas Wilby of Windmill House
oil on canvas 76.7 × 63.5 (E)
121

unknown artist
John Wilby
oil on canvas 76.7 × 64.0 (E)
126

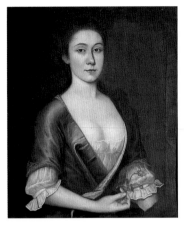

unknown artist
Mary Ash
oil on canvas 99 × 85 (E)
130

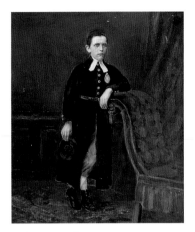

unknown artist
Christ's Hospital Boy
oil on canvas 36.4 × 31.0 (E)
139

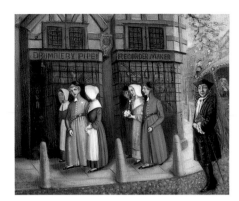

unknown artist
A Christ's Hospital Wedding
oil on canvas 24.6 × 42.6
183

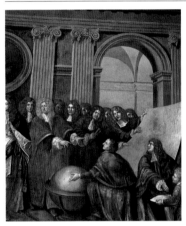

Verrio, Antonio c.1639–1707
*James II Receiving the Mathematical Scholars of
Christ's Hospital (detail)* 1684–1690
oil on canvas 487.7 × 2642.0 (E)
43

Walker, Robert (circle of) 1607–1658/1660
Thomas Barnes
oil on canvas 72.2 × 61.8 (E)
88

Ward, John Stanton b.1917
Professor Edward Kenney 1993
oil on canvas 121.9 × 91.4 (E)
73

Wood, Elizabeth
John Hansford, Headmaster (1985–1987) 1995
oil on canvas 121.9 × 91.4 (E)
81

Woodington, John
Sir Eric Riches 1976
oil on canvas 116.8 × 91.4 (E)
65

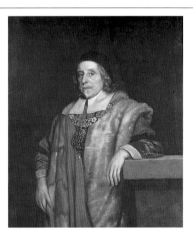

Wright, John Michael (circle of) 1617–1694
Sir Thomas Vyner
oil on canvas 122.2 × 99.7 (E)
98

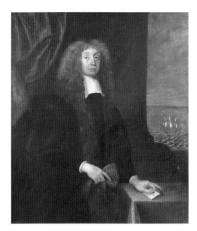

Wright, John Michael (circle of) 1617–1694
Erasmus Smith
oil on canvas 122.2 × 99.7 (E)
101

Young, D.
Interior of Dining Hall, Christ's Hospital,
London 1864
oil on canvas 58.2 × 43.6
154

Young, Henrietta b.1951
Derek Baker 1994
oil on canvas 137.2 × 91.4 (E)
34

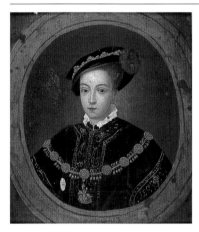

Zuccaro, Federico (after) c.1541–1609
Edward VI c.1800
oil on canvas 61.6 × 48.2 (E)
110

Horsham District Council: Horsham Museum

The Horsham Museum Society was originally founded as a subgroup of the Free Christian Church in 1893. However, it was not until 1929 that the museum found a permanent home in the basement of Park House. Until this time quarterly meetings as well as exhibitions were held in the Free Christian Church. Such an arrangement was not conducive to enlarging the collection of paintings and it was only after 1929, with the benefit of additional space, that larger framed paintings could be acquired and permanently displayed. The most notable gift at this time was '*Whither*' by Bainbridge Copnall. The work was received with mixed blessings, as a number of the committee members wanted to use the reverse of the canvas for a new picture. It was not until 1995/1996 that this painting was finally put on public display.

In 1941, the Museum Society relocated to its current home in The Causeway. Only a couple of rooms were allocated for its use, as the remainder of the rabbit-warren of rooms were used for civil defence purposes.

Horsham Museum Society did not adopt a formal policy for collecting artworks, but like other museums it obtained items from notable families and civic dignitaries as well as helping to 'rescue' paintings which would otherwise have been discarded. As an accession register was only initiated in 1990, no records relating to these early works are available. This fact accounts for the lack of information available for a number of portraits in this catalogue (the paintings in question can be identified by the 'X' which precedes their accession number).

In 1966, Horsham Museum Society decided that the collection was too large for them to run. An agreement was finally signed in 1974 with Horsham District Council whereby the museum collection would be loaned to the council, who would in turn be responsible for its management.

As a general rule, most paintings over the last 20 years or so have been acquired through purchase rather than donation. The museum has also been fortunate enough to acquire some pieces at favourable prices directly from artists. In the case of the oils by Robert Green, a noted local artist, we were fortunate to acquire examples of his work through direct donation, for which we are very grateful. His work would otherwise have been unrepresented in the collection as to purchase them would have fallen beyond the museum's budget. Another local amateur artist who is represented in the collection is Jack Carter who ran a greengrocer's shop in the town and whose flower paintings have a strong local following. The collection also holds numerous works by T. B. Mills, an amateur historian who painted a number of houses in his village of Cowfold. His paintings very much reflect the museum's priority of obtaining artwork which provides an important local historical record.

Horsham has produced a couple of noted artists. Philip Hugh Padwick was a popular artist in the 1950s, who is represented in the collection by four landscape oils. Padwick's colleague, Bainbridge Copnall, was a prolific artist whose pictures adorned many a home in Horsham. The most famous artist's name connected to Horsham is Sir John Everett Millais' son, John G. Millais, who moved to Horsham in 1899. Whilst he and his son Raoul were talented artists in their own right, the museum unfortunately holds no oils by them although it does have a bronze and some chalk drawings.

Jeremy Knight, Curator and Heritage Officer, Horsham District Council

Addison, Eileen b.1906
The Causeway 1960–1970
oil on board 54.5 × 62.5 (E)
1995.539

Anthony, Captain G. M.
Causeway House, Horsham 1931
oil on canvas 68.5 × 83.5 (E)
1953.1

Bech, Bill 20th C
War Memorial, 1914–1918
oil on canvas 50 × 34
1988.521

J. B.
Henry Mitchell, JP (1843–1908) 1905
oil on canvas 69 × 55
2000.1213

Bishop, Winifred
Arundel Mill? 1900–1930
oil on canvas 45.3 × 61.2 (E)
X1996.2468

British (English) School
Gentleman in Red 1810–1830
oil on canvas laid on panel 42.3 × 37.0 (E)
X1998.2672

British (English) School
Portrait of a Young Boy 1820–1860
oil on panel 40 × 35 (E)
X1998.2954

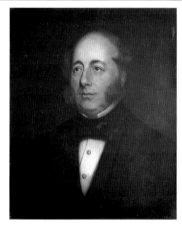

British (English) School
Henry Mitchell (1809–1874) 1869
oil on canvas 73.5 × 60.5 (E)
X2000.1212

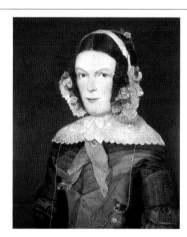

British (English) School 19th C
Lady in a Lace Collar
oil on canvas 75.7 × 63.4 (E)
X1997.2114

British (English) School
The Bishopric
oil on canvas 31 × 57
X1993.2321

Burstow, F.
John Hamilton-Smith and Charles Price 1850
oil on canvas 70.5 × 52.0 (E)
X1996.2500

Carter, Jack c.1912–1992
Flowers with Toby Jug 1953
oil on canvas 65.6 × 55.3
1998.2953

Copnall, Edward Bainbridge 1903–1973
'*Whither*' 1925
oil on canvas 119 × 166
1962.22

Copnall, Edward Bainbridge 1903–1973
Charles John Attree 1926
oil on canvas 107.3 × 81.3 (E)
X1996.2689

Copnall, Edward Bainbridge 1903–1973
Elderly Gentleman 1926
oil on canvas 101 × 67 (E)
X1996.3587

Fox, E.
Farthings Bridge
oil on canvas 19 × 27
X1996.2531

Fox, E.
North Street, Horsham
oil on canvas 26.2 × 34.2
X1996.2532

Green, Robert
Field with Stooks 1925–1930
oil on board 55 × 65 (E)
2001.5314

Green, Robert
Landscape with Lake
oil on canvas 37 × 52
2001.5316

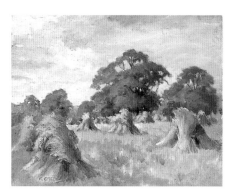

Green, Robert
Landscape with Stooks 1925–1940
oil on board 41.0 × 51.5 (E)
2001.5317

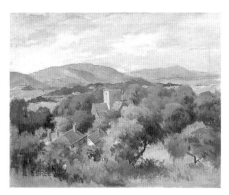

Green, Robert
Landscape Viewed from above
oil on canvas 37 × 48
2001.5318

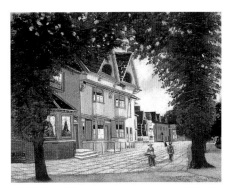

Gregory, J. M.
The Causeway 1884
oil on canvas 50 × 61 (E)
1952.7

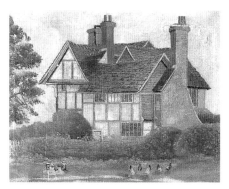

Gregory, J. M.
Chapel House, North Street, Horsham 1884
oil on canvas 44 × 55 (E)
1969.5

Gregory, J. M.
Mill Bay 1884
oil on canvas 42.0 × 56.7 (E)
1980.57

Gregory, M. E. 19th C
Church Porch from Causeway, Horsham 1884
oil on canvas 57.5 × 37.0 (E)
X1996.2688

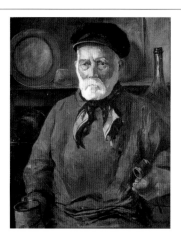

Harms, Edith Margaret active 1897–1932
An Old Fisherman 1920–1930
oil on canvas 71 × 61
1999.251

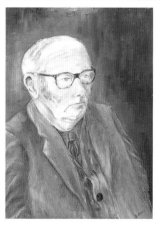

Hart, B. mid-20th C
T. B. Mills
oil on board 40 × 30 (E)
1993.1208

Kilburne, George Goodwin 1839–1924
Ewhurst Gatehouse 1900–1920
oil on panel 44.5 × 54.7 (E)
2000.2227

Kneller, Godfrey (style of) 1646–1723
Charles Eversfield and His Wife
oil on canvas 175.5 × 221.5 (E)
X1947.75

Love, R.
St Mary's Church, Horsham c.1970
oil on canvas 109.5 × 84.0
1998.494

Maidment, S. G.
The Green Man, Partridge Green 1971
oil on canvas 41.0 × 76.2
1998.2951

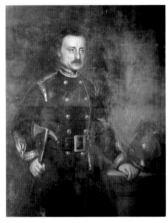

Martin, Robert Wallace 1843–1923
Captain Thomas Honeywood 1869
oil on canvas 128 × 100
1936.1

Mills, T. B. 1906–1989
Capons, Cowfold 1940–1960
oil on board 29 × 37 (E)
1993.1203

Mills, T. B. 1906–1989
Sussex Barn 1940–1970
oil on board 21 × 27 (E)
1993.1206

Mills, T. B. 1906–1989
Boshotts, West Grinstead 1950–1970
oil on board 34.0 × 41.5 (E)
1993.1209

Mills, T. B. 1906–1989
Old Barn, Eastlands 1950–1970
oil on board 35.5 × 40.0 (E)
1993.1212

Mills, T. B. 1906–1989
Hill Foot 1940–1970
oil on board 28 × 19 (E)
1993.1214

Mills, T. B. 1906–1989
Blacksmith's Shop, Cowfold 1940–1960
oil on board 30 × 39 (E)
1993.1217

Mills, T. B. 1906–1989
Sussex Downs 1950–1970
oil on board 30.5 × 40.5 (E)
1993.1218

Mills, T. B. 1906–1989
Windmills 1950–1970
oil on board 35 × 43 (E)
1993.1221

Mills, T. B. 1906–1989
Stopham Bridge 1950–1970
oil on board 28.0 × 32.5 (E)
1993.1222

Mills, T. B. 1906–1989
Old Eastlands 1950–1970
oil on board 36.5 × 50.0 (E)
1993.1228

Mills, T. B. 1906–1989
King's Barn, Kent Street, Cowfold 1940–1960
oil on board 31.5 × 45.0 (E)
1993.1231

Mills, T. B. 1906–1989
Jarvis Cottage 1940–1970
oil on board 26.0 × 34.5 (E)
1993.1232

Mills, T. B. 1906–1989
Coombes Church, Sussex 1940–1960
oil on board 32.5 × 48.0 (E)
1993.1233s

Mills, T. B. 1906–1989
Cowfold Monastery 1940–1960
oil on board 34.5 × 50.0 (E)
1993.1235

Mills, T. B. 1906–1989
Maragrett Cottages, Cowfold 1940–1960
oil on board 31 × 46 (E)
1993.1236

Mills, T. B. 1906–1989
Landscape with Cottage 1966–1989
oil on board 30.2 × 40.3 (E)
1993.1282

Mills, T. B. 1906–1989
Long House, Cowfold 1950–1970
oil on board 38 × 48
1993.1285

Mills, T. B. 1906–1989
Landscape with House 1940–1960
oil on board 31.0 × 40.7
1993.1381

Mills, T. B. 1906–1989
Cottages, Cowfold Churchyard 1950–1970
oil on board 29.5 × 39.5 (E)
1993.12004

R. A. P.
Landscape with Stag 1860–1900
oil on board 62.2 × 52.2 (E)
X1996.1922

R. A. P.
Landscape with Stags 1860–1900
oil on board 62.2 × 52.2 (E)
X1996.1924

Padwick, Philip Hugh 1876–1958
Sussex View
oil on canvas 44 × 62
1993.1308.2

Padwick, Philip Hugh 1876–1958
Sussex Landscape
oil on board 37 × 75
1993.1308.4

Padwick, Philip Hugh 1876–1958
Sussex View
oil on canvas 36 × 52
1993.1908.3

Piper, William
Wheelwright and Smith Shops, Southwater
1910
oil on board 52 × 68
1976.45

Radley, F.
Sussex and Dorking Brickworks 1936
oil on board 43.0 × 56.5 (E)
1999.81

Steer, William
Post Windmill, Possibly Champions Mill,
Horsham Common 1830
oil on oak 58.0 × 54.2 (E)
X1996.762

Thompson, J.
Waterlilies 1990
oil on board 89.5 × 140.5 (E)
2002.566

unknown artist
View of Cottage in a Forest 1800–1850
oil on canvas 51.5 × 60.7 (E)
X1999.1175

unknown artist
Joseph Marryatt, Horsham MP 1807–1812
oil on canvas 90 × 77 (E)
1999.1801

unknown artist
The Reverend George Marshall (1780–1850)
c.1820
oil on canvas 79 × 66

unknown artist
Jackson Bros. Cycle Shop 1900
oil on canvas 51 × 61 (E)
1995.499

unknown artist
Old Brighton Pier
oil on board 32 × 47
1944.3

unknown artist
Remains of Old Brighton Pier
oil on board 32 × 47
1944.4

unknown artist
The Causeway
oil on canvas 35 × 57
X1990.2322

unknown artist
Mr Newman
oil on canvas 63 × 53
x1995.1664

unknown artist
James Davidson c.1830
oil on canvas 75 × 64
X1996.2909

unknown artist
Lady with Red Cape and Green Dress
oil on canvas 76 × 63
X1997.2114

unknown artist
Town Hall, Horsham
oil on canvas 27 × 64
2004.315

Wells, Phil
Garden Pool, Henfield 1960–1980
oil on canvas 53.5 × 69.0 (E)
1998.2952

Winder, J. G.
St Mary's Church, Horsham 1960–1980
oil on board 46.3 × 56.5 (E)
X1997.6696

Horsham District Council: Park House

Grace, Alfred Fitzwalter 1844–1903
Lea Farm, Storrington c.1882
oil on canvas 94 × 160
1

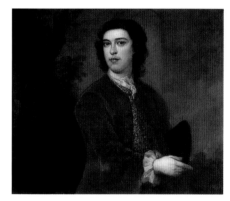

Jervas, Charles (attributed to) c.1675–1739
John Wicker II (1668–1741) c.1720
oil on canvas 82 × 95
2

Kelsey, Frank active 1887–1926
At Anchor c.1910
oil on canvas 88.9 × 134.6
3

Ramsay, James 1786–1854
The Entry of the Black Prince into London with the French King and His Son 1839
oil on canvas 132 × 193
4

Lancing Library

Thomas, Edward
View from Top of Mill Road, Lancing
oil on board 44 × 54
1

Thomas, Edward
Lancing College Buildings
acrylic on board 36 × 22
2

Thomas, Edward
Behind Lancing Manor
oil on board 39 × 50
3

Arun District Council

Snow, Sinclair
St Mary's the Virgin, East Preston, 12th Century
1984
oil on canvas 21.0 × 29.7

Facing page: Middleton, James Godsell, active 1826 –1872, *Miss Mordaunt (...)* (detail), Worthing Museum and Art Gallery (p. 150)

Littlehampton Museum

Littlehampton Museum's collection of fine art has been built up over a number of years. Most of the oil paintings have some kind of connection to Littlehampton. The majority are painted by artists from the town and represent local scenes or themes.

There are several paintings within the collection that are of local importance. One such painting shows passengers boarding the '*Worthing Belle*', which was a cross-channel ferry steamer, at the steps next to the Nelson pub. The scene dates from the 1880s, but was painted in 1966 by Leslie Arthur Wilcox. This was the only ferry service in Littlehampton and ran from 1863 to 1884. The ferry service operated to Honfleur in France.

Another important painting is of Littlehampton esplanade by A. Plant. This painting dates from 1854 and shows the seafront in Littlehampton. This provides an interesting insight into how the town used to look, as well as highlighting features which no longer exist, such as the Beach Hotel.

Rolf Zeegers, Assistant Curator

Ahlqhuist 19th C
S. S. Collingwood
oil on board 41.5 × 61.0
P035

Aldridge, Frederick James 1850–1933
Littlehampton Harbour
oil on canvas 40 × 60
P594

Baldry, George W.
Joseph Robinson
oil on canvas 54 × 43
P378

Barkhouse, J.
Pride of the Arun 1868
oil on canvas 43.0 × 58.5
P587

Bottomley, **Reginald** active 1883–1895
A Mother and Child Looking at the Virgin and Child
oil on canvas 115 × 86
P105

Burn, **Gerald Maurice** 1862–1945
Harvey's Shipyard
oil on canvas 75 × 111
P043

T. C. 19th C
Night Scene of Harbour Mouth
oil on canvas 75 × 111
P071

Clarkson, **William H.** 1872–1944
Haystacks at Dusk
oil on canvas 60 × 90
P050

Clink, **Edith L.** active 1895–1913
Arundel Bridge
oil on canvas 37 × 56
P058

Constable, **George II** active 1837–c.1862
The Arundel Watermill 1837
oil on canvas 33 × 36
P033

Gilks, **G. L.** 19th C
Harvey's Shipyard
oil on canvas 32 × 44
P070

Harris, **Edwin Lawson James** 1891–1961
Country Scene with Trees and Stream 1914
oil on canvas 55 × 75
P002

Hudson, I.
The Brigantine 'Adela' 1895
oil on canvas 59 × 90
P044

Johnston, Harry Hamilton 1858–1927
Olive Tree and Gardens of La Massa, Tunis
oil on canvas 26 × 36
P074

Kensington, C.
The Barque 'Lioness' 1884
oil on canvas 29 × 49
P039

Longstaff, Will 1879–1953
View of Arundel
oil on board 36 × 53
P047

Pike, Sidney active 1880–1907
The Golf Links, Littlehampton
oil on canvas 29 × 34
P036

Pike, Sidney active 1880–1907
Thatched Cottage in Wick 1900
oil on board 21 × 31
P049

Pike, Sidney active 1880–1907
Fishermen beside River Mouth 1900
oil on board 21 × 31
P051

Plant, A.
Littlehampton Esplanade 1854
oil on canvas 71 × 129
P032

Poulsen
The Barque 'Flirt' 1850
oil on canvas 44.5 × 65.0
P041

Poulsen
Naval Revenue Cutter 'HMS Chameleon' 1856
oil on canvas 69 × 89
P042

Poulsen
Harvey's Shipyard 1852
oil on canvas 89 × 128
P053

Randall, Maurice active 1890–1919
The Barque 'Trossachs'
oil on canvas 100 × 75
P040

Randall, Maurice active 1890–1919
Littlehampton Harbour 1890
oil on board 59 × 90
P045

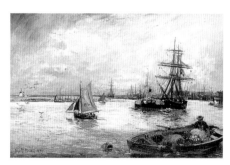

Reid, John Robertson 1851–1926
The Market Boat 1899
oil on canvas 45 × 67
P186

Roach
The Coastguard Cottages 1872
oil on canvas 32.5 × 52.0
P363

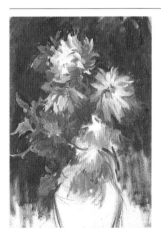

Robley, A. 19th C
Chrysanthemums
oil on board 35 × 24
P066

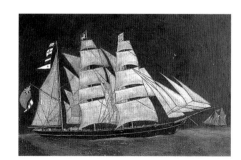

Staples, George 19th C
Jane Harvey
oil on canvas 48 × 70
P073

Terry, John
Iron Clipper 'Benvenue' 1867
oil on canvas 49 × 74
P185

unknown artist 19th C
'Honfleur' Steamer Loading at Wharf
oil on canvas 30 × 50
P037

unknown artist 19th C
Rustington Mill
oil on canvas 56 × 76
P054

unknown artist 19th C
Littlehampton Harbour Mouth
oil on canvas 27.5 × 60.0
P114

unknown artist 19th C
West Beach, Littlehampton
oil on canvas 17 × 25
P159

unknown artist 19th C
The Beach Hotel
oil on canvas 14 × 22
P333

Webb, James c.1825–1895
Littlehampton Esplanade 1887
oil on canvas 50 × 60
P031

Wilcox, Leslie Arthur 1904–1982
Passengers Boarding the 'Worthing Belle' at the Nelson Steps, Littlehampton Harbour 1966
oil on canvas 30 × 50
P387

Petworth Cottage Museum

unknown artist
Exterior of Petworth Gaol, Possibly of the Treadmill or 'Crankhouse' 1860s?
oil on canvas 27.5 × 32.0
C0093-1997.75

unknown artist
Interior of Petworth Gaol 1860s?
oil on canvas 27.5 × 32.0
E0093-1997.76

Petworth Parish Council

Courtauld, Jeanne
Northern Parishes of Petworth Rural Council 1964
oil on canvas 208 × 77
1

Courtauld, Jeanne
Petworth Parish 1965
oil on canvas 97.5 × 105.0
2

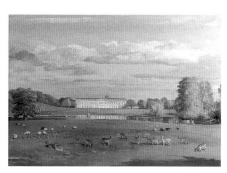

Courtauld, Jeanne
Petworth House and Lake c.1964
oil on canvas 72.5 × 105.5
3

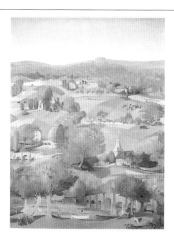

Courtauld, Jeanne
Southern Parishes of Petworth Rural Council 1963–1965
oil on canvas 207.5 × 156.0
4

Rustington Library

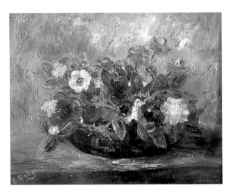

Roberts, Eileen
Anemones
oil on canvas 30 × 38
2

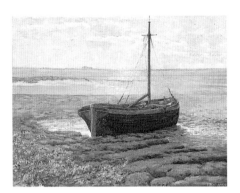

Warnes, Herschell F. b.1891
Derelict Barge, the 'Leonard Piper' 1961
oil on canvas 43 × 55
1

Adur District Council

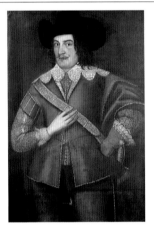

British (English) School 17th C
Captain Thomas Poole (1652–1699)
oil on canvas 100 × 70

Jenner, William
Near Kingston-by-Sea, Glowing Autumn Sunset
oil on canvas 20 × 40

Meadows, James Edwin active 1853–1875
A Rural Scene with Children, a Horse and a Cottage
oil on canvas 72.5 × 120.0

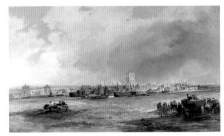

Webb, James c.1825–1895
Shoreham, Sussex
oil on canvas 70 × 125

Marlipins Museum

Marlipins Museum is run by the Sussex Archaeological Society and is housed in one of the oldest lay buildings in Sussex. Part of the building dates back to the 12th century. Its distinctive chequerboard front of Caen stone and squared flint is one of the most recognisable landmarks of Shoreham-by-Sea. Thanks to generous financial support from the Heritage Lottery Fund and others, there is now a two-storey, purpose-built annexe that opened on 1 May 2004. This allows space for an active temporary exhibition programme, displays of local history and archaeology and hanging space for the art collection.

This collection of art includes some excellent examples of pierhead paintings and local shipping, which backs up the maritime flavour of the main gallery. There is also a wide range of pictures of the area, from the spectacular views of Lancing College and the magnificent churches of St Nicolas and St Mary de Haura to detailed street scenes or portraits of people who made their mark in and around Shoreham. The museum building itself figures in works by George de Paris and R. H. Nibbs (which are not oil paintings and therefore do not feature in this catalogue) and there are many views of the old Tollbridge or the fine Norfolk Bridge which have enabled people to cross the river Adur for some 200 years.

The work of artists, in oils or watercolours, is backed by a magnificent collection of photographs of the area. Some 600 of these images from Marlipins figure in a new database in conjunction with the Library Service and five other museums in West Sussex. Those wanting to add to the information that they can see in the pictures and find out how the Shoreham area has moved with the times should visit the website at www.westsussexpast.org.uk/pictures.

Helen Poole, Senior Museums Officer for the Sussex Archaeological Society

Baker, N. A.
'Arthur Wright' 1982
oil on board 25.5 × 30.0
SHORM51

Baker, N. A.
'Sylvia Beale'
oil on board 23.0 × 27.5
SHORM147

Brander, A. K.
'The Dolphin Shoreham' off Cape Horn, 1874
c.1874
oil on canvas 59.5 × 92.0
SHORM103

Brander, A. K.
Brig 'Shannon of Shoreham' c.1871
oil on canvas 57 × 97 (E)
SHORM152

Brander, A. K. (attributed to)
'Light of the Age' at Sea, Calm Weather c.1862
oil on stretcher 48 × 73
SHORM105

Brander, A. K. (attributed to)
'Solla of Shoreham' at Sea 1864
oil on stretcher 46 × 72 (E)
SHORM106

Brander, A. K. (attributed to)
'Light of the Age' at Sea, Rough Weather c.1862
oil on stretcher 50 × 72
SHORM115

Bristow, Cedric
Barque 'Aldebaran of Shoreham'
oil on board 44.0 × 66.5
SHORM86

Cox, David the younger 1808–1885
View of Hangleton 1857
oil on canvas 51 × 75
SHORM45

Emsley, Walter active 1883–1927
River Adur, St Nicholas Church 1896
oil on canvas 50.5 × 76.0
SHORM141

Fortescue, William Banks (attributed to)
c.1855–1924
Swiss Gardens in Evening 1886
oil on canvas 46 × 66
SHORM155

Fox, Edward 1788–1875
Old Shoreham Church 1829
oil on stretcher 35.5 × 29.5 (E)
SHORM80

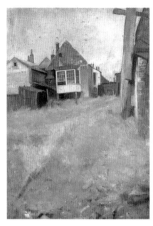

Gogin, Alma 1854–1948
Our Studio at Shoreham c.1900
oil on canvas 56 × 40 (E)
SHORM93/2139

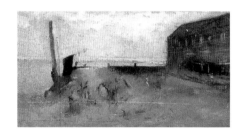

Gogin, Alma 1854–1948
Ballys Old Shipyard c.1889
oil on hardboard 22 × 40
SHORM93/2371/1

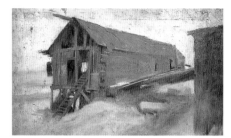

Gogin, Alma 1854–1948
Shipyard Studio, Shoreham c.1889
oil on hardboard 22 × 40
SHORM93/2371/2

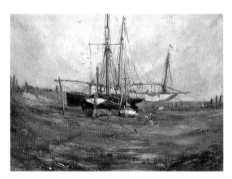

Gornold, Royal
Boats on Shoreham Mud Flat c.1935
oil on canvas 37 × 47 (E)
SHORM93/2196

Harrison, Brook 1860–1930
Swiss Gardens 1929
oil on wood 24 × 35
SHORM93/2214

Harrison, Brook 1860–1930
Swiss Gardens c.1930
oil on canvas 51 × 70
SHORM2

Harrison, Brook 1860–1930
The Fortune-Teller's Hut, Swiss Gardens 1911
oil on canvas 51 × 70
SHORM144

Harrison, Brook (attributed to) 1860–1930
By the Lake, Swiss Gardens c.1929
oil on board 24 × 34
SHORM93/2210

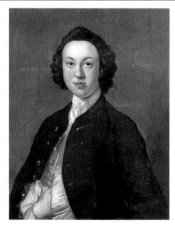

Hudson, Thomas (attributed to) 1701–1779
Charles Haddock c.1750
oil on stretcher 71 × 58 (E)
SHORM102

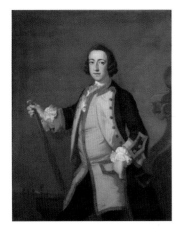

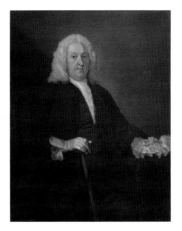

Hudson, Thomas (attributed to) 1701–1779
Probably Captain Richard Haddock
oil on canvas 124 × 99
SHORM117

Hudson, Thomas (attributed to) 1701–1779
Said to be Sir Richard Haddock (Father of Captain Richard Haddock)
oil on canvas 124 × 99
SHORM118

Jacobsen, Antonio 1849–1921
'Hector' Ship at Sea c.1887
oil on canvas 55.0 × 89.5 (E)
SHORM162

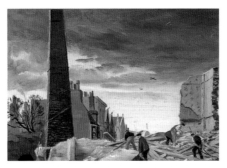

Litchfield, Anthony E.
View of Marlipins Museum 1926
oil on board 43 × 31
SHORM91

Mason
Demolition in Shoreham High Steet 1938
oil on board 24.3 × 34.3 (E)
SHORM34

Mears, George active 1866–1890
Coastal Scene with Yachts and Rowing Boat (Regatta)
oil on canvas 43 × 61 (E)
SHORM64

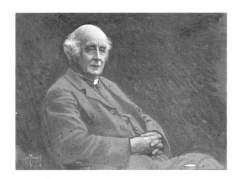

Oakman, J. J.
Lieutenant Mervyn William Curd, RNVR 1943
oil on canvas 41.5 × 35.5 (E)
SHORM79

Pannell, E. W.
Reverend Charles M. A. Tower 1918
oil on canvas 30.0 × 39.5
SHORM159

Pierce, G.
Shoreham Harbour c.1970
oil on canvas 22.0 × 45.5
O1/3149

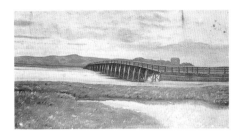

Piper
Shoreham Bridge and Mud Flats
oil on canvas 30.0 × 50.7
SHORM69

Skinner, Ivy M. b.1890
Shoreham Harbour 1974
oil on hardboard 62 × 115 (E)
SHORM156

Stamp, Ernest 1869–1942
John Street, Shoreham-by-Sea 1942
oil on wood 41.5 × 51.0 (E)
SHORM93/2147

unknown artist
Wreck of the 'Nympha' c.1750
oil on stretcher 44 × 64 (E)
SHORM116

unknown artist
Shoreham Harbour from South Bank c.1800
oil on stretched canvas 25.0 × 45.5
SHORM93/2143

unknown artist
'Eliza Emma of Shoreham' c.1855
ships paint? on canvas 49.5 × 88.0 (E)
SHORM58

unknown artist
*Southwick and Shoreham Looking West towards
Fishergate* c.1860
oil on canvas 34.3 × 52.0 (E)
SHORM13

unknown artist
Portrait of Man in a Gown c.1860
oil on stretcher 66 × 47 (E)
SHORM100

unknown artist
'Merchant of Shoreham' at Sea 1869
oil on canvas 52.0 × 78.5
SHORM59

unknown artist
Destruction of Coast Road at Lancing c.1877
oil on canvas 37 × 58 (E)
SHORM14

unknown artist
Henry Fitzalan Howard, 15th Duke of Norfolk
c.1898
oil on board 58 × 34 (E)
SHORM78

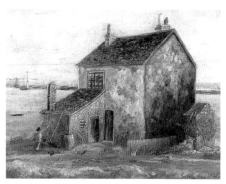

unknown artist 19th C
The Crab House, Southwick
oil on board 23 × 30 (E)
SHORM36

unknown artist 19th C
Portrait of Victorian Lady
oil on canvas 86 × 70
SHORM157

unknown artist 19th C
Portrait of Victorian Gentleman
oil on canvas 86 × 70
SHORM158

unknown artist
End of Pier c.1910
oil on canvas 47 × 57 (E)
SHORM93/2187

Steyning Museum

unknown artist
St Andrew's Church, Steyning c.1857
oil on canvas 25.8 × 65.0
2003.152 (P)

Whitmore, Robert
St Cuthman 1982
oil on canvas 55 × 76
1983.2

Worrall, E. J.
Frontage of Steyning Station 1940s
oil on board 75.0 × 60.5
2001.352

Priest House

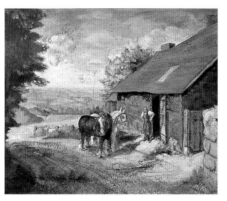

Ullmann, Thelma Beatrice c.1915–c.1999
The Old Forge, West Hoathly 1963
oil on canvas 50.7 × 61.2
WEHPH:000.228

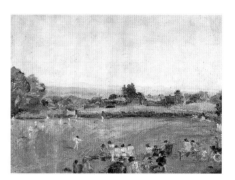

Ullmann, Thelma Beatrice c.1915–c.1999
West Hoathly Cricket Ground and Langridge Farm 1954
oil on paper 30.3 × 40.5
WEHPH:000.743

Worthing Hospital

The Worthing and Southlands Art in Hospitals Project commenced in 1994 to coincide with a large building development planned for Worthing Hospital. It was initially an uphill struggle for Dr Roger Edwards, and the late Amanda Metcalf (Artistic Advisor) because the funds which were available were sparse. However, there was a determination that the hospitals would be enriched with artworks and, for that reason, paintings were purchased from up-and-coming painters. Latterly, a most generous bequest from Miss Freda Sage has enabled the commissioning of work by more established artists.

Essentially, the subject matter of paintings throughout the project relates to the nature of the environment and the atmosphere of Worthing, Shoreham,

and the immediate surroundings. The themes are thus the sea, the towns, the South Downs and the sky. Sometimes these themes are quite loosely interpreted. The project is continuing and it is hoped that future building developments will attract further funding for purchasing art.

Dr Roger Edwards, Consultant Anaesthetist and Project Coordinator

Aggs, Christopher b.1951
Sunrise over West Sussex, 1995 1995
oil on canvas 121 × 153
1

Ball, Emily b.1967
Worthing Beach Scene, 1995 1995
oil on canvas 148 × 240
2

Ball, Emily b.1967
Worthing Beach Scene, 1995 1995
oil on canvas 117 × 178
24

Donegan, Jo b.1966
Tree of Animals 1995
oil on canvas 153 × 180
6

Donegan, Jo b.1969
Noah's Ark 1995
oil on canvas 122 × 152
21

Frith, Ann
Against the Tide 1998
oil & mixed media on board 153 × 180
5

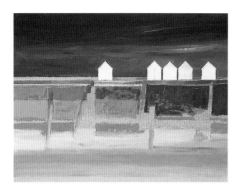

Humphreys, David b.1937
Beach Huts, Lancing c.1995
oil on canvas 90 × 121
4

Lamb, Jo b.1952
Mr Beckmann Comes to Worthing 1995
oil on canvas 122 × 152
22

Leach, Ursula
Diptych, Downlands Fields 1995
oil on canvas 137 × 203 (× 2)
9

Ottey, Piers b.1955
Bignor Hill Downs 2000
oil on canvas 46 × 88
8

Penoyre, Kate b.1954
Steyning Bowl 2001
oil on canvas 122 × 183
17

Penoyre, Kate b.1954
Devil's Dyke 2001
oil on canvas 122 × 92
18

Ruffell, Shyama b.1961
Poppy 2003
oil on board 75 × 90
10

Ruffell, Shyama b.1961
Thistle 2003
oil on board 90 × 75
11

Ruffell, Shyama b.1961
Common Spotted Orchid 2003
oil on board 75 × 90
12

Ruffell, Shyama b.1961
Tortoiseshell Butterfly 2002
oil on canvas 76 × 92
13

Ruffell, Shyama b.1961
Cabbage White Butterfly 2002
oil on canvas 76 × 92
14

Ruffell, Shyama b.1961
Purple Emperor Butterfly 2002
oil on canvas 76 × 92
15

Ruffell, Shyama b.1961
Peacock Butterfly 2002
oil on canvas 76 × 92
16

Ruffell, Shyama b.1961
Dandelion 2003
oil on board 75 × 90
23

Suhrbier, Karine b.1963
Buttercup Meadow 2003
oil on canvas 91 × 91
19

Suhrbier, Karine b.1963
Harebell Meadow 2003
oil on canvas 122 × 183
20

Tribe, Maria b.1972
Sea Forms Cyprus 1995
oil on canvas 131 × 167
3

Tribe, Maria b.1972
Trodos Mountains, Cyprus 1995
oil on canvas 152 × 122
7

Worthing Library

T. T. H.
West Tarring Church, Near Worthing, Sussex
1856
oil & pencil on paper with card 19.6 × 27.9
WA000276

Parkin, J. R.
Heene Cottage, Worthing c.1889
oil on paper with card 21.0 × 29.5
WA000397

unknown artist
Smallholding (Brickfields) Near St Leonard's
c.1878
oil on paper with card 33 × 50
WA000477

unknown artist
Farm and Coast Near St Leonard's c.1880
oil on paper with card 23.5 × 35.0
WA000476

unknown artist
St Leonard's Beach and Sea c.1900
oil on paper with card 18.0 × 25.4
WA000474

unknown artist
St Leonard's Beach and Coastline c.1900
oil on paper with card 18.0 × 25.4
WA000475

Worthing Museum and Art Gallery

The fine art collection at Worthing Museum and Art Gallery began when the museum was opened in 1908 and consists of watercolours, oils and acrylic paintings, prints and drawings. Currently there are over 200 oil paintings within the fine art collection.

The fine art collection as a whole has been built up with bequests, donations and purchases. Over the years the collection policy has developed a focus on the major movements in British art from around 1800 onwards, with a few exceptions. However, this policy was not put in place until Worthing became a registered museum in the 1970s. Prior to this, the museum had no strict collecting policy. The aim, since then, has been for the collection to be representative of the main British art movements since 1800.

Romantic, Pre-Raphaelite and particularly the Modern British movements are well represented in the oil painting collection. Conversely, there are a few significant gaps, such as examples of work by John Constable and the Bloomsbury Group. While there is a watercolour by J. M. W. Turner in the collection we do not have an oil painting by him. Oil paintings of landscapes, portraits and local views feature strongly, as well as still life and figurative works. Overall, there are few abstract or contemporary paintings, although we are actively acquiring more. The local influence is prevalent throughout the collections and many paintings depict a Sussex subject or are painted by an artist with a Sussex association.

The Camden Town Group are well represented and the collection includes works by Harold Gilman, Spencer Gore, Charles Ginner, Lucien Pissarro and Walter Sickert. The 'jewel in the crown' of the collection is *Bianca*, a rare Shakespearean-inspired portrait of 1869, by William Holman Hunt, one of the founders of the Pre-Raphaelite Brotherhood. There is also an extensive and fine variety of Victorian works. The contemporary paintings include pieces by John Bratby and Ivon Hitchens. All of these and many more are regularly lent to galleries and museums for specific exhibitions in the UK and abroad. In 2004 we lent Holman Hunt's *Bianca* to the Uffizi in Florence and regularly lend out *The Furnace Man* by Stanley Spencer. The few examples of earlier work in the collection include a portrait of Mary Anne Colmore by Francis Cotes who was a successful society portrait painter during the 18th century. A good example of early topographical landscape painting is seen in William Challen's *Panoramic View from the Miller's Tomb, Highdown Hill 1770*, which depicts a local view. The collection also includes a small number of works by influential European artists such as Meindert Hobbema, Jan Wijnants and Jacopo Bassano and their followers.

Our aim is for the fine art collection to continue to develop, particularly in building upon the less represented areas whilst still maintaining the current collection. The other commitment is to making the collections as accessible to the public as possible.

Emma Ball, Assistant Curator, Art & Exhibitions and Laura Kidner, Assistant Curator, Art & Exhibitions

Facing page: Procter, Ernest, 1886–1935, *All the Fun of the Fair* (detail), c.1927–1928, Worthing Museum and Art Gallery (p. 154)

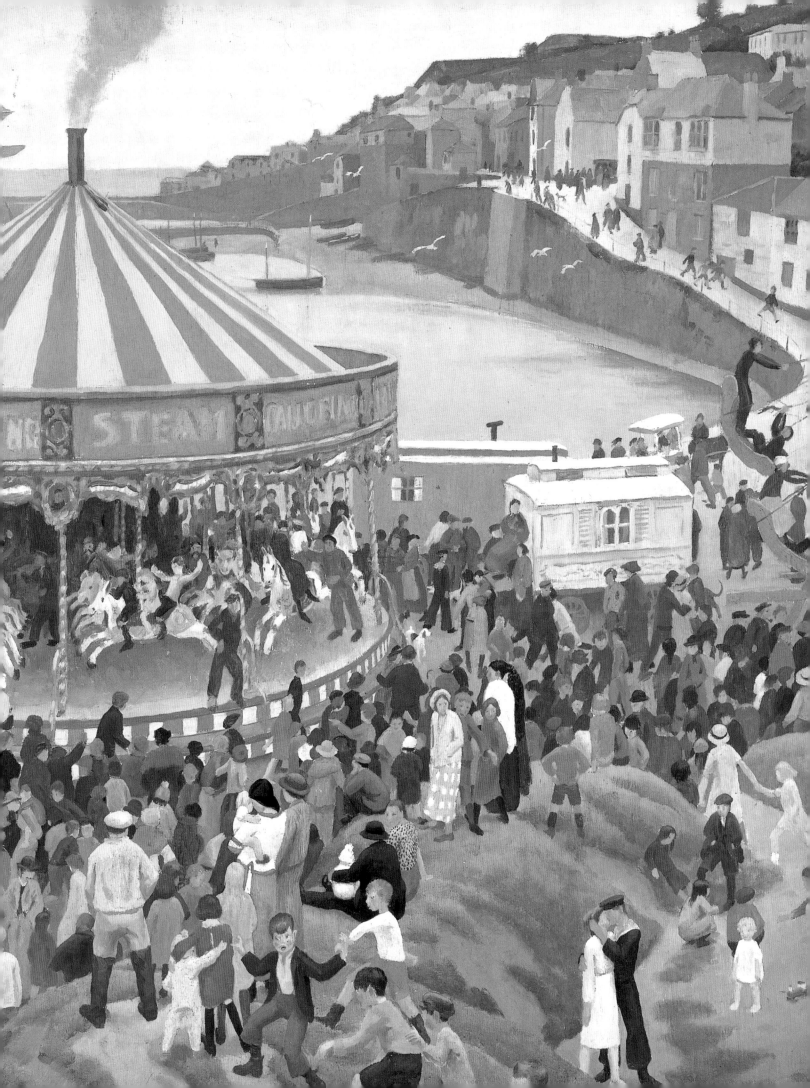

Aggs, Christopher b.1951
The Collection c.1990–2000
oil on canvas 80 × 71 (E)
2001/352

Allom, Thomas 1804–1872
The Church of St Jacques, Antwerp
oil on canvas 81.5 × 122.2
x1983/209

Baker, E.
High Street, Tarring 1888
oil on canvas 43.2 × 56.0
1973/362

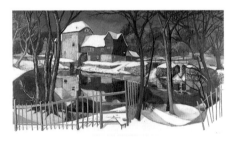

Barnden, Bruce b.1925
Mill Near Midhurst 1961
oil on hardboard 70.8 × 121.2
1962/3593

Baron, Danielle b.1944
Feux d'artifices sur la principauté 1970
oil on canvas 25.1 × 60.7
1970/681

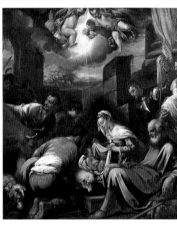

Bassano, Jacopo il vecchio (school of)
c.1510–1592
Il presepio di san Giuseppe
oil on canvas 125.3 × 111.0
x1964/286

Benger, Berenger 1868–1935
Shoreham Harbour
oil on canvas board 25.4 × 35.5
1962/3588

Benger, Berenger 1868–1935
Rural Scene 1921
oil on panel 25.1 × 35.7
1962/3592

Benger, Berenger 1868–1935
Downland Landscape 1923
oil on canvas board 25.5 × 35.5
1967/825

Benney, Ernest Alfred Sallis 1894–1966
A Sussex Barn
oil on canvas 35.6 × 45.8
1929

Berwick, John
Dr Pitt Senior c.1950s
oil on canvas 75 × 63
2003/127

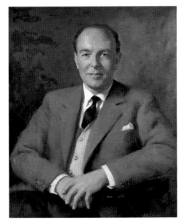

Berwick, John
Dr William Pitt Junior c.1950s
oil on canvas 75 × 63
2003/128

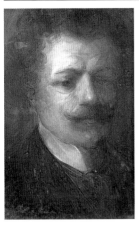

Blaker, Hugh Oswald 1873–1936
Self Portrait 1906
oil on panel 23.6 × 16.4
2227

Blaker, Hugh Oswald 1873–1936
Man's Head in Colour
oil on brown paper 30.5 × 20.5
2715

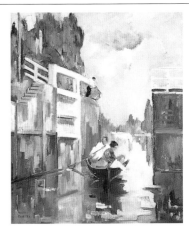

Blaker, Hugh Oswald 1873–1936
Teddington Lock
oil on canvas 76.1 × 63.4
2738

Blaker, Hugh Oswald 1873–1936
Homeless
oil on board 63.5 × 76.0
2739

Bland, Emily Beatrice 1864–1951
Littlehampton
oil on canvas 30.5 × 51.0
1932

Bloomer, W. H.
Miss Langley, Postmistress at Tarring c.1910
oil on canvas mounted on board 36.1 × 25.5
1961/77

Bottomley, Albert Ernest 1873–1950
Norfolk Bridge, Shoreham 1921
oil on canvas 36.0 × 46.3
1921

Brangwyn, Frank 1867–1956
The Crushing Mill 1948
oil on panel 45 × 55
2697 🐝

Bratby, John Randall 1928–1992
Self Portrait Triptych 1961
oil on canvas 121.7 × 93.4
1969/337 🐝

Bratby, John Randall 1928–1992
Red, Red 1990
oil on canvas 122.5 × 92.0
1996/1 🐝

Brighton, Bob
Four 1996
acrylic on canvas 168 × 122
2003/159

Brighton, Bob
Four 1996
acrylic on canvas 168 × 122
2003/160

Brighton, Bob
Four 1996
acrylic on canvas 168 × 122
2003/161

Brighton, Bob
Four 1996
acrylic on canvas 168 × 122
2003/162

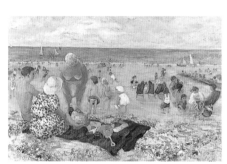

Brooks, Brenda
Bank Holiday 1992
oil on canvas 60.5 × 89.5
2000/5

Brooks, Brenda
Punch and Judy 1996
oil on canvas 87 × 62
2001/241

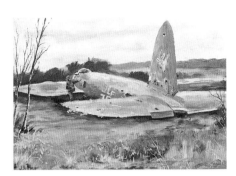

Brown, N. O.
'Heinkel' Shot Down on High Salvington,
August 1940 c.1940
oil on canvas 25.6 × 36.0
1973/843

Burleigh, C. H. H. 1875–1956
The Oak Dresser
oil on canvas 86.3 × 62.0
1938

Callam, Arthur Edward 1904–1980
Arthur's Castle, Tintagel
oil on hardboard 76.0 × 101.2
1981/1

Cattermole, Lance 1898–1992
Lady Stern 1941
oil on canvas 61.0 × 45.8
1972/1457

Cattermole, Lance 1898–1992
The First Royal Visit
oil on canvas 63.5 × 76.5
1982/162

Cattermole, Lance 1898–1992
The Art Critic 1962
oil on canvas 81.0 × 93.8
2002/34

Challen, William
Panoramic View from the Miller's Tomb,
Highdown Hill 1770
oil on canvas 80.5 × 151.8
x1975/382

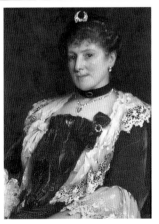

Clark
Portrait of a Lady c.1880
oil on canvas 71.3 × 58.3
1965/433

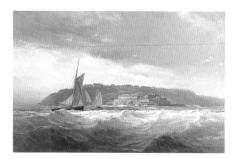

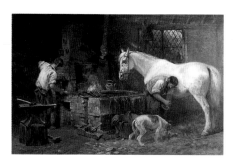

Cole, George 1810–1883
Mount Edgecumbe
oil on panel 31 × 46
1927

Cole, George 1810–1883
The Smithy
oil on canvas 35.3 × 53.0
1933

Cole, Rex Vicat 1870–1940
A Sussex Granary
oil on canvas 50.7 × 61.2
817

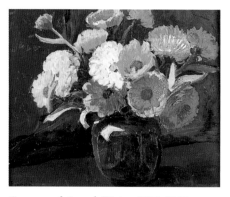

Communal, Joseph Victor 1876–1962
Soucis
oil on plywood 38.3 × 46.4
1922

Compton, Edwin
Broadwater Church from Manor Field 1881
oil on board 31.8 × 60.9
x1969/342

Compton, Edwin
The Half Brick Inn 1867
oil on canvas 36.7 × 50.0
x1973/65

Compton, Edwin
Old Cottages in Heene Lane 1891
oil on canvas 47.0 × 60.8
x1974/110

Condy, Nicholas c.1793–1857
'HMS Royal Adelaide' 1836
oil on canvas 43.1 × 60.7
680

Cooke, Anthony R. b.1933
Houses and Houseboats, Shoreham
oil on canvas 76.5 × 101.3
1964/385

Cooper, Thomas Sidney 1803–1902
Studies in Figures
oil on board 27.8 × 21.7
1962/2378

Cotes, Francis 1726–1770
Mary Anne Colmore 1764
oil on canvas 127.0 × 101.8
1980/415

Cox, David the elder 1783–1859
Rook Shooting 1849
oil on panel 46.0 × 30.5
1965/581

Cumming, Peter b.1916
Worthing Seafront 1950's c.1950s
oil on canvas 51.0 × 60.5
2003/131

De Karlowska, Stanislawa 1876–1952
Le Lavoir, St Nicholas-du-Pelem, Brittany
1931–1932
oil on canvas 50.8 × 40.6
1968/484

Dillens, Adolphe-Alexander 1821–1877
British Volunteers and the Belgian Garde
Civique in Brussels 1866
oil on canvas 40.7 × 53.4
834

Douglas, Edwin 1848–1914
My Queen 1876
oil on canvas 41.0 × 27.5
1972/1346

Earl, Maud 1848–1943
Sussex Pocket Beagles
oil on canvas 76.5 × 102.5
3565

Estall, William Charles 1857–1897
Sheep on the Downs
oil on panel 26.8 × 37.8
1963/1968

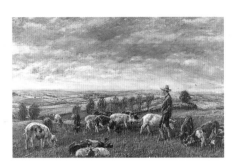

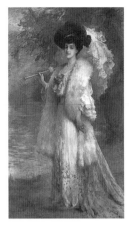

Ferneley, John E. 1782–1860
Two Horses and a Dog 1845
oil on canvas 86.2 × 106.4
x1964/285

Fisher, Mark 1841–1923
On the Sussex Downs c.1883
oil on canvas 54.8 × 80.6
1964/386

Fisher, Samuel Melton 1859–1939
Mrs Rodocanachi 1905
oil on canvas 240 × 139
x1974/392

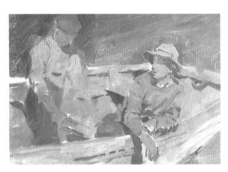

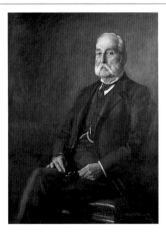

Forbes, Stanhope Alexander 1857–1947
The Fishers
oil on canvas 26.6 × 36.8
1971/1460

Ford, Peter b.1937
Nice Business, Nice People 1977
oil on scrim and hardboard 66 × 93
1977/70

Gardiner, John H. active 1910–1925
Alderman A. Cortis 1910
oil on canvas 122.0 × 91.5
1994/317

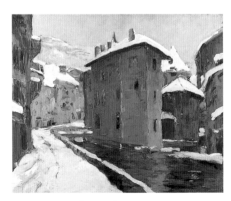

Germain, Louise Denise 1870–1963
Vielles casernes, Annecy
oil on panel 50.4 × 61.3
1925

Giles, Frank Lynton 1910–2003
Low Tide at Bosham Harbour
oil on hardboard 25.3 × 30.4
1974/105

Gilman, Harold 1876–1919
The Mountain Bridge 1913
oil on canvas 62 × 80
2425

Ginner, Charles 1878–1952
Rottingdean 1914
oil on canvas 64.8 × 81.2
1937

Gore, Spencer 1878–1914
The Pond 1912–1913
oil on canvas 50.8 × 61.0
1968/292

Gorton, Lesley-Ann b.1939
Winter in Mid-Sussex 1966
oil on hardboard 61.0 × 91.5
1966/126

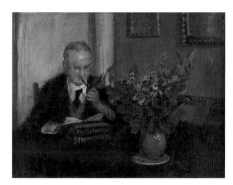

Gosse, Laura Sylvia 1881–1968
The Harpist
oil on canvas 106.8 × 45.0
2718

Guthrie, Robin 1902–1971
James J. Guthrie
oil on canvas 35.5 × 45.8
2657

Guthrie, Robin 1902–1971
Equestrian Portrait 1934
oil on canvas 103.7 × 152.3
3263

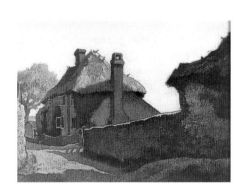

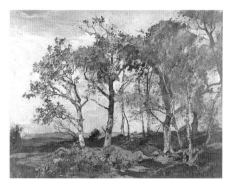

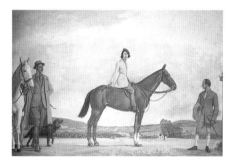

Guy, Cyril Graham active 1929–1938
Old Cottage, Amberley
oil on canvas 30.8 × 40.5
1928

Hall, Oliver 1869–1957
Oak Trees on Duncton Common
oil on canvas 55.8 × 71.0
819

Henderson, Keith 1883–1982
Sunlit Cliff, Arabian Desert
oil on canvas board 48.5 × 35.1
1971/1274

Henderson, Keith 1883–1982
Harbour Crowd c.1930
oil on canvas 70.7 × 84.0
810

Henderson, Keith 1883–1982
Ayios Varnavas, Cyprus; Monks with a Black Kid
oil on board 30.3 × 34.8
L173/G (P)

Henry, George F. 1858–1943
Pastoral 1939
oil on canvas 50.6 × 60.8
818

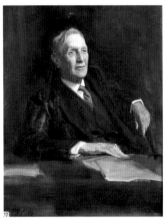

Hepple, Norman b.1908
Sir Fredrick Stern OBE, MC 1953
oil on canvas 50.8 × 40.5
1972/1456

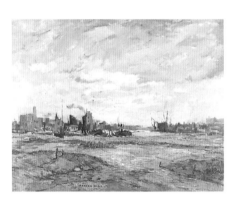

Hill, Adrian Keith Graham 1895–1977
The Estuary, Southport 1949
oil on canvas 71.2 × 91.7
1964/387

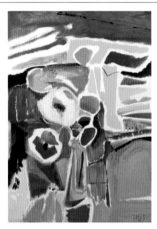

Hitchens, Ivon 1893–1979
Flowers in Hot Sun 1975
oil on canvas 121.5 × 86.7
1979/95

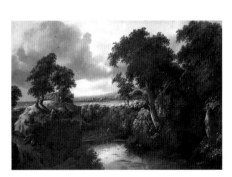

Hobbema, Meindert (after) 1638–1709
Landscape
oil on canvas 108.5 × 154.5
1947

Hobby, M.
Sunflowers c.1890
oil on canvas 75.9 × 32.6
1964/1387

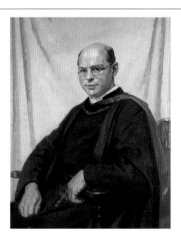

Hodge, Francis Edwin 1883–1949
The Reverend C. H. S. Runge
oil on canvas 91.7 × 71.3
x1964/281

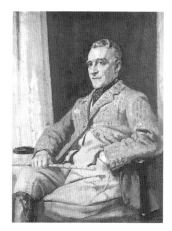

Hodge, Francis Edwin 1883–1949
Arthur Wimperis
oil on canvas 112.0 × 86.6
1974/393

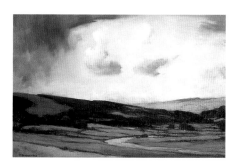

Holding, Edgar Thomas 1870–1952
The Passing Storm
oil on canvas 51.4 × 76.6
821

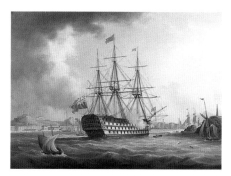

Hornbrook, Thomas Lyde 1780–1850
The San Josef 1833
oil on canvas 44.0 × 60.2
1955/48

Hornbrook, Thomas Lyde 1780–1850
'HMS Pallas' Entering Plymouth Harbour
oil on canvas 44.8 × 59.5
681

Howard, Jennifer
Salmon Heads
oil on canvas 50.5 × 61.0
1963/2068

Hubbard, Eric Hesketh 1892–1957
Derelict Ships
oil on canvas 75.6 × 93.5
x1969/336

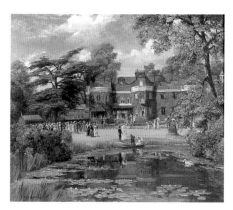

Hughes, Talbot 1869–1942
Garden Party at Milburn, Esher 1907
oil on canvas 76.5 × 91.6
x1971/1281

Humphreys, David b.1937
Summer Landscape, Sussex 1970
oil on canvas 46 × 60
2002/526

Hunt, William Holman 1827–1910
Bianca 1869
oil on canvas 88.3 × 66.8
1957/151

Jack, Richard 1866–1952
The Flower Seller 1923
oil on canvas 102 × 127
811

Jamieson, Robert Kirkland 1881–1950
The Roman Bridge at Lanark
oil on canvas 71.2 × 92.3
2451

King, K. A.
Gardener's Cottage 1899
oil on card 47.0 × 62.3
1988/754

K. B. K.
Bradford Laundry
oil on academy board 22.8 × 28.3
1982/349

King, Yeend 1855–1924
Early Autumn
oil on panel 101.7 × 81.0
1956

Knight, Laura 1877–1970
Young Gypsies 1937
oil on canvas 63.4 × 76.2
x1964/291

Koekkoek, Hermanus the younger
1836–1909
The Old Creek, Noorden, Holland
oil on panel 50.7 × 76.2
1971/279

Lessore, Thérèse 1884–1945
Swainswick Valley, Bath 1943
oil on hessian 63.5 × 81.5
2531

Maitland, Paul Fordyce 1863–1909
The Thames above Battersea Bridge
oil on canvas 35.5 × 46.4
2712

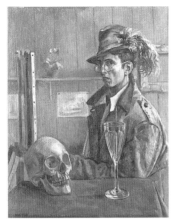

Makinson, Trevor b.1926
Drink Will Be the Death of Me 1951
oil on canvas 50.5 × 40.5
1954/380

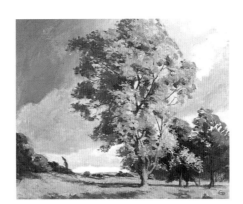

Malden, E. Scott active 1920
Wind in the Trees, Wiston
oil on canvas 50.8 × 61.0
825

March
Herbert Lodge, Conductor of the Municipal Orchestra 1950
oil on canvas 101.8 × 76.2
1971/1320

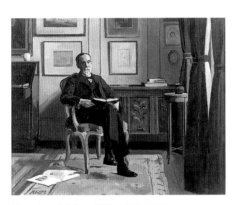

Marriott, Richard W. 1902–1942
The Connoisseur c.1926
oil on canvas 46.5 × 56.6
1969/4

Marriott, Richard W. 1902–1942
Snow in London c.1935
oil on canvas 69.0 × 51.2
1969/5

Marshall, Thomas Falcon 1818–1878
Returning Health
oil on canvas 46.8 × 71.0
1971/1480

May, Leonard
Ernest G. Townsend, Town Clerk of Worthing (1941–1962) 1955
oil on canvas 127.0 × 101.7
L102 (P)

Meninsky, Bernard 1891–1950
Young Woman
oil on canvas 68.5 × 55.8
1978/9

Merriott, Jack 1901–1968
In the Sunshine with Esmeralda c.1966
oil on canvas 71.2 × 91.5
1970/46

Methuen, Paul Ayshford 1886–1974
Dyrham, Gloucestershire
oil on canvas 50.6 × 76.4
4329

Middleton, James Godsell active 1826–1872
*Miss Mordaunt (Mrs Nisbett) as Constance in
'The Love Chase', Worthing Theatre, 21
September 1838*
oil on canvas 128.3 × 101.5
809

Miles, Ella Cleevia 1910–1983
Worthing's Town Hall 1964
oil on canvas 60.4 × 50.6
2003/194

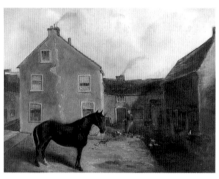

Mills, Percy
'The Rambler Inn', West Street, Worthing 1867
oil on canvas 36 × 46
1973/66

Minton, John 1917–1957
Landscape
oil on canvas 51.0 × 76.3
1973/64

Moody, John Charles 1884–1962
The New Sluice
oil on canvas 71.7 × 91.6
x1980/129

Moody, John Charles 1884–1962
Autumn in the Pennines
oil on canvas 61.2 × 76.3
x1985/578

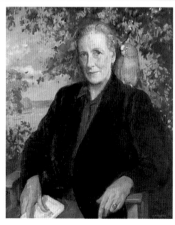

Morris, Charles Alfred 1898–1983
Miss Nancy Price
oil on canvas 76.5 × 63.4
x1964/283

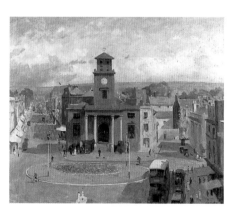

Morris, Charles Alfred 1898–1983
The Old Town Hall 1934
oil on canvas 63.2 × 76.5
1966/127

Morris, Charles Alfred 1898–1983
Percy Bysshe Shelley and Miss Phillips at Warwick Street Printery, Worthing, 1810
c.1940
oil on canvas 51.0 × 60.5
1982/161

Morris, Charles Alfred 1898–1983
Mary Bryan
oil on canvas 76.5 × 63.5
1983/384

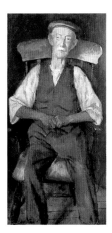

Morris, Charles Alfred 1898–1983
Harry Riddles c.1950
oil on canvas 76.5 × 37.5
1998/343

Morris, Charles Alfred 1898–1983
Lambley's Lane, Sompting
oil on canvas 45.5 × 61.5
822

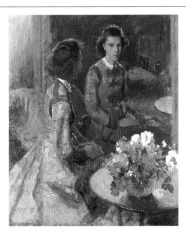

Morris, Charles Alfred 1898–1983
The Inherited Dress
oil on canvas 72.1 × 60.3
2587

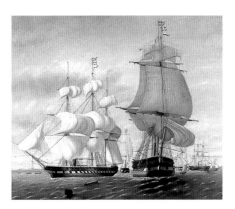

Morrison, William
Baltic Flying Squadron 1856
oil on canvas 51 × 61
x1966/521

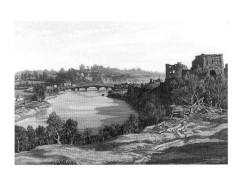

Muncaster, Claude 1903–1974
The Wye at Chepstow
oil on canvas 51.0 × 76.8
x1964/282

Nash, John Northcote 1893–1977
Winter Evening
oil on canvas 63.5 × 76.0
1962/3596

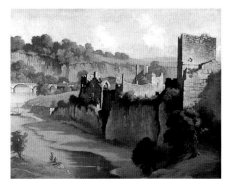

Nicholls, Bertram 1883–1974
Chepstow Castle
oil on canvas 71.0 × 91.2
x1964/280

Nicholls, Bertram 1883–1974
The Bridge 1921
oil on canvas board 45.5 × 61.5
815

Oppenheimer, Charles 1875–1961
Early Morning, a Solway Port
oil on canvas 97.3 × 121.8
826

Orr, James R. Wallace 1907–1992
Queen Street Gardens, Edinburgh 1947
oil on canvas 50.7 × 60.9
x1983/268

Padwick, Philip Hugh 1876–1958
Chichester
oil on canvas board 35.8 × 51.0
1884

Padwick, Philip Hugh 1876–1958
Landscape
oil on canvas 35.8 × 51.0
1924

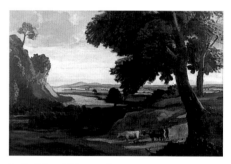

Padwick, Philip Hugh 1876–1958
Landscape and Rivers
oil on canvas 61.0 × 91.5
1953

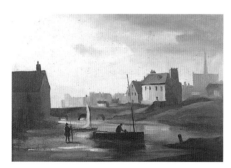

Padwick, Philip Hugh 1876–1958
Town on a River 1948
oil on canvas board 35.4 × 50.8
1963/1969

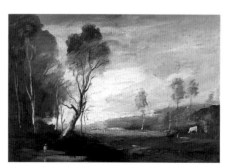

Padwick, Philip Hugh 1876–1958
Landscape with Cow
oil on canvas board 34.5 × 50.0
1963/1969a

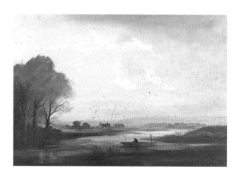

Padwick, Philip Hugh 1876–1958
River Landscape with Boat
oil on canvas board 35.8 × 51.0
1963/1969b

Padwick, Philip Hugh 1876–1958
Landscape
oil on canvas board 35.8 × 51.0
1963/1969c

Padwick, Philip Hugh 1876–1958
Town on the Arun
oil on canvas board 35.4 × 50.8
1963/1969d

Padwick, Philip Hugh 1876–1958
The Wharf
oil on canvas board 35 × 50
1963/1969e

Pelham, Thomas Kent active 1860–1891
Still Life
oil on canvas 61.0 × 51.2
x1975/298

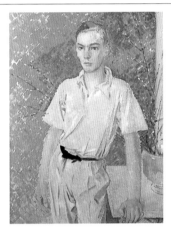

Philpot, Glyn Warren 1884–1937
Master Jasper Kingscote 1933
oil on canvas 101.8 × 77.2
1979/87

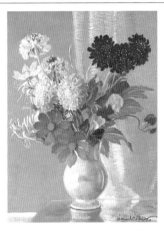

Philpot, Leonard Daniel 1877–1973
Scabious 1932
oil on panel 45.5 × 35.5
780

Pissarro, Lucien 1863–1944
Cottage at Storrington 1911
oil on canvas 40.5 × 60.0
1975/722

Pollard, Alfred R.
The Worthing Lifeboat Attending a Wreck 1891
oil on canvas 30.1 × 60.8
1982/137

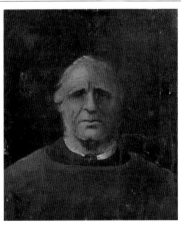

Pollard, Henry 1895–1965
A Portrait
oil on canvas 35.5 × 30.2
1982/346

Priestman, Bertram 1868–1951
Blytheborough from Henham 1925
oil on canvas 71 × 91
813

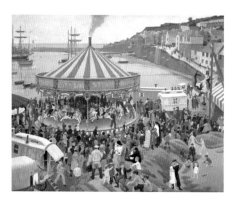

Procter, Ernest 1886–1935
All the Fun of the Fair c.1927–1928
oil on panel 64.3 × 78.5
1959 🐝

Prout, Margaret Fisher 1875–1963
Stapleford Village
oil on board 48 × 59
x1964/290

Redpath, Anne 1895–1965
Spanish Street Scene
oil on canvas 51 × 61
1968/291 🐝

Rendle, Morgan 1889–1952
Tramps Heritage
oil on panel 107 × 107
820

Roerich, Nicholas 1874–1947
A Northern Sunset 1918
oil on board 51.0 × 65.9
831

Rowys, T.
Colonel Sergeant A. Cortis 1866
oil on canvas 152.0 × 117.7
1994/316

Russell, Walter Westley 1867–1949
The Jetty, Shoreham 1922
oil on canvas 50.5 × 76.6
1935

Sanders, Christopher 1905–1991
Weymouth Harbour
oil on canvas 50.5 × 60.5
1964/483

Facing page: Fox, Edward, 1788–1875, *Old Shoreham Church* (detail), 1829, Marlipins Museum (p. 126)

Sedgley, Peter b.1930
Warbel
acrylic on card 15.0 × 20.5
1989/211

Sharp, Dorothea 1874–1955
Spring Morning, Sussex Downs
oil on canvas 51.2 × 61.4
1926

Sickert, Walter Richard 1860–1942
Home Sweet Home c.1935–1938
oil on hessian 87.5 × 72.4
2526

Sillince, William Augustus 1906–1974
Old Town Hall, Worthing c.1948
oil on canvas 29.5 × 45.0
1996/527

Sillince, William Augustus 1906–1974
Brickworks c.1948
oil on canvas 50.5 × 61.0
1996/528

Sinden, Gordon P. b.1930
Broadwater 1990
oil on hardboard 44.5 × 63.5
1991/1

Spear, Ruskin 1911–1990
Mrs Maud Drysdale c.1960
oil on canvas 74 × 64
2003/116

Spear, Ruskin 1911–1990
Mr Drysdale 1959
oil on canvas 79 × 68
2003/117

Speechley, Gilbert b.1926
Pier 1996
acrylic & watercolour on hardboard
43.2 × 53.0
1996/271

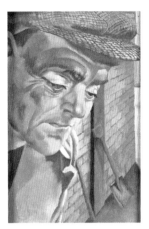

Spencer, Stanley 1891–1959
The Furnace Man c.1940–1944
oil on hardboard 37 × 25
1961/273

Staples, Robert Ponsonby 1853–1943
The Last Shot for the Queen's Prize, Wimbledon
1887
oil on canvas 114.0 × 231.5
838a

Staples, Robert Ponsonby 1853–1943
Queen's Prizemen 1860–1887
oil on canvas 50 × 257
838b

Starr, Sydney 1857–1925
Miss Jane Cobden
oil on canvas 91.2 × 61.0
2610

Towner, Donald Chisholm 1903–1985
Chalk Quarries, Amberley 1945
oil on canvas 70.7 × 87.4
1987/259

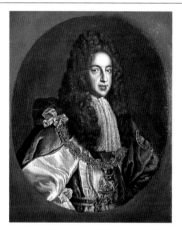

unknown artist 18th C
*James Francis Edward Stuart: The Old
Pretender*
oil on canvas 26 × 20
1994/511

unknown artist
Lieutenant (Later Admiral) William Hargood
1828
oil on canvas 31.0 × 25.7
x1955/44

unknown artist
*Mrs William Hargood (née Catherine
Harrison)* 1828
oil on canvas 31.0 × 25.9
x1955/45

unknown artist
A Flood in South Street, Worthing c.1877
oil on canvas 22 × 31
x1969/340

unknown artist
Alderman Alfred Cortis, First Mayor of Worthing 1890
oil on canvas 112.0 × 86.3
832

unknown artist early 19th C
Portrait of a Young Man
oil on canvas 56.0 × 47.3
2002/512

unknown artist 19th C
Farm Scene
oil on canvas 61.2 × 92.0
x1974/111

unknown artist late 19th C
Portrait of Unknown Lady
oil on canvas 25 × 20
x1994/83/1

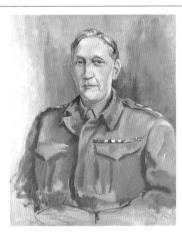

unknown artist
Sir Henry Stern c.1940
oil on canvas 76.1 × 63.5
1973/250

unknown artist
Jan Cervenka c.1970s
oil on canvas 55.0 × 40.3
1997/105

unknown artist early 20th C
Highworth House, Liverpool Road, Worthing
oil on photograph 36 × 44
1973/1062

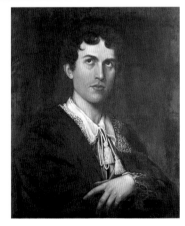

unknown artist
Thomas J. Searle as Hamlet
oil on canvas 76.5 × 64.1
1965/340

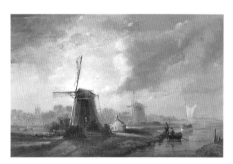

unknown artist
Moonlit Landscape
oil on panel 17.0 × 25.5
1971/1574

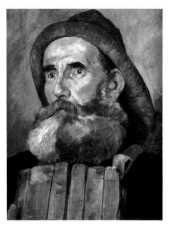

unknown artist
*Charles Lee (1833–1910), Coxswain of
Worthing Lifeboat, 'Henry Harris'*
oil on canvas 45.8 × 35.4
1973/869

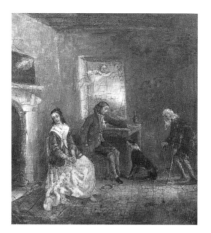

unknown artist
When Poverty Enters the Door
oil on canvas 33.3 × 30.7
1974/86

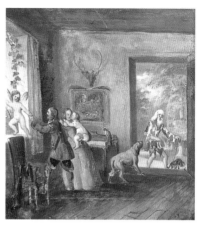

unknown artist
Love Flies out of the Window
oil on canvas 33.0 × 30.5
1974/87

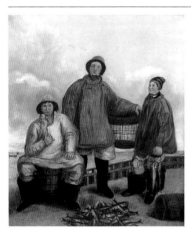

unknown artist
Three Fishermen
oil on canvas 53.3 × 45.7
x1980/130

unknown artist
A Portrait
oil on panel 25.3 × 19.8
1982/345

unknown artist
Fields at Tarring, Sussex
oil on panel 19.8 × 25.3
1982/347

unknown artist
Edwin Henty, DL, JP, FSA
oil on canvas 61.0 × 50.8
x1983/265

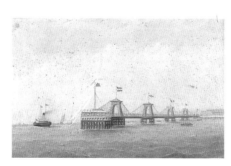

unknown artist
The Chain Pier at Brighton
oil on board 28.5 × 41.0
x1994/450

unknown artist
*Lady Hamilton as a Bacchante (after Joshua
Reynolds)*
oil on canvas 86.8 × 70.5
2617

Vaughan, **John Keith** 1912–1977
The Trial 1949–1959
oil on cardboard 71.0 × 99.6
1983/146

Walker, **Ethel** 1861–1951
Kathleen and Iris 1935
oil on canvas 51 × 41
1962/727

Ward, **James** 1769–1859
Sheep on the Downs 1832
oil on canvas 77.5 × 101.0
1965/334

Ward, **James** 1769–1859
Sheep by a Stream
oil on panel 14.5 × 19.2
2527

Watson, **F.** active 1914
At the Bedside
oil on canvas 35.5 × 41.0
x1983/266

Watson, **F.** active 1914
Still Life
oil on canvas 32.1 × 42.5
x1983/267

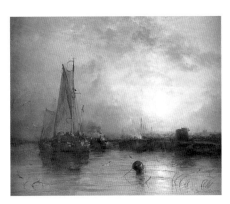

Webb, **James** c.1825–1895
Near Cologne 1881
oil on panel 37.6 × 46.2
1949

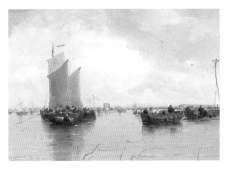

Webb, **James** c.1825–1895
A Calm Afternoon 1881
oil on panel 17.3 × 25.3
2528

Weiss, **José** 1859–1919
Tranquil Pastures
oil on canvas 61.5 × 91.5
823

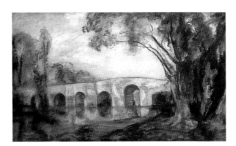

Wethered, Vernon 1865–1952
The Manor Farm, Bury 1932
oil on canvas 45.7 × 35.4
1972/294

Wethered, Vernon 1865–1952
Stopham Bridge
oil on canvas 55.6 × 91.5
1972/340

Wiens, Stephen Makepeace 1871–1956
Dorothy Primrose as Ophelia 1937
oil on canvas 90.3 × 74.0
1951

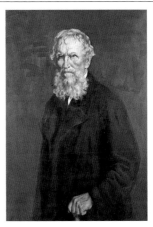

Wiens, Stephen Makepeace 1871–1956
Portrait of a Lady c.1900
oil on canvas 92.3 × 67.7
1964/1598

Wiens, Stephen Makepeace 1871–1956
Miss Mordaunt (…), as Constance in 'The Love Chase', Worthing Theatre, 21st September 1838 (after James Godsell Middleton)
oil on canvas 76.3 × 58.3
1982/159

Wiens, Stephen Makepeace 1871–1956
Edward John Trelawny 1951
oil on canvas 102 × 73
1982/160

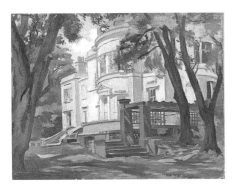

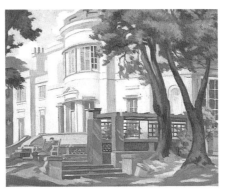

Wiens, Stephen Makepeace 1871–1956
Beach House, Worthing
oil on canvas 27.3 × 35.2
1982/353

Wiens, Stephen Makepeace 1871–1956
Beach House, Worthing
oil on canvas 30.2 × 37.7
1982/354

Wijnants, Jan c.1635–1684
Wooded Landscape 1671
oil on canvas 98.0 × 120.8
x1964/287

Wright, Henry 1823–1871
The Duke of Norfolk's 'Prince' 1860
oil on canvas 46 × 61
1972/1506

Facing page: Laroon, Marcellus I (attributed to), 1653–1702, *Charles II* (detail), Christ's Hospital Foundation (p. 97)

Paintings Without Reproductions

This section lists all the paintings that have not been included in the main pages of the catalogue. They were excluded from the main pages as it was not possible to photograph them for this project. Additional information relating to acquisition credit lines or loan details is also included. For this reason the information below is not repeated in the Further Information section.

Chichester District Museum

Codd, Michael b.1938, *Roman Chichester, c. 100 AD*, 76.0 x 51.8, acrylic on card, acquisition: Jan. 2000. Reconstruction painting commissioned by Chichester District Museum, 1999, © Michael Codd, missing at the time of photography

Codd, Michael b.1938, *Norman Castle, Chichester*, 52.5 x 74.6 (E), acrylic on card, acquisition: Jan. 2000. Reconstruction painting commissioned by Chichester District Museum, 1999, © Michael Codd, missing at the time of photography

Codd, Michael b.1938, *Chichester Greyfriars*, 52.8 x 74.3 (E), acrylic on card, acquisition: Jan. 2000. Reconstruction painting commissioned by Chichester District Museum, 1999, © Michael Codd, missing at the time of photography

Codd, Michael b.1938, *East Street, Chichester, c.1501*, 76.1 x 51.8, acrylic on card, acquisition: Jan. 2000. Reconstruction painting commissioned by Chichester District Museum, 1999, © Michael Codd, missing at the time of photography

Crawley Museum Centre

Burr, Victor 1908–1993, *The Upper Square*, 25 x 30 (E), oil on canvas, © Crawley Museum, missing at the time of photography

Burr, Victor 1908–1993, *Waiting for the Coach*, 43.2 x 53.3 (E), oil on canvas, © Crawley Museum, aquired after photography

Worthing Museum and Art Gallery

unknown artist late 19th C, *Portrait of Unknown Man*, in conservation

Further Information

This section lists all the paintings that are featured on the illustrated pages of the catalogue, under the same headings and in the same order as on those pages. Where there is any additional information relating to one or more of the five categories outlined below, this information is also included.

I	The full name of the artist if this was too long to display in the illustrated pages of the catalogue. Such cases are marked in the catalogue with a (…).
II	The full title of the painting if this was too long to display in the illustrated pages of the catalogue. Such cases are marked in the catalogue with a (…).
III	Acquisition information or acquisition credit lines as well as information about loans, copied from the records of the owner collection.
IV	Artist copyright credit lines where the copyright owner has been traced. Exhaustive efforts have been made to locate the copyright owners of all the images included within this catalogue and to meet their requirements. Any omissions or mistakes brought to our attention will be duly attended to and corrected in future publications.
V	The credit line of the lender of the transparency if the transparency has been borrowed. Bridgeman images are available subject to any relevant copyright approvals from the Bridgeman Art Library at www.bridgeman.co.uk

Arundel Museum and Heritage Centre

Ellis, Ralph, *W. B. Ellis, Naturalist*
Ellis, Ralph, *Portrait of a Countryman*
Ellis, Ralph, *Arundel Cathedral from the River*
Ellis, Ralph, *Seated Worker*
Morris, D., *The Timber Wharf, Arundel*
Ravenscroft, Frederick E. active 1891–1902, *Old Mill by Swanbourne Lake*
Ravenscroft, Frederick E. active 1891–1902, *Arundel Castle from the Arun*
Ravenscroft, Frederick E. active 1891–1902, *Arundel Castle from the Arun*
Wilson, F., *View of Arundel*
Wright, Helena, *Corner of Maltravers Street and High Street*

Billingshurst Library

Jones, Oliver late 20th C, *Path to St Mary's Church*

Chichester City Council

Ashford, Faith, *Chartres*
Bol, Ferdinand (attributed to) 1616–1680, *Man in Black Doublet with White Ruff c.17th Century*
Charles, James 1851–1906, *Sussex Downs*
Gilbert, Joseph Francis 1792–1855, *Winter Scene (Landscape with Village and Figures Skating)*

Hudson, Thomas (1701–1779) **or Jervas, Charles** (c.1675–1739) **(attributed to)**, *John Costello, Mayor of Chichester, 1720*
Hudson, Thomas (1701–1779) **or Jervas, Charles** (c.1675–1739) **(attributed to)**, *Ann Costello, Daughter of John Costello*
Marche, *Chartres Cathedral wih Bridge over River*
Müller, William James 1812–1845, *Clearing after Rain, Pont Hoogan*
Pether, Abraham 1756–1812, *River Landscape with Foreground Figures around a Fire, River and Bridge in Distance*
Pether, Abraham 1756–1812, *Moonlit Estuary Scene*
Pether, Abraham 1756–1812, *River with Cattle Drinking, Ruined Church and Bridge*
Pether, Henry 1800–1880, *A View of Chichester Cross from East Street*
Riches, Elizabeth b.1931, *The Late Eric Banks, Chichester, Town Clerk to Chichester (1936–1965 & 1974–1981)*
Romney, George 1734–1802, *Harry Peckham Esq. Recorder of Chichester, 1785*
Smith, George 1714–1776, *Winter Scene (Classical Ruins with Bridge in the Foreground and Figures with Horse)*
Smith, George 1714–1776, *Still Life (Sirloin of Beef with Numerous Vessels and Utensils on a White Cloth)*
Smith, George 1714–1776, *Man in Green Coat Holding a Hare with Four Hounds at his Feet*
Smith, George 1714–1776, *Wintry Scene with Burning Cottage in Foreground*
Smith, George 1714–1776, *Rocky Shore Scene wih Ship Foundering*
Smith, John c.1717–1764, *Rural Scene with Cottage and Lake in Foreground, Fishermen, Figures and Sheep*
Smith, John c.1717–1764, *River View with a Church in the Distance and Figures in Foreground*
Smith, William 1707–1764, *Winter Scene of a Cave in Foreground and Fire with Figures Dancing*
Smith, William (after) 1707–1764, *The Honourable James Brudenell, Recorder of Chichester, MP for Chichester (1713–1715 & 1734–1746)*
Smith, William (after) 1707–1764, *Charles, Second Duke of Richmond, KG, Mayor of Chichester (1735)*
unknown artist, *Dr Henry King, Bishop of Chichester*
unknown artist early 17th C, *Said to be William Cawley, MP, Founder of St Bartholomew's Hospital, Chichester in 1626 and one of the Judges of King Charles I*
unknown artist late 17th C?, *Man in Armour with White Ruff*
unknown artist, *Dr Edward Waddington, Bishop of Chichester 1724*
unknown artist 18th C?, *Sir Richard Farrington, Bt, Member for the City, 1714*
unknown artist, *Seated Victorian Gentleman, Facing Half-Right with Papers in Hand*
unknown artist, *George II*
unknown artist, *Charles I*
unknown artist, *George I*
unknown artist, *Charles II*

Vizard, W. active 1886–1903, *Peyton Temple Mackeson, MA (Oxen) JP, Hon. Freeman of the City of Chichester, Mayor (1901–1904)*

Chichester District Museum

Foulger, John, *A Breezy Day in the Harbour, Chichester*, gift from Littlehampton Museum, acting on behalf of deceased owner's family 1997
Jenner, Isaac Walter 1836–1901, *The Mill Quay, Bosham*, gift from J. T. Tough, 101 Westgate, Nov. 1962
Jennings, Audrey, *Westgate at Twilight*, gift of the artist May 1964
Malby, Walter Noah 1858–1892, *Chichester Canal*, gift from West Sussex Record Office Oct. 1962
Skelton, John 1923–1996, *Slate Sculpture for Chichester Museum*, gift from Stanley Roth 1977
Skelton, John 1923–1996, *Slate Sculpture for Chichester Museum, Symbol of Discovery*, gift from Stanley Roth 1977
Swan, Robert John 1888–1980, *Charles Ernest Shippam, President*, acquired from Stride & Son auctioneers, Chichester, left for disposal, 1992
unknown artist, *The Market Place at Chichester, Sussex*, purchased at auction, 23/7/2002 Henry Adams, Baffins Hall, Chichester, Lot 432
unknown artist, *James Ewer Cutten and His Family*, bequeathed by David Cutten 1996
unknown artist, *Sarah Cutten*,

bequeathed by David Cutten 1996
unknown artist, *Oliver Whitby (after a painting attributed to Mary Beale)*, gift from H. Dootson, Chairman Oliver Whitby Old Boys' Association, Oct. 1973
unknown artist, *The Grange, Tower Street, Chichester*, gift from Miss Caroline Gentle 1967
unknown artist, *Hurrah for Shippams*, purchased at auction, 5/3/1992 Stride & Son, St John's St, Chichester, Lot 61
Watts, Roland active 1940–1960, *Chichester from Donnington, Summer 1950*, gift from T. Saul Nov. 1974

Chichester Festival Theatre

Hailstone, Bernard 1910–1987, *Leslie Evershed-Martin, Founder of Chichester Festival Theatre*, purchased by the Theatre Trust

Chichester Library

Towell, W. K., *Tower Street, Chichester c.1900*, donation

Fishbourne Roman Palace

Baker, Evelyn active c.1960–2004, *Spiral Vine Tendril Border on Late First Century Mosaic*, probable donation
Baker, Evelyn active c.1960–2004, *Third Century Duplex Knot Mosaic*, probable donation
Baker, Evelyn active c.1960–2004,

Mid-Second Century Cupid on a Dolphin Mosaic, probable donation

Pallant House Gallery

Adler, Jankel 1895–1949, *Reclining Nude*, Wilson Loan (2004), © DACS 2004, photo credit: Stephen Head; Pallant House Gallery
Aitchison, Craigie Ronald John b.1926, *Crucifixion IX*, Wilson Loan (2004), Pallant House Gallery/ © courtesy of the artist's estate/ www.bridgeman.co.uk, photo credit: www.bridgeman.co.uk
Andrews, Michael 1928–1995, *Study for 'Colony Room'*, Wilson Gift, through the National Art Collections Fund (2004), photo credit: Pallant House Gallery © June & Melanie Andrews
Andrews, Michael 1928–1995, *Two Girls in the Garden*, Wilson Loan (2004) © June & Melanie Andrews
Andrews, Michael 1928–1995, *Thames Painting: The Estuary (Mouth of the Thames)*, Wilson Gift, through the National Art Collections Fund (2004), photo credit: Matthew Hollow; Pallant House Gallery © June & Melanie Andrews
Andrews, Michael 1928–1995, *Colony Room I (The Colony Room)*, Wilson Gift, through the National Art Collections Fund (2004), photo credit: Rodney Tidnam; Pallant House Gallery © June & Melanie Andrews
Andrews, Michael 1928–1995, *Study of a Head for a Group of Figures (Study of a Head with Green Turban)*, Wilson Loan (2004), photo credit: Pallant House Gallery © June & Melanie Andrews
Armstrong, John 1893–1973, *The Open Door*, loan, private collection, © the artist's estate
Auerbach, Frank Helmuth b.1931, *Reclining Head of Gerda Boehm*, Hussey Bequest, Chichester District Council (1985), © the artist, photo credit: Stephen Head; Pallant House Gallery
Auerbach, Frank Helmuth b.1931, *To the Studios*, Hussey Bequest, Chichester District Council (1985), © the artist
Auerbach, Frank Helmuth b.1931, *Oxford Street Building Site*, Wilson Loan (2004), © the artist, photo credit: Stephen Head; Pallant House Gallery
Auerbach, Frank Helmuth b.1931, *Camden Palace*, Wilson Gift, through the National Art Collections Fund (2004), © the artist, photo credit: Stephen Head; Pallant House Gallery
Auerbach, Frank Helmuth b.1931, *Reclining Model in the Studio I*, Wilson Loan (2004), © the artist, photo credit: Pallant House Gallery
Barker, Kit 1916–1988, *Gathered Reeds, Grande Brière*, presented by Mrs I. Barker (1995), © the artist's estate
Barker, Kit 1916–1988, *Llanmadoc, Gower*, Mrs D. M. Lucas Bequest (1995), © the artist's estate, photo credit: Pallant House Gallery
Barnard, Lambert c.1490–1567, *Semiramis, from the Amberley Castle 'Heroines of Antiquity' (Amberley Queens)*, loan, Chichester District Council, photo credit: Pallant House Gallery
Barnard, Lambert c.1490–1567, *Lampedo, from the Amberley Castle 'Heroines of Antiquity' (Amberley Queens)*, loan, Chichester District Council, photo credit: Pallant House Gallery
Barnard, Lambert c.1490–1567, *Menalippe, from the Amberley Castle, 'Heroines of Antiquity' (Amberley Queens)*, loan, Chichester District Council, photo credit: Pallant House Gallery
Barnard, Lambert c.1490–1567, *Hippolyta, from the Amberley Castle 'Heroines of Antiquity' (Amberley Queens)*, loan, Chichester District Council, photo credit: Pallant House Gallery
Barnard, Lambert c.1490–1567, *Zenobia, from the Amberley Castle 'Heroines of Antiquity' (Amberley Queens)*, loan, Chichester District Council, photo credit: Pallant House Gallery
Barnard, Lambert c.1490–1567, *Sinope, from the Amberley Castle 'Heroines of Antiquity' (Amberley Queens)*, loan, Chichester District Council, photo credit: Pallant House Gallery
Barnard, Lambert c.1490–1567, *Thamoris, from the Amberley Castle 'Heroines of Antiquity' (Amberley Queens)*, loan, Chichester District Council, photo credit: Pallant House Gallery
Barnard, Lambert c.1490–1567, *Cassandra, from the Amberley Castle 'Heroines of Antiquity' (Amberley Queens)*, loan, Chichester District Council, photo credit: Pallant House Gallery
Bell, Leland 1922–1991, *Two Nudes*, Wilson Gift, through the National Art Collections Fund (2004)
Bell, Leland 1922–1991, *Butterfly Group*, Wilson Gift, through the National Art Collections Fund (2004)
Bell, Vanessa 1879–1961, *Angelica*, loan, private collection, © 1961 estate of Vanessa Bell courtesy Henrietta Garnett, photo credit: Terry Pickering; Pallant House Gallery
Blake, Peter b.1932, *La Vern Baker*, Wilson Loan (2004), © Peter Blake 2004. All Rights Reserved, DACS
Blake, Peter b.1932, *Siriol, She-Devil of Naked Madness*, Wilson Loan (2004), © Peter Blake 2004. All Rights Reserved, DACS, photo credit: Marcus Leith and Andrew Dunkley, Tate; Pallant House Gallery
Blake, Peter b.1932, *Irish Lord X*, Wilson Loan (2004), © Peter Blake 2004. All Rights Reserved, DACS
Blake, Peter b.1932, *The Beatles 1962*, Wilson Gift, through the NACF, © Peter Blake 2004. All Rights Reserved, DACS, photo credit: Stephen Head; Pallant House Gallery
Blake, Peter b.1932, *Girls with Their Hero*, Wilson Gift, through the National Art Collections Fund (2004), © Peter Blake 2004. All Rights Reserved, DACS, photo credit: Richard Caspole; Pallant House Gallery
Blake, Peter b.1932, *Roxy Roxy*, Wilson Loan (2004), © Peter Blake 2004. All Rights Reserved, DACS, photo credit: Stephen Head; Pallant House Gallery
Blake, Peter b.1932, *EL*, Wilson Loan (2004), © Peter Blake 2004. All Rights Reserved, DACS, photo credit: Pallant House Gallery
Bomberg, David 1890–1957, *Ronda Bridge*, Hussey Bequest, Chichester District Council (1985), © the artist's family, photo credit: Pallant House Gallery
Bomberg, David 1890–1957, *The Southeast Corner, Jerusalem (Palestinian Landscape)*, Wilson Gift, through the National Art Collections Fund (2004), © the artist's family, photo credit: Pallant House Gallery
Bomberg, David 1890–1957, *The Last Landscape (Tajo and Rocks, Ronda)*, Wilson Loan (2004), © the artist's family, photo credit: Stephen Head; Pallant House Gallery
Bomberg, David 1890–1957, *Last Self Portrait*, Wilson Gift, through the NACF, © the artist's family, photo credit: Stephen Head; Pallant House Gallery
Bomberg, David 1890–1957, *Interior of a Peasant House, Kolonia*, Wilson Gift, through the National Art Collections Fund (2004), © the artist's family
Bomberg, David 1890–1957, *Talmudist*, Wilson Gift, through the National Art Collections Fund (2004), © the artist's family, photo credit: Pallant House Gallery
Bomberg, David 1890–1957, *Soliloquy Noonday Sun, Ronda*, Wilson Loan (2004), © the artist's family, photo credit: Pallant House Gallery
Bomberg, David 1890–1957, *Self Portrait*, Wilson Loan (2004), © the artist's family, photo credit: Pallant House Gallery
Bomberg, David 1890–1957, *Self Portrait (Recto: 'The Man')*, Wilson Loan (2004), © the artist's family, photo credit: Pallant House Gallery
Bomberg, David 1890–1957, *The Man (Verso: 'Self Portrait')*, Wilson Loan (2004), © the artist's family, photo credit: Pallant House
British School 18th C, *East Street, Chichester*, loan, private collection, photo credit: Beaver Photography; Pallant House Gallery
Carter, Bernard Arthur Ruston (Sam) b.1909, *University College School, Hampstead from the Artist's Studio Window (No.8 Camberwell Painters)*, Wilson Loan (2004)
Caulfield, Patrick b.1936, *Coloured Still Life*, Wilson Loan (2004), © Patrick Caulfield 2004. All Rights Reserved, DACS
Caulfield, Patrick b.1936, *Juan Gris*, Wilson Gift, through the National Art Collections Fund (2004), © Patrick Caulfield 2004. All Rights Reserved, DACS, photo credit: Stephen Head; Pallant House Gallery
Caulfield, Patrick b.1936, *Kellerbar*, Wilson Loan (2004), © Patrick Caulfield 2004. All Rights Reserved, DACS
Caulfield, Patrick b.1936, *Pipe on Table*, Wilson Gift, through the National Art Collections Fund (2004), © Patrick Caulfield 2004. All Rights Reserved, DACS
Caulfield, Patrick b.1936, *Still Life with Figs*, Wilson Gift, through the National Art Collections Fund (2004), © Patrick Caulfield 2004. All Rights Reserved, DACS
Caulfield, Patrick b.1936, *Landscape with Birds*, Wilson Gift, through the National Art Collections Fund (2004), © Patrick Caulfield 2004. All Rights Reserved, DACS, photo credit: Pallant House Gallery
Caulfield, Patrick b.1936, *View of the Chimneys*, Wilson Gift, through the National Art Collections Fund (2004), © Patrick Caulfield 2004. All Rights Reserved, DACS
Caulfield, Patrick b.1936, *Reserved Table*, Wilson Gift, through the National Art Collections Fund (2004), © Patrick Caulfield 2004. All Rights Reserved, DACS, photo credit: Stephen Head; Pallant House Gallery
Caulfield, Patrick b.1936, *Study for the British Library Tapestry (Pause on the Landing)*, Wilson Loan (2004), © Patrick Caulfield 2004. All Rights Reserved, DACS
Chandler, John Westbrooke (attributed to) 1764–1804/1805, *Portrait of a Young Gentleman Reading (Young Burke)*, presented by Miss J. Courtauld (1985)
Chorley, Adrian b.1906, *Monks Eleigh, Suffolk*, presented by Mr A. Scrivener (2001)
Clough, Prunella 1919–1999, *Disused Land*, Wilson Gift, through the National Art Collections Fund (2004)
Clough, Prunella 1919–1999, *Brown Wall*, Wilson Gift, through the National Art Collections Fund (2004), photo credit: Stephen Head; Pallant House Gallery
Coldstream, William Menzies 1908–1987, *Dr Bell, Bishop of Chichester*, on long loan from the Tate Gallery, London, Pallant House Gallery/ © courtesy of the artist's estate/ www.bridgeman.co.uk, photo credit: www.bridgeman.co.uk
Coldstream, William Menzies 1908–1987, *Westminster IX*, Wilson Loan (2004), Pallant House Gallery/ © courtesy of the artist's estate/ www.bridgeman.co.uk, photo credit: www.bridgeman.co.uk
Coldstream, William Menzies 1908–1987, *Colin St John Wilson*, Wilson Loan (2004), Pallant House Gallery/ © courtesy of the artist's estate/ www.bridgeman.co.uk, photo credit: www.bridgeman.co.uk
Coldstream, William Menzies 1908–1987, *Seated Nude*, Wilson Gift, through the National Art Collections Fund (2004), Pallant House Gallery/ © courtesy of the artist's estate/ www.bridgeman.co.uk, photo credit: www.bridgeman.co.uk
Coldstream, William Menzies 1908–1987, *The Opera House, Rimini, Interior (Bomb Damaged Theatre, Italy)*, Wilson Gift, through the National Art Collections Fund (2004), Pallant House Gallery/ © courtesy of the artist's estate/ www.bridgeman.co.uk, photo credit: www.bridgeman.co.uk
Coldstream, William Menzies 1908–1987, *View across Frognal Lane*, Wilson Gift, through the National Art Collections Fund (2004), Pallant House Gallery/ © courtesy of the artist's estate/ www.bridgeman.co.uk, photo credit: www.bridgeman.co.uk
Coldstream, William Menzies 1908–1987, *View from Kitchen Window, Cannon Hill (Emmanuel Church)*, Wilson Loan (2004), Pallant House Gallery/ © courtesy of the artist's estate/ www.bridgeman.co.uk, photo credit: www.bridgeman.co.uk
Coldstream, William Menzies 1908–1987, *Seated Nude*, Wilson Loan (2004), Pallant House Gallery/ © courtesy of the artist's estate/ www.bridgeman.co.uk, photo credit: www.bridgeman.co.uk
Coldstream, William Menzies 1908–1987, *Girl Reflecting*, Wilson Loan (2004), Pallant House Gallery/ © courtesy of the artist's estate/ www.bridgeman.co.uk, photo credit: www.bridgeman.co.uk
Collins, Cecil 1908–1989, *Fête gallante*, loan, private collection, © Tate, London 2004
Cooper, John L. G. 1894–1943, *Three Prima Donnas*, loan, private collection, © the artist's estate, photo credit: Terry Pickering; Pallant House Gallery
Coxon, Raymond James

1896–1997, *Cumberland*, loan, private collection, © the artist's estate, photo credit: Terry Pickering; Pallant House Gallery

Craxton, John b.1922, *Hare on a Table*, loan from the artist, photo credit: Pallant House Gallery

Creffield, Dennis b.1931, *Petworth: South End from East*, Wilson Gift, through the National Art Collections Fund (2004), © the artist

Cunningham, Vera 1897–1955, *Susannah and the Elders*, loan, private collection, © the artist's estate, photo credit: Terry Pickering; Pallant House Gallery

de Francia, Peter b.1921, *A Diary of our Times (Triptych)*, Wilson Gift, through the National Art Collections Fund (2004), © the artist, photo credit: Pallant House Gallery

de Francia, Peter b.1921, *A Diary of our Times (Triptych)*, Wilson Gift, through the National Art Collections Fund (2004), © the artist, photo credit: Pallant House Gallery

de Francia, Peter b.1921, *A Diary of our Times (Triptych)*, Wilson Gift, through the National Art Collections Fund (2004), © the artist, photo credit: Pallant House Gallery

de Francia, Peter b.1921, *Two Nudes*, Wilson Gift, through the National Art Collections Fund (2004), © the artist

de Francia, Peter b.1921, *Ship of Fools*, Wilson Gift, through the National Art Collections Fund (2004), © the artist, photo credit: Stephen Head; Pallant House Gallery

de Maistre, Leroy Leveson Laurent Joseph 1894–1968, *Christ Falls the First Time*, bequeathed by Mr Philip Stroud, OBE, DL (2002)

Donagh, Rita b.1939, *Overhead*, Wilson Gift, through the National Art Collections Fund (2004)

Donaldson, Marysia active 1937–1959, *Promise (A Window in Hampstead)*, presented by Mr A. Scrivener (2001)

Engelbach, Florence 1872–1951, *Crocus and Stocks*, loan, private collection, photo credit: Terry Pickering; Pallant House Gallery

Eurich, Richard Ernst 1903–1992, *Chesil Beach*, Hussey Bequest, Chichester District Council (1985), Pallant House Gallery/ © courtesy of the artist's estate/ www.bridgeman.co.uk, photo credit: www.bridgeman.co.uk

Evans, Merlyn Oliver 1910–1973, *The Lock*, loan, private collection

Fedden, Mary b.1915, *The Yellow Truck*, presented from the Estate of Lady C. Bonham-Carter, through the National Art Collections Fund (1991), © the artist, photo credit: Pallant House Gallery

Fedden, Mary b.1915, *Still Life with Artichoke*, Percy Brown Bequest (1996), © the artist, photo

credit: Stephen Head; Pallant House Gallery

Feibusch, Hans 1898–1998, *Narcissus*, presented by the artist (1997), © the artist's estate, photo credit: Stephen Head; Pallant House Gallery

Feibusch, Hans 1898–1998, *Rotes Tor, Taormina*, presented by the artist (1997), © the artist's estate

Feibusch, Hans 1898–1998, *Roemische Tempel*, presented by the artist (1997), © the artist's estate

Feibusch, Hans 1898–1998, *Untitled Meditterranean Landscape*, presented by the artist (1997), © the artist's estate

Feibusch, Hans 1898–1998, *Untitled Wooded Landscape*, presented by the artist (1997), © the artist's estate

Feibusch, Hans 1898–1998, *Landscape Study: Talnyva*, presented by the artist (1997), © the artist's estate

Feibusch, Hans 1898–1998, *Untitled Still Life of Bust, Candle, Vase and Shell*, presented by the artist (1997), © the artist's estate

Feibusch, Hans 1898–1998, *The Grey Cloud (Four Mourning Figures in a Crucifixion Scene)*, presented by the artist (1997), © the artist's estate

Feibusch, Hans 1898–1998, *Descent into Hell (Hollensturs 2)*, presented by the artist (1997), © the artist's estate

Feibusch, Hans 1898–1998, *Homage to Poplinsee*, presented by the artist (1997), © the artist's estate

Feibusch, Hans 1898–1998, *The Flagellation*, presented by the artist, © the artist's estate

Feibusch, Hans 1898–1998, *Elijah's Ascension*, presented by the artist (1997), © the artist's estate

Feibusch, Hans 1898–1998, *Strife*, presented by the artist (1997), © the artist's estate

Feibusch, Hans 1898–1998, *Miraculous Draft of Fishes*, presented by the artist (1997), © the artist's estate

Feibusch, Hans 1898–1998, *Men and Satyrs Dancing*, presented by the artist (1997), © the artist's estate

Feibusch, Hans 1898–1998, *Guardian Angels*, presented by the artist (1997), © the artist's estate

Feibusch, Hans 1898–1998, *Study for the Bishop's Chapel Mural, Chichester*, presented by the artist (1997), © the artist's estate

Feibusch, Hans 1898–1998, *Untitled Study, Men and Satyrs*, presented by the artist (1997), © the artist's estate

Feibusch, Hans 1898–1998, *Landscape with Large Terracotta Jars*, presented by the artist (1997), © the artist's estate

Feibusch, Hans 1898–1998, *Untitled Scene (Adam and Eve)*, presented by the artist (1997), ©

the artist's estate

Feibusch, Hans 1898–1998, *Untitled Study of Reclining Female Nude with Blue Wrap*, presented by the artist (1997), © the artist's estate

Feibusch, Hans 1898–1998, *Untitled Study of Roman Bust, Fruit, Leaves and Drape*, presented by the artist (1997), © the artist's estate

Feibusch, Hans 1898–1998, *Untitled Still Life of Head, Wreath, Shell, Fruit and Candle*, presented by the artist (1997), © the artist's estate

Feibusch, Hans 1898–1998, *Untitled Landscape with Woman in an Olive Grove*, presented by the artist (1997), © the artist's estate

Feibusch, Hans 1898–1998, *Untitled Study of Three Turtles Swimming with Fish*, presented by the artist (1997), © the artist's estate

Feibusch, Hans 1898–1998, *Untitled Gloucestershire Landscape, Evening*, presented by the artist (1997), © the artist's estate

Feibusch, Hans 1898–1998, *Taormina, Sicily*, presented by the artist (1997), © the artist's estate

Feibusch, Hans 1898–1998, *Untitled Still Life of Candle, Bowl of Apples and Vase of Bergenia*, presented by the artist (1997), © the artist's estate

Feibusch, Hans 1898–1998, *Untitled Still Life of Candle, Drape, Apples and Shell*, presented by the artist (1997), © the artist's estate

Feibusch, Hans 1898–1998, *Still Life with Head*, presented by the artist (1997), © the artist's estate

Feibusch, Hans 1898–1998, *Dream Flight*, presented by the artist (1997), © the artist's estate

Feibusch, Hans 1898–1998, *Untitled (Two Females)*, © the artist's estate

Feibusch, Hans 1898–1998, *At the Feet of Christ on the Cross*, presented by the artist (1997), © the artist's estate

Feibusch, Hans 1898–1998, *The Huck (A Meditteranean Landscape)*, presented by the artist (1997), © the artist's estate

Feibusch, Hans 1898–1998, *Olive Grove*, presented by the artist (1997), © the artist's estate

Feibusch, Hans 1898–1998, *Untitled Still Life of Candle, Marrow, Squashes and Bucket*, presented by the artist (1997), © the artist's estate

Feibusch, Hans 1898–1998, *Still Life (Fish and Candle)*, presented by the artist (1997), © the artist's estate

Feibusch, Hans 1898–1998, *Untitled Study of Two Women in an Aquarium*, presented by the artist (1997), © the artist's estate

Feibusch, Hans 1898–1998, *Untitled Still Life of Sunflowers with Two Heads*, presented by the artist (1997), © the artist's estate

Feibusch, Hans 1898–1998, *Untitled Still Life of Two Heads, Three Shells and a Candle*, presented by the artist (1997), © the artist's estate

Feibusch, Hans 1898–1998, *Gloucester Landscape 'Wye'*, presented by the artist (1997), © the artist's estate

Feibusch, Hans 1898–1998, *Cloud Shadows*, presented by the artist (1997), © the artist's estate

Feibusch, Hans 1898–1998, *Untitled (Tobias and the Angel)*, presented by the artist (1997), © the artist's estate

Feibusch, Hans 1898–1998, *The Old Gods*, presented by the artist (1997), © the artist's estate

Feibusch, Hans 1898–1998, *Crucifixion*, presented by the artist (1997), © the artist's estate

Feibusch, Hans 1898–1998, *Resurrection*, presented by the artist (1997), © the artist's estate

Filla, Emil 1882–1953, *Homme assis tenant un journal*, Kearley Bequest, through the National Art Collections Fund (1989), photo credit: Stephen Head; Pallant House Gallery

Finer, Stephen b.1949, *Sir Morris Finer*, presented by the artist (2001), © the artist

Fisher, Sandra 1947–1994, *Cosima in a Black Hat (Spender's Granddaughter)*, Wilson Gift, through the National Art Collections Fund (2004), © the artist's estate

Freud, Lucian b.1922, *Unripe Tangerine*, Wilson Loan (2004), photo credit: Stephen Head; Pallant House Gallery © Lucian Freud

Gertler, Mark 1892–1939, *Near Swanage*, Kearley Bequest, through the National Art Collections Fund (1989), © the artist's estate, photo credit: Stephen Head; Pallant House Gallery

González, Pedro b.1927, *Untitled Abstract of Figures*, Kearley Bequest, through the National Art Collections Fund (1989)

Gore, Spencer 1878–1914, *The Garden Path, Garth House*, Hussey Bequest, Chichester District Council (1985), photo credit: Stephen Head; Pallant House Gallery

Gotlib, Henryk 1890–1966, *Fireside Nude*, presented by Mr A. Scrivener (2001), © the artist's estate

Grant, Duncan 1885–1978, *Bathers by the Pond*, Hussey Bequest, Chichester District Council (1985), © 1978 estate of Duncan Grant, photo credit: Stephen Head; Pallant House Gallery

Grant, Duncan 1885–1978, *Rosamund Lehmann*, presented by Miss Patricia Routledge OBE (1997), © 1978 estate of Duncan Grant

Grant, Duncan 1885–1978, *Still*

Life, loan, private collection, © 1978 estate of Duncan Grant, photo credit: Terry Pickering; Pallant House Gallery

Greaves, Derrick b.1927, *Flower Piece*, presented by an anonymous donor (2003), © the artist

Hamilton, Gawen 1697–1737, *The Rawson Conversation Piece*, bought by the Friends of Pallant House with assistance from the National Art Collections Fund and V&A Purchase Grant Fund (1994), photo credit: Stephen Head; Pallant House Gallery

Hamilton, Richard b.1922, *Swingeing London '67*, Wilson Gift, through the National Art Collections Fund (2004), © Richard Hamilton 2004. All Rights Reserved DACS, photo credit: Pallant House Gallery

Hamilton, Richard b.1922, *Hers in a Lush Situation*, Wilson Gift, through the National Art Collections Fund (2004), © Richard Hamilton 2004. All Rights Reserved DACS, photo credit: Pallant House Gallery

Hamilton, Richard b.1922, *Respective*, Wilson Loan (2004), © Richard Hamilton 2004. All Rights Reserved DACS, photo credit: Stephen Head; Pallant House Gallery

Hayden, Henri 1883–1970, *Cubist 1919*, Kearley Bequest, through the National Art Collections Fund (1989), © ADAGP, Paris and DACS, London 2004, photo credit: Stephen Head; Pallant House Gallery

Hayter, Stanley William 1901–1988, *Composition (Matin serrisant une…)*, loan, private collection, © ADAGP, Paris and DACS, London 2004, photo credit: Terry Pickering; Pallant House Gallery

Hayter, Stanley William 1901–1988, *Composition (Leda)*, loan, private collection, © ADAGP, Paris and DACS, London 2004, photo credit: Terry Pickering; Pallant House Gallery

Henderson, Nigel 1917–1985, *Black Landscape*, Wilson Gift, through the National Art Collections Fund (2004)

Hillier, Tristram Paul 1905–1983, *La truite aux pommes vapeurs*, loan, private collection, © the artist's estate, photo credit: Terry Pickering; Pallant House Gallery

Hillier, Tristram Paul 1905–1983, *Marine*, loan, private collection, © the artist's estate, photo credit: Terry Pickering; Pallant House Gallery

Hitchens, Ivon 1893–1979, *Curved Barn (The Barn)*, presented by the artist in memory of Claude Flight (1978), © Ivon Hitchens' estate/ Jonathan Clark & Co, photo credit: Stephen Head; Pallant House Gallery

Hitchens, Ivon 1893–1979, *November Revelation*, presented by

Romney, George 1734–1802, *Lady Gough*, loan, private collection

Seago, Edward Brian 1910–1974, *The Rainbow*, loan from the National Trust (1996–2006) bequest of Dr & Mrs A. R. Harrison of Arundel, © by kind permission of the Trustees of the estate of Edward Seago, courtesy of Thomas Gibson Fine Art Limited

Self, Colin b.1941, *Waiting Women and 2 Nuclear Bombers (Handley Page Victors)*, Wilson Gift, through the National Art Collections Fund (2004), © Colin Self 2004. All Rights Reserved, DACS, photo credit: Stephen Head; Pallant House Gallery

Self, Colin b.1941, *At the Party (Hunt Ball)*, Wilson Loan (2004), © Colin Self 2004. All Rights Reserved, DACS

Severini, Gino 1883–1966, *Danseuse No.5*, Kearley Bequest, through the National Art Collections Fund (1989), © ADAGP, Paris and DACS, London 2004, photo credit: Stephen Head; Pallant House Gallery

Sickert, Walter Richard 1860–1942, *Les arcades de la poissonerie, quai Duguesne, Dieppe*, Hussey Bequest, Chichester District Council (1985), © Estate of Walter R. Sickert. All Rights Reserved, DACS, photo credit: Stephen Head; Pallant House Gallery

Sickert, Walter Richard 1860–1942, *Hubby and Wilson Steer - A Sketch*, Kearley Bequest, through the National Art Collections Fund (1989), © Estate of Walter R. Sickert. All Rights Reserved, DACS

Sickert, Walter Richard 1860–1942, *Jack Ashore*, Wilson Gift, through the National Art Collections Fund (2004), © Estate of Walter R. Sickert. All Rights Reserved, DACS, photo credit: Stephen Head; Pallant House Gallery

Sickert, Walter Richard 1860–1942, *Hotel de Commerce, Dieppe*, loan, private collection, © Estate of Walter R. Sickert. All Rights Reserved, DACS

Sickert, Walter Richard 1860–1942, *Chagford Across Fields*, loan, private collection, © Estate of Walter R. Sickert. All Rights Reserved, DACS

Sickert, Walter Richard 1860–1942, *La rue Picquet, Dieppe*, loan, private collection, © Estate of Walter R. Sickert. All Rights Reserved, DACS

Sickert, Walter Richard 1860–1942, *Pulteney Bridge, Bath*, loan, private collection, © Estate of Walter R. Sickert. All Rights Reserved, DACS

Sickert, Walter Richard 1860–1942, *St Jacques, rue Picquet*, loan, private collection, © Estate of Walter R. Sickert. All Rights Reserved, DACS

Sickert, Walter Richard 1860–1942, *Gwen Ffrangcon-Davies in 'The Lady With a Lamp'*, Wilson Gift, through the National Art Collections Fund (2004), © Estate of Walter R. Sickert. All Rights Reserved, DACS, photo credit: Stephen Head; Pallant House Gallery

Smith, George 1714–1776, *Winter Landscape*, bought by the Friends of Pallant House with assistance from the V&A Purchase Grant Fund (1985), photo credit: Stephen Head; Pallant House Gallery

Smith, George 1714–1776, *Winter Landscape with Two-Arched Bridge*, loan, private collection

Smith, George 1714–1776, *Farmhouse with Cattle in Mountainous Landscape*, loan, private collection

Smith, George 1714–1776, *Cocking Millpond*, loan, private collection

Smith, George 1714–1776, *The Watermill (Sullington, Near Storrington)*, loan, private collection

Smith, George 1714–1776 & **Smith, John** c.1717–1764, *The Shepherd, Evening*, loan, private collection

Smith, George 1714–1776 & **Smith, John** c.1717–1764, *The Shepherd, Morning*, loan, private collection

Smith, Matthew Arnold Bracy 1879–1959, *Landscape Near Cagnes*, Hussey Bequest, Chichester District Council (1985), © by permission of copyright holder, photo credit: Stephen Head; Pallant House Gallery

Smith, Matthew Arnold Bracy 1879–1959, *Flowers and Mixed Fruit*, Hussey Bequest, Chichester District Council (1985), © by permission of copyright holder

Smith, Matthew Arnold Bracy 1879–1959, *Portrait of a Lady*, Kearley Bequest, through the National Art Collections Fund (1989), © by permission of copyright holder

Smith, Matthew Arnold Bracy 1879–1959, *Reclining Nude (Vera)*, presented by Mrs Simon (1997), © by permission of copyright holder, photo credit: Beaver Photography; Pallant House Gallery

Smith, William 1707–1764, *Still Life with Grapes, Peaches and Plums*, loan, private collection

Smith, William 1707–1764, *Landscape with Horsemen*, loan, private collection

Smith, William 1707–1764, *Still Life of Grapes*, loan, private collection

Smith, William 1707–1764, *Still Life of Peaches, Plums and Cobnuts*, loan, private collection

Smith, William 1707–1764, *Still Life of Peaches, Grapes and Cobnuts*, loan, private collection

Smith, William 1707–1764, *A Shepherd and Shepherdess in a Landscape*, loan, private collection

Stokes, Adrian Durham 1902–1972, *Landscape*, Wilson Gift, through the National Art Collections Fund (2004)

Stokes, Adrian Durham 1902–1972, *Nude*, Wilson Gift, through the National Art Collections Fund (2004), photo credit: Pallant House Gallery

Sutherland, Graham Vivian 1903–1980, *Crucifixion*, Hussey Bequest, Chichester District Council (1985), © estate of Graham Sutherland, photo credit: Stephen Head; Pallant House Gallery

Sutherland, Graham Vivian 1903–1980, *Thorn Head*, Hussey Bequest, Chichester District Council (1985), © estate of Graham Sutherland, photo credit: Stephen Head; Pallant House Gallery

Sutherland, Graham Vivian 1903–1980, *Track Junction in the South of France*, Hussey Bequest, Chichester District Council (1985), © estate of Graham Sutherland

Sutherland, Graham Vivian 1903–1980, *Landscape in the South of France*, Hussey Bequest, Chichester District Council (1985), © estate of Graham Sutherland

Sutherland, Graham Vivian 1903–1980, *Datura Flowers*, Hussey Bequest, Chichester District Council (1985), © estate of Graham Sutherland

Sutherland, Graham Vivian 1903–1980, *Christ Appearing to Mary Magdalen (Noli me tangere)*, Hussey Bequest, Chichester District Council (1985), © estate of Graham Sutherland, photo credit: Stephen Head; Pallant House Gallery

Sutherland, Graham Vivian 1903–1980, *Walter Hussey*, Hussey Bequest, Chichester District Council (1985), © estate of Graham Sutherland, photo credit: Stephen Head; Pallant House Gallery

Tilson, Joe b.1928, *Triptych No.3A*, Hussey Bequest, Chichester District Council (1985), © Joe Tilson 2004. All Rights Reserved, DACS

Tilson, Joe b.1928, *Small Geometry No.1*, Wilson Gift, through the National Art Collections Fund (2004), © Joe Tilson 2004. All Rights Reserved, DACS, photo credit: Pallant House Gallery

Tilson, Joe b.1928, *1–5 (The Senses)*, Wilson Loan (2004), © Joe Tilson 2004. All Rights Reserved, DACS, photo credit: Pallant House Gallery

Tilson, Joe b.1928, *Maltese Cross Cut-Out*, Wilson Loan (2004), © Joe Tilson 2004. All Rights Reserved, DACS

Tindle, David b.1932, *Bonfire*, loan, private collection, © the artist

Turnbull, William b.1922, *Walking Figure (Man)*, Wilson Gift, through the National Art Collections Fund (2004), © William Turnbull 2004. All Rights Reserved, DACS

Wadsworth, Edward Alexander 1889–1949, *Composition on a Pink Background*, loan, private collection, © estate of Edward Wadsworth 2004. All Rights Reserved, DACS, photo credit: Terry Pickering; Pallant House Gallery

Wadsworth, Edward Alexander 1889–1949, *Conversation*, loan, private collection, © estate of Edward Wadsworth 2004. All Rights Reserved, DACS, photo credit: Terry Pickering; Pallant House Gallery

Webb, Marjorie 1903–1978, *Sutherland Sunset*, presented by Nora Webb (1992), © the artist's estate

West, Francis b.1936, *Study for the Last Judgement*, loan, private collection, © the artist

West, Francis b.1936, *The Skaters*, loan, private collection, © the artist

West, Francis b.1936, *The Last Judgement*, loan, private collection, © the artist

Whaite, H. Clarence 1895–1978, *Spring, Farringford*, presented by a Friend (2000), © the artist's estate

Williamson, Harold Sandys 1892–1978, *Church and People*, Hussey Bequest, Chichester District Council (1985), © Paul Williamson

Willing, Victor 1928–1988, *Judge*, Wilson Gift, through the National Art Collections Fund (2004), © the artist's estate, photo credit: Stephen Head; Pallant House Gallery

Willing, Victor 1928–1988, *Night*, Wilson Gift, through the National Art Collections Fund (2004), © the artist's estate, photo credit: Pallant House Gallery

Willing, Victor 1928–1988, *Swing*, Wilson Loan (2004), © the artist's estate, photo credit: Pallant House Gallery

Willing, Victor 1928–1988, *Self Portrait at 70*, Wilson Loan (2004), © the artist's estate

Willing, Victor 1928–1988, *Painting with Stepladder*, Wilson Loan (2004), © the artist's estate, photo credit: Stephen Head; Pallant House Gallery

Wood, Christopher 1901–1930, *Lemons in a Blue Basket*, Hussey Bequest, Chichester District Council (1985), photo credit: Stephen Head; Pallant House Gallery

Yeats, Jack Butler 1871–1957, *The Ox Mountains*, Kearley Bequest, through the National Art Collections Fund (1989) © The Estate of Jack B. Yeats 2004. All Rights Reserved, DACS, photo credit: Stephen Head; Pallant House Gallery

Royal Military Police Museum

Ademollo, Carlo 1825–1911, *Colonel Becky in Prison 1860*, presented by F. Chandler to the Depot and Training School, RMP

Billingham, P. P., *Redcap Portrait*

Boden, Leonard 1911–1999, *HRH Queen Elizabeth*

Boughey, Arther, *General Miles Dempsey*

Boughey, Arther, *General Geoffrey Baker*

Boughey, Arther, *Field Marshal James Cassels*

Boughey, Arther, *General Cecil Blacker*

Fordyce, *Major Narbir Thupa*

Howard, Ken b.1932, *Centenary of Royal Military Police*, © Royal Military Police Museum/ © courtesy of the artist's estate/ www.bridgeman.co.uk, photo credit: www.bridgeman.co.uk

Hutchins, (Colonel) P. E., *Europe, 1945*

Kevic, *Kosovo*

Kitchen, Michael S. late 20th C, *First Gulf War*

Kitchen, Michael S. late 20th C, *Northern Ireland*

Kitchen, Michael S. late 20th C, *Falklands*

Leach, M. C., *Checkpoint Charlie*

Potter, James, *Lieutenant Colonel Christopher Wallace, Colonel Commandant of Royal Military Police Regiment*

Potter, James, *Bosnia*

Sargeant, *Lieutenant Colonel Frank Baggley on a Horse*

unknown artist, *Slavic Building*

Wanklyn, Joan, *Disbandment Parade*

Wragg, Stephan 20th C, *Red Cap Tree*

Wragg, Stephan 20th C, *The TP Near Casino*

Wragg, Stephan 20th C, *Gathering Prisoners before San Felice*

Royal West Sussex NHS Trust

Dudgeon, Gerry b.1952, *Mughal Blues*, © the artist

Eastman, Frank S. b.1878, *Richard Henty*

Hunkin, Sally 20th C, *Echos*

Hunkin, Sally 20th C, *The Road*

Purchase, Hugo & Nigel, *Goodwood*

Purchase, Nigel, *Cricket Match*

unknown artist 20th C, *Flowers I*

unknown artist 20th C, *Flowers II*

Woodward, L. 20th C, *Richard Paine, Chairman (1993–2001)*

University College Chichester, Otter Gallery

Bain, Peter b.1927, *Painting*, pur-

chased Ash Barn Gallery 1965
Ballard, Kenneth, *Irises*, donation by Mrs Joan Sturdy (old student 1929–1931)
Barnden, Bruce b.1925, *Chalk Pit*, presented in 1978 by Mrs Jill Dawson, photo credit: www.bridgeman.co.uk
Bernard, Barbara, *Jon*
Blow, Sandra b.1925, *Painting*, puchased from David Paul Gallery in Chichester, © the artist
Bond, Julian, *Grey Day*
Bradley, Michael, *Refugee Camp*
Bratby, John Randall 1928–1992, *Girl with a Rose in Her Lap*, purchased 1962 from the Zwemmer Gallery, Otter Gallery/ © copyright courtesy of the artist's estate/ www.bridgeman.co.uk, photo credit: www.bridgeman.co.uk
Bray, Jill, *Red and Brown Abstract*
Burns, William 1921–1972, *Small Harbour*, purchased 1967
Clifford, Geoffrey, *Double Portrait*
Duffin, Gillian, *Head of a Girl*
Elsey, Dick, *Still Life No.2*
Enwonwu, Ben 1921–1994, *Monotony*, presented by Miss K. M. E. Murray in 1977, photo credit: www.bridgeman.co.uk
Eurich, Richard Ernst 1903–1992, *Solent Angler*, Otter Gallery/ © copyright courtesy of the artist's estate/ www.bridgeman.co.uk, photo credit: www.bridgeman.co.uk
Fedden, Mary b.1915, *Still Life with Two Oranges*, bought c.1966 from Heals Gallery, © the artist, photo credit: www.bridgeman.co.uk
Feiler, Paul b.1918, *Boats and Sea*, bought from the Redfern Gallery, photo credit: www.bridgeman.co.uk
Fernee, Kenneth b.1926, *Shadows and Lights - Evening*, purchased from the David Paul Gallery in Chichester 1966
Flint, Rhona, *Mum and Dad*, purchased by Trustees from artist, © the artist
Freestone, Ian, *Lying Figure*
Frost, Terry 1915–2003, *Red Painting October 62/May 63*, purchased Waddington Gallery, © the artist's estate
Gasking, Elspeth, *Trees*
Gavin, James b.1928, *Corrida 2*, purchased from the Scottish Gallery, Edinburgh 1967, photo credit: www.bridgeman.co.uk
Gear, William 1915–1997, *White Features*, purchased from artist 1959, © the artist's estate
Gear, William 1915–1997, *Black Figures*, purchased 1964, © the artist's estate
Ginns, Greg, *Landscape Planes*
Goodwin, Elaine, *Philip*, 1971
Greig, Rita b.1918, *Kings, Wizards and Other Creatures*, © the artist
Harris, Jane b.1956, *Boats 1975*
Harris, Norma, *Study in Blue*, 1976
Hayward, Peter active from 1960s, *Painting 1968*

Hayward, Peter active from 1960s, *Two Trains*
Hayward, Peter active from 1960s, *Railway Station*
Heron, Patrick 1920–1999, *Black and White: April 1956*, © estate of Patrick Heron 2004. All Rights Reserved, DACS, photo credit: DACS
Hitchens, Ivon 1893–1979, *Autumn Stream*, purchased from the artist in 1950, © Ivon Hitchens' estate/Jonathan Clark & Co
Hitchens, John b.1940, *Flowers in a Shore Window*, purchased 1971 from the David Paul Gallery Chichester, © the artist
Hoad, Simon, *Pink Painting*
Howell, Christopher, *Sussex Trees*
Humphreys, David b.1937, *Landfall*, purchased from the Duff Gallery, Arundel
Hunt, Eileen, *Apples*
Jenkins, Paul, *Geoffrey*, © ADAGP, Paris and DACS, London 2004, photo credit: DACS
John, Stephen, *When Comes the Day*
King, Carolanne, *Shell and Sea Mat on Shingle*
Lanyon, Peter 1918–1964, *The Green Mile*, purchased October 1955, © the artist
Le Goupillot, Richard, *Painting 1973*
Lees, Stewart b.1926, *The Exact Patch*, purchased Royal Academy 1980 presented by Sally Mather
Liddell, Peter b.1954, *Beck Falls 1*
Lock, Priscilla, *Chimneys*
Lord, Tim, *John*
Martin, Bob, *Winter Morning - Del Quay*
Mather, Sally, *Nets*, acquired May 1958, © the artist
McCririck, Sheila 1916–2001, *Nude 1947*, donated by Sally Mather, © the artist
Mellon, Eric James b.1925, *Circus Horse and Rider*, purchased 1972, © the artist
Meninsky, Bernard 1891–1950, *Portrait*, purchased privately from his son, © the artist's estate, photo credit: www.bridgeman.co.uk
Michie, David Alan Redpath b.1928, *Patterned Garden*, purchased 1972 from Mercury Gallery, London, © the artist, photo credit: www.bridgeman.co.uk
Moffatt, Heather, *'My God, my God, why hast Thou forsaken me?'*
Mohanti, Prafulla, *Painting*, painting presented to the College in 1973 by Asa Briggs, Vice-Chancellor of the University of Sussex, © the artist
Murray, Andrew b.1917, *Young Footballers at Newlyn, Cornwall*, purchased 1979 Portal Gallery
Murray, Fay, *Daisies*
Naylor, Albert b.1932, *Crucifixion*, presented by Sheila McCririck in 1977, © the artist
Oliver-Jones, Robert, *Three Men, Prize Winner*

Patel, Jenny, *Orange Figure*
Patten, John, *Trees in Snow*
Peckham, Laura, *Introspective 1*
Pescott, Ann, *Evening at Kingley Vale*
Pettrie, Les, *The Breeze*
Redgrave, William 1903–1986, *Tiger, Tiger*, purchased 1959 from the artist, photo credit: www.bridgeman.co.uk
Scott, William George 1913–1989, *Harbour*, purchased May 1953 Redfern Gallery, London
Sentence, Bryan, *Me*
Simcock, Jack b.1929, *Cottages, Mow Copp II 1959*, purchased David Paul Gallery, Chichester 1974
Smith, Larry, *Chaplin*
Stanshall, Vivian 1943–1995, *Speranza Regards Her Son*, purchased from artist
Stark, Andrew, *Man on Drab Pavement next to Exotic Advertising Hoarding*
Stern, Bernard b.1920, *Boy with Blue Hat*, purchased John Whitley Gallery, London 1973
Stern, Bernard b.1920, *Musical Notes*
Topping, Gillian, *Tumbling*, given by student 1977
Tremlett, Irene, *Hanging On*
Tucker, Jane, *Portrait*
unknown artist, *Seven Figures*
Wallis, Alfred 1855–1942, *Boat (Fishing Lugger at Sea)*, David Paul Gallery, Chichester, © DACS - text awaited, photo credit: www.bridgeman.co.uk
Walton, Frank b.1905, *Prophet Abstract*
Webb, Marjorie 1903–1978, *Aubergines and Fish*, © the artist's estate
Wicks, Claire, *Despondency*
Williams, Cherry, *Singleton*
Williams, John, *The Cricket Match*

West Sussex County Council

Codd, Michael b.1938, *North Park Furnace, Fernhurst*, commissioned by council, © Michael Codd, photo credit: Mike Codd/WSCC/PPL (www.pplmedia.com)
Codd, Michael b.1938, *Devil's Jumps, Treyford, Barrow Cemetery*, commissioned by council, © Michael Codd, photo credit: Mike Codd/WSCC/PPL (www.pplmedia.com)
Codd, Michael b.1938, *Church Norton Mound, Norman Castle*, commissioned by council, © Michael Codd, photo credit: Mike Codd/WSCC/PPL (www.pplmedia.com)
Codd, Michael b.1938, *Wealden Iron Industry: Iron Ore Extraction - Minepits, Charcoal Burning, Coppicing and Cording*, commissioned by council, © Michael Codd, photo credit: Mike Codd/WSCC/PPL (www.pplmedia.com)

Codd, Michael b.1938, *Portsmouth to Arundel Canal at Hunston, Bullion Shipment*, commissioned by council, © Michael Codd, photo credit: Mike Codd/WSCC/PPL (www.pplmedia.com)
Codd, Michael b.1938, *Portsmouth to Arundel Canal: Ford Lock and Pumping Station*, commissioned by council, © Michael Codd, photo credit: Mike Codd/WSCC/PPL (www.pplmedia.com)
Codd, Michael b.1938, *West Grinstead Wharf (Baybridge Canal)*, commissioned by council, © Michael Codd, photo credit: Mike Codd/WSCC/PPL (www.ppl-media.com)
Codd, Michael b.1938, *Bines Bridge, River Adur*, commissioned by council, © Michael Codd, photo credit: Mike Codd/WSCC/PPL (www.pplmedia.com)
Codd, Michael b.1938, *Wealden Hammer Pond*, commissioned by council, © Michael Codd, photo credit: Mike Codd/WSCC/PPL (www.pplmedia.com)
Codd, Michael b.1938, *Wealden Hammer Forge*, commissioned by council, © Michael Codd, photo credit: Mike Codd/WSCC/PPL (www.pplmedia.com)
Codd, Michael b.1938, *Balcombe Viaduct*, commissioned by council, © Michael Codd, photo credit: Mike Codd/WSCC/PPL (www.ppl-media.com)
Codd, Michael b.1938, *Boxgrove Palaeolithic Site (Diptych)*, commissioned by council, © Michael Codd, photo credit: Mike Codd/WSCC/PPL (www.pplmedia.com)
Codd, Michael b.1938, *Boxgrove Palaeolithic Site (Diptych)*, commissioned by council, © Michael Codd, photo credit: Mike Codd/WSCC/PPL (www.pplmedia.com)
Codd, Michael b.1938, *Shoreham Fort*, commissioned by council, © Michael Codd, photo credit: Mike Codd/WSCC/PPL (www.pplmedia.com)
Codd, Michael b.1938, *Rifleman, Sussex Artillery Volunteers*, commissioned by council, © Michael Codd, photo credit: Mike Codd/WSCC/PPL (www.pplmedia.com)
Codd, Michael b.1938, *Tote Copse Castle, Aldingbourne*, commissioned by council, © Michael Codd, photo credit: Mike Codd/WSCC/PPL (www.pplmedia.com)

West Sussex Record Office

British (English) School early 19th C, *William Huntington*, deposit
Field, Yvonne, *Bernard Vick*, deposit

Gilbert, Joseph Francis 1792–1855, *East Street Market, Chichester*, deposit
Holman, Thomas & Holman, William, *Map of Woodmancote and Albourne*, acquired from East Sussex Record Office, 1975
Jaques, C. H. B., *Coventry Patmore*, deposit
Jennings, Audrey, *Francis William Steer*, deposit
Romney, George 1734–1802, *William Hayley*, deposit
Romney, George 1734–1802, *William Hayley*, deposit
Shayer, William 1788–1879, *Smith Brothers of Chichester*, deposit
Tilman, *West Grinstead Church Exterior*, deposit
unknown artist, *Charles Jaques*, deposit
unknown artist, *Ann Jaques*, deposit
unknown artist, *Charles Jaques*, deposit
unknown artist, *View from Pitshill, Tillington*, presented in memory of Captain A. W. F. Fuller
unknown artist, *Lady Augusta Maxse*, deposit
unknown artist, *Sir Henry Berkeley Fitzhardinge Maxse*, deposit
unknown artist, *Sir Alexander Ferrier*, deposit for display
unknown artist, *Sir Robert Turing*
unknown artist, *East Marden Clothing Fund*, deposit
unknown artist, *Felpham Church Exterior*, acquired from county librarian

Crawley Library

Burr, Victor 1908–1993, *Visit of Princess Elizabeth to Crawley*

Crawley Museum Centre

Burr, Victor 1908–1993, *Harvest Festival (St John the Baptist Church, Crawley)*, © Crawley Museum

Cuckfield Museum Trust

Anscombe, Joseph, *South Street, Cuckfield*, presented by R. A. Bevan 1913
Gray, M., *Nurse Stoner*, bequeathed by sitter 1947
Ruff, George 1826–1903, *Afterglow*, donated by Mrs Winifred Seldon 1993
Ruff, George 1826–1903, *Harvest Time*, donated by Freddie Mitchell 1986
unknown artist, *Profile of Gentleman*, donated by Mrs Ardagh 1983

Chequer Mead Theatre and Arts Centre Trust

East Grinstead Millennium Mural Team, *In the Beginning There Were Only Trees*, © East Grinstead Millennium Mural Team

East Grinstead Millennium Mural Team, *…Then Only a Hovel*, © East Grinstead Millennium Mural Team

East Grinstead Millennium Mural Team, *The Romans Just Missed Us*, © East Grinstead Millennium Mural Team

East Grinstead Millennium Mural Team, *Greenstede Starts to Form*, © East Grinstead Millennium Mural Team

East Grinstead Millennium Mural Team, *c.700 Church Named after St Swithun*, © East Grinstead Millennium Mural Team

East Grinstead Millennium Mural Team, *1086 We Are in the Domesday Book*, © East Grinstead Millennium Mural Team

East Grinstead Millennium Mural Team, *1220s High Street Laid Out*, © East Grinstead Millennium Mural Team

East Grinstead Millennium Mural Team, *1247 and 1516 Royal Charter for Spring and Autumn Fairs*, © East Grinstead Millennium Mural Team

East Grinstead Millennium Mural Team, *1490s–1800s Wealden Iron Industry*, © East Grinstead Millennium Mural Team

East Grinstead Millennium Mural Team, *1556 Martyrs Burnt at the Stake*, © East Grinstead Millennium Mural Team

East Grinstead Millennium Mural Team, *1572 Granted Seal for Towne of Estgrinstead*, © East Grinstead Millennium Mural Team

East Grinstead Millennium Mural Team, *1609 Sackville College Founded*, © East Grinstead Millennium Mural Team

East Grinstead Millennium Mural Team, *1683 Church Struck by Lightning*, © East Grinstead Millennium Mural Team

East Grinstead Millennium Mural Team, *1717 Introduction of the Turnpike Tolls*, © East Grinstead Millennium Mural Team

East Grinstead Millennium Mural Team, *1750 The Coaching Industry*, © East Grinstead Millennium Mural Team

East Grinstead Millennium Mural Team, *1854 St Margaret's Convent Founded*, © East Grinstead Millennium Mural Team

East Grinstead Millennium Mural Team, *1855 Railway to Three Bridges Opened*, © East Grinstead Millennium Mural Team

East Grinstead Millennium Mural Team, *1863 First Fire Brigade Formed*, © East Grinstead Millennium Mural Team

East Grinstead Millennium Mural Team, *1884 Greenwich Meridian Established*, © East Grinstead Millennium Mural Team

East Grinstead Millennium Mural

Team, *1908 First East Grinstead Scout Troop Founded*, © East Grinstead Millennium Mural Team

East Grinstead Millennium Mural Team, *1940 McIndoe's Burns Unit at QV hospital*, © East Grinstead Millennium Mural Team

East Grinstead Millennium Mural Team, *1943 Whitehall Cinema Destroyed by Enemy Action*, © East Grinstead Millennium Mural Team

East Grinstead Millennium Mural Team, *1954 Granted a Coat of Arms*, © East Grinstead Millennium Mural Team

East Grinstead Millennium Mural Team, *1962 Town Twinning Founded*, © East Grinstead Millennium Mural Team

East Grinstead Millennium Mural Team, *1970s Office Buildings Change Town's Character*, © East Grinstead Millennium Mural Team

East Grinstead Millennium Mural Team, *1999 Monday 3 May Visitors to the 'Lions' May Fayre'*, © East Grinstead Millennium Mural Team

East Grinstead Millennium Mural Team, *1999 East Grinstead Millennium Logo*, © East Grinstead Millennium Mural Team

East Grinstead Millennium Mural Team, *Anno Domini MM*, © East Grinstead Millennium Mural Team

Rix, Anne-France b.1973, *The Bigger Picture*, given by Chequer Mead Friends on November 1999 © the artist

unknown artist, *title unknown*

East Grinstead Town Council

Collison, Edward c.1920–2001, *East Court at Springtime*, © the artist's estate

Lane, Bill, *Street Market Railway Approach, East Grinstead*

Moss, William George active 1814–1838, *East Grinstead from the Lewes Old Road*

Tupholme-Barton, Nicola, *Queen Elizabeth II, Golden Jubilee*

unknown artist 20th C?, *Alfred Wagg*

East Grinstead Town Museum

Collison, Edward c.1920–2001, *Red Lion at Chelwood Gate*, given by E. J. Collison (the artist), © the artist's estate

Collison, Edward c.1920–2001, *Set Fair*, given by E. J. Collison (the artist), © the artist's estate

Collison, Edward c.1920–2001, *Southwark Bridge*, given by E. J. Collison (the artist), © the artist's estate

Michell, Ronald 1916–1991, *Robert Sackville, Second Earl of Dorset*, given by R. Michell (the

artist)

Pepper, William Reynolds, *East Grinstead High Street Looking West to Middle Row*, given by P. D. Wood 1993

Pepper, William Reynolds, *Great Walking Fe(e)t(e)*, given by P. D. Wood 1993

Pepper, William Reynolds, *An Obstructionist 'Cloture' That Didn't Come off*, given by P. D. Wood 1993

Pepper, William Reynolds, *Public Rights of Way*, given by P. D. Wood 1993

Pepper, William Reynolds, *The Fable of the Hare, the Turtle and the Fox*, given by P. D. Wood 1993

Sawyer, F. E. late 19th C, *East Grinstead from the Old Lewes Road (copy after William George Moss)*, given by A. Barr-Hamilton 22/06/1976

Ullmann, Thelma Beatrice c.1915–c.1999, *Backyard of Crown Hotel Looking East*, given by the artist, © the artist's estate

unknown artist, *High Street at Junction with London Road*, given by P. D. Wood 1994

Hassocks Parish Council

Deschamps, A., *Hotel de ville, Montmirail*

Princess Royal Hospital Arts Project

Edwards, Trudie, *Garden Scene with Waterlilies and Bridge*

Gray, Anthony John b.1946, *Squares, Lines, Circles and Rainbows*, © the artist

Gray, Anthony John b.1946, *Squares, Lines, Circles and Rainbows*, © the artist

Gray, Anthony John b.1946, *Squares, Lines, Circles and Rainbows*, © the artist

Gray, Anthony John b.1946, *Squares, Lines, Circles and Rainbows*, © the artist

Gray, Anthony John b.1946, *Squares, Lines, Circles and Rainbows*, © the artist

Gray, Anthony John b.1946, *Surreal Painting - Women's Faces with Birds, Blue Sky and Clouds*, © the artist

Gray, Anthony John b.1946, *Circles within Squares*, © the artist

Gray, Anthony John b.1946, *Geometric Diamonds over Snowy Mountains*, © the artist

Gray, Anthony John b.1946, *Geometric Diamonds over Snowy Mountains*, © the artist

Holmes Pickup, M., *Landscape*

Parrott, Bill, *Jack and Jill Windmill*, © the artist

Phillips, K. K., *Poppies*

Sanderson, Elizabeth, *Impression of Sidmouth*

Tetley, P. I. D., *Chalk Pit on the Downs*

unknown artist, *Winter Lake*

Henfield Museum

Burleigh, Veronica 1909–1998, *Threshing*, donation © the artist

Gordon, J., *Congregational Chapel, Henfield*, donation

Gordon, J. (attributed to), *Windmill Lane, Henfield*, donation

Gray, Rosa 1868–1958, *Cottage by Road*, donation

Green, Robert, *From Barrow Hill, Henfield*, donation

Holden, Bertha 1911–1999, *The Health Centre from Cagefoot Lane, Henfield*, donation © the artist

Milne, Malcolm 1887–1954, *Primeval Henfield*, donation

Milne, Malcolm 1887–1954, *Henfield High Street, AD1850*, donation

Milne, Malcolm 1887–1954, *Henfield, AD1500*, donation

Milne, Malcolm 1887–1954, *Henfield, AD1000*, donation

Russell, M., *The Cat House Henfield*, donation

Squire, Harold 1881–1959, *Clay Pits, Dorset*, donation

unknown artist, *High Street, Henfield*, donation

unknown artist, *Cottage Garden, Henfield*, donation

unknown artist, *Backsettown Barn, Henfield*, donation

unknown artist 20th C, *A Cottage Kitchen*, donation

Christ's Hospital

Ayoub, Moussa active 1903–1938, *The Right Reverend Edmund Courtenay Pearce, DD*

Ayoub, Moussa active 1903–1938, *Mervyn Boecher Davie*

Beale, Mary (attributed to) 1633–1699, *Oliver Whitby*

Beresford, Frank Ernest 1881–1967, *John Rose*

Bowness, William 1809–1867, *John Guy Webster as a Christ's Hospital Boy*

Brangwyn, Frank 1867–1956, *St Patrick in the Forest*, commission, © Christ's Hospital/ © courtesy of the artist's estate/ www.bridgeman.co.uk, photo credit: www.bridgeman.co.uk

Brangwyn, Frank 1867–1956, *St Alban Martyr*, commission, © Christ's Hospital/ © courtesy of the artist's estate/ www.bridgeman.co.uk, photo credit: www.bridgeman.co.uk

Brangwyn, Frank 1867–1956, *St Augustine at Ebbsfleet*, commission, © Christ's Hospital/ © courtesy of the artist's estate/ www.bridgeman.co.uk, photo credit: www.bridgeman.co.uk

Brangwyn, Frank 1867–1956, *St Aidan, Bishop of North Cumbria, 635 AD Training Boys at*

Lindisfarne, commission, © Christ's Hospital/ © courtesy of the artist's estate/ www.bridgeman.co.uk, photo credit: www.bridgeman.co.uk

Brangwyn, Frank 1867–1956, *St Wilfred, First Bishop of Selsey Teaching the South Saxons, 681 AD*, commission, © Christ's Hospital/ © courtesy of the artist's estate/ www.bridgeman.co.uk, photo credit: www.bridgeman.co.uk

Brangwyn, Frank 1867–1956, *William Caxton Printing Bibles at Westminster, 1476 AD*, commission, © Christ's Hospital/ © courtesy of the artist's estate/ www.bridgeman.co.uk, photo credit: www.bridgeman.co.uk

Brangwyn, Frank 1867–1956, *John Eliot Giving Bibles to the Mohicans, 1660 AD*, commission, © Christ's Hospital/ © courtesy of the artist's estate/ www.bridgeman.co.uk, photo credit: www.bridgeman.co.uk

Brangwyn, Frank 1867–1956, *'Let the people praise thee O God, let all the people praise thee'*, commission, © Christ's Hospital/ © courtesy of the artist's estate/ www.bridgeman.co.uk, photo credit: www.bridgeman.co.uk

Brangwyn, Frank 1867–1956, *'Peter standing up with the eleven lifted up his voice and spake'*, commission, © Christ's Hospital/ © courtesy of the artist's estate/ www.bridgeman.co.uk, photo credit: www.bridgeman.co.uk

Brangwyn, Frank 1867–1956, *The Martyrdom of St Stephen*, commission, © Christ's Hospital/ © courtesy of the artist's estate/ www.bridgeman.co.uk, photo credit: www.bridgeman.co.uk

Brangwyn, Frank 1867–1956, *The Men Led Saul by the Hand and Brought him to Damascus*, commission, © Christ's Hospital/ © courtesy of the artist's estate/ www.bridgeman.co.uk, photo credit: www.bridgeman.co.uk

Brangwyn, Frank 1867–1956, *St Paul Shipwrecked*, commission, © Christ's Hospital/ © courtesy of the artist's estate/ www.bridgeman.co.uk, photo credit: www.bridgeman.co.uk

Brangwyn, Frank 1867–1956, *The Arrival of St Paul at Rome*, commission, © Christ's Hospital/ © courtesy of the artist's estate/ www.bridgeman.co.uk, photo credit: www.bridgeman.co.uk

Brangwyn, Frank 1867–1956, *The Conversion of St Augustine at Milan, 387 AD*, commission, © Christ's Hospital/ © courtesy of the artist's estate/ www.bridgeman.co.uk, photo credit: www.bridgeman.co.uk

Brangwyn, Frank 1867–1956, *St Ambrose Training the Choir at his Church in Milan, 385 AD*, commission, © Christ's Hospital/ © courtesy of the artist's estate/ www.bridgeman.co.uk, photo

credit: www.bridgeman.co.uk

Brangwyn, Frank 1867–1956, *St Columba Landing at Iona*, commission, © Christ's Hospital/ © courtesy of the artist's estate/ www.bridgeman.co.uk, photo credit: www.bridgeman.co.uk

British (English) School early 17th C, *Dame Mary Ramsay*

British (English) School 17th C, *Edward VI*

British (English) School mid-17th C, *William Gibbon, Treasurer (1662)*

British (English) School mid-17th C, *John Fowke*

British (English) School, *Thomas Parr of Lisbon, Merchant*

British (English) School early 18th C, *Queen Anne*

British (English) School early 18th C, *Portrait of a Gentleman said to be Thomas Parr*

British (English) School early 18th C, *Portrait of a Christ's Hospital Boy*

British (English) School 18th C, *James Hodgson, FRS*

British (English) School early 19th C, *William Walker Wilby of Windmill House (1770–1842)*

British (English) School 19th C, *Susannah Holmes*

British (English) School 19th C, *S. T. Coleridge*

British (English) School 19th C, *Edward Thornton*

British (English) School 19th C, *Edward Pitts*

British (English) School early 20th C, *Reverend Arthur William Upcott*

British (English) School early 20th C, *Frederick Wilby of Stortford Park (1849–1925)*

British (English) School early 20th C, *Sir John Pound*

British (English) School early 20th C, *Sir Henry Vanderpant*

British (English) School 20th C, *William Hamilton Fyfe*

British (English) School, *Miss M. Robertson*

British (English) School, *Sir John Savory*

British (English) School, *Richard Dobbs, Lord Mayor of London (1551–1552)*

Brown, Mather 1761–1831, *Richard Clark*

Brown, Mather (attributed to) 1761–1831, *Sir John William Anderson*

Carpenter (school of) early 19th C, *Portrait of Christ's Hospital Boy*

Carpenter, William 1818–1899, *George Atkinson*, Purchased

Chamberlin, Mason (attributed to) active c.1786–1826, *Mrs Le Keux*

Chinnery, George 1774–1852, *Captain Charles Shea (Died 1866)*

Clarke, George Frederick 1823–1906, *William Foster White (after John Prescott Knight)*

Closterman, John (attributed to) 1660–1711, *Daniel Colwall*

Collier, John 1850–1934, *Herbert William Walmisley*

Collier, John 1850–1934, *Portrait of Unknown Soldier*

Cooper, Alfred Egerton 1883–1974, *HRH Henry Duke of Gloucester Receiving His Charge as President, 14 April 1937*

Cooper, Alfred Egerton 1883–1974, *Reverend Richard Lee, Headmaster*

Cooper, Alfred Egerton 1883–1974, *Miss Norah Cicely Craig*

Cooper, Alfred Egerton 1883–1974, *Miss D. West*

Cooper, Alfred Egerton 1883–1974, *Sir Oliver Lodge*

Cooper, Alfred Egerton 1883–1974, *Joseph James Brown*

Cooper, Alfred Egerton 1883–1974, *Charles Wilfred Thompson*

Cooper, Alfred Egerton 1883–1974, *Sir Barnes Wallis*

Cooper, Alfred Egerton 1883–1974, *Barnes Wallis*

Cosway, Richard 1742–1821, *Admiral Michael Everitt*

Critz, John de the elder (style of) 1551/1552–1642, *Wolston Dixey, President (1590–1593)*

Crowe, Eyre 1824–1910, *Christ's Hospital Children in London Quad*, purchased through Sothebys in 2000

Dahl, Michael I (attributed to) 1656/1659–1743, *Thomas Lockington*

Dahl, Michael I (circle of) 1656/1659–1743, *William Garway*

Daniell, William 1769–1837, *Sea Battle between a French Squadron and Ships of the East India Company*

Daniell, William 1769–1837, *The Action of Commodore Dance and the Comte de Linois off the Straits of Malacca,15 February 1804*

Dicksee, Thomas Francis 1819–1895, *Matthius Sidney Smith Dipnall*

Edwards, Peter Douglas b.1955, *Susan Mitchell, Treasurer (1996–2002) and Her Husband John*

Geeraerts, Marcus the younger (circle of) 1561–1635, *Sir John Leman*

Grant, Francis 1803–1878, *William Thompson*

Grant, Francis 1803–1878, *HM Queen Victoria*

Grant, Francis 1803–1878, *HRH Prince Albert*

Gray, Douglas Stannus 1890–1959, *A Christ's Hospital Boy Studying*, Given by Revd J F Ticker

Green, Kenneth 1905–1986, *Thomas Edward Limmer*, © the artist's estate

Green, Kenneth 1905–1986, *Oswald Lael Flecker*, © the artist's estate

Green, Kenneth 1905–1986, *Reginald Edgeley Oldfield*, © the artist's estate

Green, Kenneth 1905–1986, *R. E.*

**Oldfield, Treasurer (1945–1957)*, © the artist's estate

Hacker, Arthur 1858–1919, *Sir Walter Vaughan Morgan*

Hardy, Benjamin, *Ernest Harold Pearce*

Hayls, John (circle of) active 1651–1679, *Thomas Barnes*

Herkomer, Hubert von 1849–1914, *John D. Allcroft, Treasurer, (1873–1891)*

Higgins or R. Scott (Captain), *The Ship 'Thomas Grenville'*

Highmore, Joseph (circle of) 1692–1780, *John Smith*

Highmore, Joseph (circle of) 1692–1780, *Reverend Edmund Tew*

Hindman, John (attributed to) 18th C, *Portrait of a Pupil of Christ's Hospital*

Hodgson, E. S., *Christ's Hospital from the Treasurer's Garden*

Holbein, Hans the younger (after) 1497/1498–1543, *Henry VIII*

Hunt, Gerard Leigh 1858–after 1928, *James Leigh Hunt*

Hunt, Richard active 1640–1642, *Thomas Singleton*

Hyndman, Arnold active 1921–1932, *Frederick Augustus White*

Hyndman, Arnold active 1921–1932, *The Right Reverend E. H. Pearce*

Hysing, Hans (attributed to) 1678–1753, *Thomas Birch*

Hysing, Hans (attributed to) 1678–1753, *Sir Francis Child (Died 1740)*

Jackson, John 1778–1831, *Portrait said to be of James Henry Leigh Hunt, Aged 18*

Janssens van Ceulen, Cornelis (follower of) 1593–1661, *Richard Young*

Kneller, Godfrey (attributed to) 1646–1723, *Josiah Bacon*

Kneller, Godfrey (attributed to) 1646–1723, *Thomas Stretchley, 1692*

Kneller, Godfrey (circle of) 1646–1723, *Sir Francis Child (Died 1713)*

Kneller, Godfrey (circle of) 1646–1723, *Charles II*

Kneller, Godfrey (studio of) 1646–1723, *James II*

Knight, John Prescott 1803–1881, *The Duke of Cambridge*

Knight, P. or Pickersgill, Henry William 1782–1875, *Richard Hotham Pigeon*

Lambert, George Washington 1873–1930, *Constant Lambert as a Christ's Hospital Schoolboy*

Larking, Patrick Lambert 1907–1981, *Portrait of a Christ's Hospital Boy (G. J. L. Crewdson)*

Laroon, Marcellus I (attributed to) 1653–1702, *Charles II*

Lawrence, Joseph (circle of) early 19th C?, *Thomas Wilby*

Lawrence, Thomas 1769–1830, *James Palmer, Treasurer (1798–1824)*

Lely, Peter (circle of) 1618–1680, *Sir John Frederick, Kt*

Logsdail, William 1859–1944,

Edward Logsdail as Christ's Hospital Scholar, Christ's Hospital/ © courtesy of the artist's estate/ www.bridgeman.co.uk, photo credit: www.bridgeman.co.uk

Luxmoore, Ben 20th C, *Interior of Christ's Hospital Chapel*

Luxmoore, Ben 20th C, *Christ's Hospital Boys Running in Avenue*

Luxmoore, Ben 20th C, *Ben Waters*

Luxmoore, Ben 20th C, *Portrait of a Christ's Hospital Boy*

Myles, Frank, *Mr Keymer*

Nelson, Edmund b.1910, *The Presentation of the Lord Mayor's Bounty*, loan

Northcote, James (attributed to) 1746–1831, *Commodore Sir Nathaniel Dance*

Oliver, Archer James 1774–1842, *Susannah Holmes*, gift of Mr Alcroft 1827

Palmer, Margaret b.1922, *James Forbes*, © the artist

Palmer, Margaret b.1922, *Richard Nicholls*, © the artist

Pannett, Juliet b.1911, *Sir David Hay Newsome*

Pannett, Juliet b.1911, *Miss E. M. Tucker*

Pannett, Juliet b.1911, *Miss J. Morrison*

Pannett, Juliet b.1911, *Sir Barnes Wallis*

Parmenter, Susan, *Sean Davis*

Ramos, Theodore b.1928, *Clarence Milton Edward Seaman*, © the artist

Richardson, Jonathan the elder (attributed to) 1665–1745, *Sir Francis Forbes*

Richmond, George 1809–1896, *William Gilpin*

Rigby, Harold Ainsworth active 1904–1915, *A Classical Scene*

Riley, John (attributed to) 1646–1691, *Sir John Moore*

Riley, John (attributed to) 1646–1691, *John Morris*

Rubbra, Benedict b.1938, *Angus Ross, Treasurer (1970–1976)*, © the artist

Rubbra, Benedict b.1938, *Richard Poulton, Headmaster (1987–1997)*, © the artist

Scott, Robert 1771–1841, *The 'Buckinghamshire' off the 'Asses' Ears', China Sea, December 1833*

Scrots, Guillim (circle of) active 1537–1553, *Edward VI, Founder of Christ's Hospital*

Scrots, Guillim (circle of) active 1537–1553, *Edward VI*

Shee, Martin Archer 1769–1850, *Thomas Poynder Junior, Treasurer (1824–1835)*

Smee, Michael b.1946, *Professor Jack Morpurgo*, © the artist

Speed, Harold 1872–1957, *Lieutenant Colonel T. H. Boardman*

Tayler, Edward E. active 1915–1935, *Portrait of a Naval Officer*

unknown artist, *A Remarkable Occurrence in the Life of Brook Watson (copy of John Singleton Copley)*

unknown artist, *General View of Christ's Hospital c.1820*

unknown artist, *Sir James Leigh-Wood*

unknown artist 20th C, *Sir Edward Ernest Cooper*

unknown artist, *John Thackeray*

unknown artist, *Thomas Nixson*

unknown artist, *Portrait of an Unknown Gentleman*

unknown artist, *Edward VI*

unknown artist, *Henry Stone*

unknown artist, *Presentation of Royal Charter by Edward VI*

unknown artist, *Christ's Hospital Boy*

unknown artist, *Sir Christopher Clitherow*

unknown artist, *Thomas Wilby of Windmill House*

unknown artist, *John Wilby*

unknown artist, *Mary Ash*

unknown artist, *Christ's Hospital Boy*

unknown artist, *A Christ's Hospital Wedding*

Verrio, Antonio c.1639–1707, *James II Receiving the Mathematical Scholars of Christ's Hospital (detail)*

Walker, Robert (circle of) 1607–1658/1660, *Thomas Barnes*

Ward, John Stanton b.1917, *Professor Edward Kenney*, Christ's Hospital/ © courtesy of the artist's estate/ www.bridgeman.co.uk, photo credit: www.bridgeman.co.uk

Wood, Elizabeth, *John Hansford, Headmaster (1985–1987)*, © the artist

Woodington, John, *Sir Eric Riches*

Wright, John Michael (circle of) 1617–1694, *Sir Thomas Vyner*

Wright, John Michael (circle of) 1617–1694, *Erasmus Smith*

Young, D., *Interior of Dining Hall, Christ's Hospital, London*

Young, Henrietta b.1951, *Derek Baker*, © the artist

Zuccaro, Federico (after) c.1541–1609, *Edward VI*

Horsham District Council: Horsham Museum

Addison, Eileen b.1906, *The Causeway*, donation 10th May 1995

Anthony, Captain G. M., *Causeway House, Horsham*, donation C. F. M. Taylor, Horsham

Bech, Bill 20th C, *War Memorial, 1914–1918*

J. B., *Henry Mitchell, JP (1843–1908)*, unknown

Bishop, Winifred, *Arundel Mill?*, unknown

British (English) School, *Gentleman in Red*, unknown

British (English) School, *Portrait of a Young Boy*, unknown

British (English) School, *Henry Mitchell (1809–1874)*, unknown

British (English) School 19th C, *Lady in a Lace Collar*, unknown

British (English) School, *The*

Bishopric
Burstow, F., *John Hamilton-Smith and Charles Price*, unknown
Carter, Jack c.1912–1992, *Flowers with Toby Jug*
Copnall, Edward Bainbridge 1903–1973, *'Whither'*, presented by P. H. Padwick
Copnall, Edward Bainbridge 1903–1973, *Charles John Attree*
Copnall, Edward Bainbridge 1903–1973, *Elderly Gentleman*, unknown
Fox, E., *Farthings Bridge*
Fox, E., *North Street, Horsham*
Green, Robert, *Field with Stooks*, donation Mrs Heather Wrighton
Green, Robert, *Landscape with Lake*
Green, Robert, *Landscape with Stooks*, donation Mrs Heather Wrighton
Green, Robert, *Landscape Viewed from above*
Gregory, J. M., *The Causeway*, donated by Mr Don Edwards, 10 May 1995
Gregory, J. M., *Chapel House, North Street, Horsham*, donation
Gregory, J. M., *Mill Bay*, donated by Mr Hunt April 1980
Gregory, M. E. 19th C, *Church Porch from Causeway, Horsham*, unknown
Harms, Edith Margaret active 1897–1932, *An Old Fisherman*, bequest 1999 acquired from solicitors
Hart, B. mid-20th C, *T. B. Mills*, donation R. G. Mills (son of artist) September 1993
Kilburne, George Goodwin 1839–1924, *Ewhurst Gatehouse*, purchased
Kneller, Godfrey (style of) 1646–1723, *Charles Eversfield and His Wife*, purchase for Museum by Cyril Hunt, Mr Turner, Mr Albery
Love, R., *St Mary's Church, Horsham*
Maidment, S. G., *The Green Man, Partridge Green*, purchased
Martin, Robert Wallace 1843–1923, *Captain Thomas Honeywood*
Mills, T. B. 1906–1989, *Capons, Cowfold*, donation R. G. Mills (son of artist) September 1993
Mills, T. B. 1906–1989, *Sussex Barn*, donation R. G. Mills (son of artist) September 1993
Mills, T. B. 1906–1989, *Boshotts, West Grinstead*, donation R. G. Mills (son of artist) September 1993
Mills, T. B. 1906–1989, *Old Barn, Eastlands*, donation R. G. Mills (son of artist) September 1993
Mills, T. B. 1906–1989, *Hill Foot*, donation R.,G. Mills (son of artist) September 1993
Mills, T. B. 1906–1989, *Blacksmith's Shop, Cowfold*, donation R. G. Mills (son of artist) September 1993
Mills, T. B. 1906–1989, *Sussex Downs*, donation R. G. Mills (son of artist) September 1993

Mills, T. B. 1906–1989, *Windmills*, donation R. G. Mills (son of artist) September 1993
Mills, T. B. 1906–1989, *Stopham Bridge*, donation R. G. Mills (son of artist) September 1993
Mills, T. B. 1906–1989, *Old Eastlands*, donation R. G. Mills (son of artist) September 1993
Mills, T. B. 1906–1989, *King's Barn, Kent Street, Cowfold*, donated by R. G. Mills (son of artist) September 1933
Mills, T. B. 1906–1989, *Jarvis Cottage*, donation R. G. Mills (son of artist) September 1993
Mills, T. B. 1906–1989, *Coombes Church, Sussex*, donated by R. G. Mills (son of artist) September 1933
Mills, T. B. 1906–1989, *Cowfold Monastery*, donated by R. G. Mills (son of artist) September 1933
Mills, T. B. 1906–1989, *Maragrett Cottages, Cowfold*, donated by R. G. Mills (son of artist) Oct. 1993
Mills, T. B. 1906–1989, *Landscape with Cottage*, donated by R. G. Mills (son of artist) September 1933
Mills, T. B. 1906–1989, *Long House, Cowfold*, donation R. G. Mills (son of artist) September 1993
Mills, T. B. 1906–1989, *Landscape with House*
Mills, T. B. 1906–1989, *Cottages, Cowfold Churchyard*, donation R. G. Mills (son of artist) September 1993
R. A. P., *Landscape with Stag*, unknown
R. A. P., *Landscape with Stags*, unknown
Padwick, Philip Hugh 1876–1958, *Sussex View*
Padwick, Philip Hugh 1876–1958, *Sussex Landscape*
Padwick, Philip Hugh 1876–1958, *Sussex View*
Piper, William, *Wheelwright and Smith Shops, Southwater*
Radley, F., *Sussex and Dorking Brickworks*, donated by Whitehouse Family December 1998. Four generations of brickmakers.
Steer, William, *Post Windmill, Possibly Champions Mill, Horsham Common*, unknown
Thompson, J., *Waterlilies*, donated by Arts Centre, Horsham, January 2002
unknown artist, *View of Cottage in a Forest*, unknown
unknown artist, *Joseph Marryatt, Horsham MP*, donation Wimbledon Museum Society
unknown artist, *The Reverend George Marshall (1780–1850)*, on loan from West Sussex Records Office
unknown artist, *Jackson Bros. Cycle Shop*, donated lst July 1995 by Mr P. A. Faires, great-grandson of G. H. Jackson
unknown artist, *Old Brighton Pier*
unknown artist, *Remains of Old*

Brighton Pier
unknown artist, *The Causeway*
unknown artist, *Mr Newman*, unknown
unknown artist, *James Davidson*, unknown
unknown artist, *Lady with Red Cape and Green Dress*
unknown artist, *Town Hall, Horsham*
Wells, Phil, *Garden Pool, Henfield*, purchase Rupert Toovey & Co. Ltd Auctioneers 1998
Winder, J. G., *St Mary's Church, Horsham*, purchase Ray Luff, Reigate

Horsham District Council: Park House

Grace, Alfred Fitzwalter 1844–1903, *Lea Farm, Storrington*, presented by Councillor Lieutenant Colonel H. V. Ravenscroft, JP 1934
Jervas, Charles (attributed to) c.1675–1739, *John Wicker II (1668–1741)*
Kelsey, Frank active 1887–1926, *At Anchor*
Ramsay, James 1786–1854, *The Entry of the Black Prince into London with the French King and his Son*

Lancing Library

Thomas, Edward, *View from Top of Mill Road, Lancing*
Thomas, Edward, *Lancing College Buildings*
Thomas, Edward, *Behind Lancing Manor*

Arun District Council

Snow, Sinclair, *St Mary's the Virgin, East Preston, 12th Century*

Littlehampton Museum

Ahlqhuist 19th C, *S. S. Collingwood*
Aldridge, Frederick James 1850–1933, *Littlehampton Harbour*
Baldry, George W., *Joseph Robinson*
Barkhouse, J., *Pride of the Arun*
Bottomley, Reginald active 1883–1895, *A Mother and Child Looking at the Virgin and Child*
Burn, Gerald Maurice 1862–1945, *Harvey's Shipyard*
T. C. 19th C, *Night Scene of Harbour Mouth*
Clarkson, William H. active 1893–1940, *Haystacks at Dusk*
Clink, Edith L. active 1895–1913, *Arundel Bridge*
Constable, George II active 1837–c.1862, *The Arundel Watermill*
Gilks, G. L. 19th C, *Harvey's Shipyard*

Harris, Edwin Lawson James 1891–1961, *Country Scene with Trees and Stream*
Hudson, I., *The Brigantine 'Adela'*
Johnston, Harry Hamilton 1858–1927, *Olive Tree and Gardens of La Massa, Tunis*
Kensington, C., *The Barque 'Lioness'*
Longstaff, Will 1879–1953, *View of Arundel*, © the artist's estate
Pike, Sidney active 1880–1907, *The Golf Links, Littlehampton*
Pike, Sidney active 1880–1907, *Thatched Cottage in Wick*
Pike, Sidney active 1880–1907, *Fishermen beside River Mouth*
Plant, A., *Littlehampton Esplanade*
Poulsen, *The Barque 'Flirt'*
Poulsen, *Naval Revenue Cutter 'HMS Chameleon'*
Poulsen, *Harvey's Shipyard*
Randall, Maurice active 1899–1919, *The Barque 'Trossachs'*
Randall, Maurice active 1899–1919, *Littlehampton Harbour*
Reid, John Robertson 1851–1926, *The Market Boat*
Roach, *The Coastguard Cottages*
Robley, A. 19th C, *Chrysanthemums*
Staples, George 19th C, *Jane Harvey*
Terry, John, *Iron Clipper 'Benvenue'*
unknown artist 19th C, *'Honfleur' Steamer Loading at Wharf*
unknown artist 19th C, *Rustington Mill*
unknown artist 19th C, *Littlehampton Harbour Mouth*
unknown artist 19th C, *West Beach, Littlehampton*
unknown artist 19th C, *The Beach Hotel*
Webb, James c.1825–1895, *Littlehampton Esplanade*
Wilcox, Leslie Arthur 1904–1982, *Passengers Boarding the 'Worthing Belle' at the Nelson Steps, Littlehampton Harbour*, purchased from Parker Gallery with grant from NACF, December 1985

Petworth Cottage Museum

unknown artist, *Exterior of Petworth Gaol, Possibly of the Treadmill or 'Crankhouse'*
unknown artist, *Interior of Petworth Gaol*, courtesy of Mr K. Sadler

Petworth Parish Council

Courtauld, Jeanne, *Northern Parishes of Petworth Rural Council*, bequeathed to Petworth Rural Council by the artist Jeanne Courtauld in March 1965
Courtauld, Jeanne, *Petworth Parish*, bequeathed to Petworth Rural Council by the artist Jeanne Courtauld in March 1965
Courtauld, Jeanne, *Petworth House and Lake*, bequeathed to

Petworth Rural Council by the artist Jeanne Courtauld in March 1965
Courtauld, Jeanne, *Southern Parishes of Petworth Rural Council*, bequeathed to Petworth Rural Council by the artist Jeanne Courtauld in March 1965

Rustington Library

Roberts, Eileen, *Anemones*
Warnes, Herschell F. b.1891, *Derelict Barge - The 'Leonard Piper'*

Adur District Council

British (English) School 17th C, *Captain Thomas Poole (1652–1699)*
Jenner, William, *Near Kingston-by-Sea, Glowing Autumn Sunset*
Meadows, James Edwin active 1853–1875, *A Rural Scene with Children, a Horse and a Cottage*
Webb, James c.1825–1895, *Shoreham, Sussex*

Marlipins Museum

Baker, N. A., *'Arthur Wright'*
Baker, N. A., *'Sylvia Beale'*
Brander, A. K., *'The Dolphin Shoreham' off Cape Horn, 1874*
Brander, A. K., *Brig Shannon of Shoreham*, bequest F. H. R. Batchelor
Brander, A. K. (attributed to), *'Light of the Age' at Sea, Calm Weather*
Brander, A. K. (attributed to), *'Solla of Shoreham' at Sea*, presented by Mr R. Longden
Brander, A. K. (attributed to), *'Light of the Age' at Sea, Rough Weather*, donated Mr B. Jupp October 1972
Bristow, Cedric, *Barque Aldebaran of Shoreham*
Cox, David the younger 1808–1885, *View of Hangleton*
Emsley, Walter, *River Adur, St Nicholas Church*
Fortescue, William Banks (attributed to) c.1855–1924, *Swiss Gardens in Evening*
Fox, Edward 1788–1875, *Old Shoreham Church*
Gogin, Alma 1854–1948, *Our Studio at Shoreham*, donated by Alma Gogin
Gogin, Alma 1854–1948, *Ballys Old Shipyard*, presented
Gogin, Alma 1854–1948, *Shipyard Studio, Shoreham*, presented
Gornold, Royal, *Boats on Shoreham Mud Flat*, donated by Mrs A. Gornold
Harrison, Brook 1860–1930, *Swiss Gardens*
Harrison, Brook 1860–1930, *Swiss Gardens*
Harrison, Brook 1860–1930, *The Fortune-Teller's Hut, Swiss Gardens*
Harrison, Brook (attributed to) 1860–1930, *By the Lake, Swiss*

Gardens

Hudson, Thomas (attributed to) 1701–1779, *Charles Haddock*, bequest of C. B. Tahourdin

Hudson, Thomas (attributed to) 1701–1779, *Probably Captain Richard Haddock*

Hudson, Thomas (attributed to) 1701–1779, *Said to be Sir Richard Haddock (Father of Captain Richard Haddock)*

Jacobsen, Antonio 1849–1921, *'Hector' Ship at Sea*

Litchfield, Anthony E., *View of Marlipins Museum*, donated by artist c.1952

Mason, *Demolition in Shoreham High Steet*, donated by artist (before 1952)

Mears, George active 1866–1890, *Coastal Scene with Yachts and Rowing Boat (Regatta)*

Oakman, J. J., *Lieutenant Mervyn William Curd, RNVR*

Pannell, E. W., *Reverend Charles M. A. Tower*

Pierce, G., *Shoreham Harbour*, donated by Rachel Cohen

Piper, *Shoreham Bridge and Mud Flats*

Skinner, Ivy M. b.1890, *Shoreham Harbour*

Stamp, Ernest 1869–1942, *John Street, Shoreham-by-Sea*

unknown artist, *Wreck of the 'Nympha'*

unknown artist, *Shoreham Harbour from South Bank*

unknown artist, *Eliza Emma of Shoreham*, donated by Douglas Coffin

unknown artist, *Southwick and Shoreham Looking West towards Fishergate*

unknown artist, *Portrait of Man in a Gown*

unknown artist, *'Merchant of Shoreham' at Sea*

unknown artist, *Destruction of Coast Road at Lancing*, donated by Albert Patching

unknown artist, *Henry Fitzalan Howard, 15th Duke of Norfolk*, donated by Mr Cheesman

unknown artist 19th C, *The Crab House, Southwick*

unknown artist 19th C, *Portrait of Victorian Lady*

unknown artist 19th C, *Portrait of Victorian Gentleman*

unknown artist, *End of Pier*

Steyning Museum

unknown artist, *St Andrew's Church, Steyning*

Whitmore, Robert, *St Cuthman*, donated by the Steyning Society

Worrall, E. J., *Frontage of Steyning Station*, donated by artist's brother-in-law

Priest House

Ullmann, Thelma Beatrice c.1915–c.1999, *The Old Forge, West*

Hoathly, given by Ethelwyn Newnham, date unknown, © the artist's estate

Ullmann, Thelma Beatrice c.1915–c.1999, *West Hoathly Cricket Ground and Langridge Farm*, given by Thelma Ullmann, date unknown, © the artist's estate

Worthing Hospital

Aggs, Christopher b.1951, *Sunrise over West Sussex*, 1995, donation J. Grindle, © the artist

Ball, Emily b.1967, *Worthing Beach Scene*, 1995, direct purchase, © the artist

Ball, Emily b.1967, *Worthing Beach Scene*, 1995, direct purchase, © the artist

Donegan, Jo b.1966, *Tree of Animals*, direct purchase, © the artist

Donegan, Jo b.1969, *Noah's Ark*, direct purchase, © the artist

Frith, Ann, *Against the Tide*, donation G. Withrington

Humphreys, David b.1937, *Beach Huts, Lancing*, direct purchase, © the artist

Lamb, Jo b.1952, *Mr Beckmann Comes to Worthing*, direct purchase, © the artist

Leach, Ursula, *Diptych, Downlands Fields*, purchase by PGMC, © the artist

Ottey, Piers b.1955, *Bignor Hill Downs*, purchase by PGMC, © the artist

Penoyre, Kate b.1954, *Steyning Bowl*, direct purchase, © the artist

Penoyre, Kate b.1954, *Devil's Dyke*, direct purchase, © the artist

Ruffell, Shyama b.1961, *Poppy*, direct purchase, © the artist

Ruffell, Shyama b.1961, *Thistle*, direct purchase, © the artist

Ruffell, Shyama b.1961, *Common Spotted Orchid*, direct purchase, © the artist

Ruffell, Shyama b.1961, *Tortoiseshell Butterfly*, direct purchase, © the artist

Ruffell, Shyama b.1961, *Cabbage White Butterfly*, direct purchase, © the artist

Ruffell, Shyama b.1961, *Purple Emperor Butterfly*, direct purchase, © the artist

Ruffell, Shyama b.1961, *Peacock Butterfly*, direct purchase, © the artist

Ruffell, Shyama b.1961, *Dandelion*, direct purchase, © the artist

Suhrbier, Karine b.1963, *Buttercup Meadow*, direct purchase, © the artist

Suhrbier, Karine b.1963, *Harebell Meadow*, direct purchase, © the artist

Tribe, Maria b.1972, *Sea Forms Cyprus*, direct purchase, © the artist

Tribe, Maria b.1972, *Trodos Mountains, Cyprus*, purchase by PGMC, © the artist

Worthing Library

T. T. H., *West Tarring Church, Near Worthing, Sussex*, unknown

Parkin, J. R., *Heene Cottage, Worthing*, unknown

unknown artist, *Smallholding (Brickfields) Near St Leonard's*, unknown

unknown artist, *Farm and Coast Near St Leonard's*, unknown

unknown artist, *St Leonard's Beach and Sea*, unknown

unknown artist, *St Leonard's Beach and Coastline*, unknown

Worthing Museum and Art Gallery

Aggs, Christopher b.1951, *The Collection*, purchased by the Friends of Worthing Museum and Art Gallery, © the artist

Allom, Thomas 1804–1872, *The Church of St Jacques, Antwerp*, bequest of Mrs F. Slade

Baker, E., *High Street, Tarring*, donated by Mr Robbins

Barnden, Bruce b.1925, *Mill Near Midhurst*, purchased from the artist, © the artist

Baron, Danielle b.1944, *Feux d'artifices sur la principauté*, donated by Danielle Pitt

Bassano, Jacopo il vecchio (school of) c.1510–1592, *Il presepio di san Giuseppe*, bequeathed by Mrs K. Napper

Benger, Berenger 1868–1935, *Shoreham Harbour*, bequeathed by the artist

Benger, Berenger 1868–1935, *Rural Scene*, bequeathed by the artist

Benger, Berenger 1868–1935, *Downland Landscape*, unknown

Benney, Ernest Alfred Sallis 1894–1966, *A Sussex Barn*, purchased from Aldridge Bros.

Berwick, John, *Dr Pitt Senior*, donated by Jean Miller

Berwick, John, *Dr William Pitt Junior*, donated by Jean Miller

Blaker, Hugh Oswald 1873–1936, *Self Portrait*, purchased from Miss M. Thomas, © the artist

Blaker, Hugh Oswald 1873–1936, *Man's Head in Colour*, donated by Mr Murray Urquhart, © the artist

Blaker, Hugh Oswald 1873–1936, *Teddington Lock*, donated by Mr H. Blaker & Mrs J. Bampton, © the artist

Blaker, Hugh Oswald 1873–1936, *Homeless*, donated by Mr H. Blaker & Mrs J. Bampton, © the artist

Bland, Emily Beatrice 1864–1951, *Littlehampton*, purchased from Cortis Bequest

Bloomer, W. H., *Miss Langley, Postmistress at Tarring*, donated by Miss W. H. Bloomer

Bottomley, Albert Ernest 1873–1950, *Norfolk Bridge, Shoreham*, purchased from Cortis Bequest

Brangwyn, Frank 1867–1956, *The Crushing Mill*, purchased from Fine Arts Exhibition, Worthing Museum & Art Gallery/ © courtesy of the artist's estate / www.bridgeman.co.uk, photo credit: www.bridgeman.co.uk

Bratby, John Randall 1928–1992, *Self Portrait Triptych*, purchased from the artist, Worthing Museum & Art Gallery/ © courtesy of the artist's estate / www.bridgeman.co.uk, photo credit: www.bridgeman.co.uk

Bratby, John Randall 1928–1992, *Red, Red*, purchased from Mrs Patti Bratby, Worthing Museum & Art Gallery/ © courtesy of the artist's estate / www.bridgeman.co.uk, photo credit: www.bridgeman.co.uk

Brighton, Bob, *Four*, donated by Bob Brighton, © the artist

Brighton, Bob, *Four*, donated by Bob Brighton, © the artist

Brighton, Bob, *Four*, donated by Bob Brighton, © the artist

Brighton, Bob, *Four*, donated by Bob Brighton, © the artist

Brooks, Brenda, *Bank Holiday*, donated by the artist, © the artist

Brooks, Brenda, *Punch and Judy*, donated by the artist, © the artist

Brown, N. O., *'Heinkel' Shot Down on High Salvington, August 1940*, ex-Sussex Room Collection

Burleigh, C. H. H. 1875–1956, *The Oak Dresser*, purchased through the Cortis Bequest

Callam, Arthur Edward 1904–1980, *Arthur's Castle, Tintagel*, donated by Mrs G. H. Callam

Cattermole, Lance 1898–1992, *Lady Stern*, bequeathed by Lady Stern

Cattermole, Lance 1898–1992, *The First Royal Visit*, vendor Derek & Ursula Powell

Cattermole, Lance 1898–1992, *The Art Critic*, donated by Ms J. E. Bowman & Mr Alan Stoddart

Challen, William, *Panoramic View from the Miller's Tomb, Highdown Hill*, unknown

Clark, *Portrait of a Lady*, donated by Mrs Hume

Cole, George 1810–1883, *Mount Edgecumbe*, donated by Alderman A. Cortis

Cole, George 1810–1883, *The Smithy*, purchased by the Cortis Bequest

Cole, Rex Vicat 1870–1940, *A Sussex Granary*, purchased from the Cortis Bequest

Communal, Joseph Victor 1876–1962, *Soucis*, unknown, © ADAGP, Paris and DACS, London 2004

Compton, Edwin, *Broadwater Church from Manor Field*, presented by B. J. Wells

Compton, Edwin, *The Half Brick*

Inn, donated by the family of Walter James Butcher & Mrs Elizabeth Butcher

Compton, Edwin, *Old Cottages in Heene Lane*, donated by the family of Walter James Butcher & Mrs Elizabeth Butcher

Condy, Nicholas c.1793–1857, *'HMS Royal Adelaide'*, donated by the executors of the late Harry Hargood

Cooke, Anthony R. b.1933, *Houses and Houseboats, Shoreham*, vendor Royal Academy, © Worthing Gallery

Cooper, Thomas Sidney 1803–1902, *Studies in Figures*, vendor Goddens

Cotes, Francis 1726–1770, *Mary Anne Colmore*, vendor Christie Manson & Woods Ltd

Cox, David the elder 1783–1859, *Rook Shooting*, donated by Miss C. E. S. Williams

Cumming, Peter b.1916, *Worthing Seafront 1950's*, vendor John Shepherd

De Karlowska, Stanislawa 1876–1952, *Le Lavoir, St Nicholas-du-Pelem, Brittany*, donated by Mrs E. H. Baty

Dillens, Adolphe-Alexander 1821–1877, *British Volunteers and the Belgian Garde Civique in Brussels*, unknown

Douglas, Edwin 1848–1914, *My Queen*, purchased from Aldridge Bros.

Earl, Maud 1848–1943, *Sussex Pocket Beagles*, donated by Alderman Mrs Chapman

Estall, William Charles 1857–1897, *Sheep on the Downs*, donated by Mr & Mrs Bellin Carter

Ferneley, John E. 1782–1860, *Two Horses and a Dog*, vendor J. Leger & Son

Fisher, Mark 1841–1923, *On the Sussex Downs*, vendor Aldridge Bros.

Fisher, Samuel Melton 1859–1939, *Mrs Rodocanachi*, donated by Colonel J. E. Rodosanachi

Forbes, Stanhope Alexander 1857–1947, *The Fishers*, donated by Mrs Godfrey, Worthing Museum & Art Gallery/ © courtesy of the artist's estate/ www.bridgeman.co.uk, photo credit: www.bridgeman.co.uk

Ford, Peter b.1937, *Nice Business, Nice People*, vendor Peter Ford, © the artist

Gardiner, John H. active 1910–1925, *Alderman A. Cortis*, was property of the townhall ownership passed on to the museum in 1994

Germain, Louise Denise 1870–1963, *Vielles casernes, Annecy*, vendor Cooling & Son

Giles, Frank Lynton 1910–2003, *Low Tide at Bosham Harbour*, donated by Lynton Giles, © the artist's estate

Gilman, Harold 1876–1919, *The Mountain Bridge*, donated by Miss

J. Blaker

Ginner, Charles 1878–1952, *Rottingdean*, vendor private collection of Frank Rutter

Gore, Spencer 1878–1914, *The Pond*, purchased by Worthing Corporation

Gorton, Lesley-Ann b.1939, *Winter in Mid-Sussex*, vendor Lesley-Ann Gorton

Gosse, Laura Sylvia 1881–1968, *The Harpist*, donated by the Sickert Trust, Worthing Museum & Art Gallery /© courtesy of the artist's estate/ www.bridgeman.co.uk, photo credit: www.bridgeman.co.uk

Guthrie, Robin 1902–1971, *James J. Guthrie*, donor or vendor Mr L. M. Wilson

Guthrie, Robin 1902–1971, *Equestrian Portrait*, donated by L. M. Wilson

Guy, Cyril Graham active 1929–1938, *Old Cottage, Amberley*, vendor Aldridge Bros.

Hall, Oliver 1869–1957, *Oak Trees on Duncton Common*, unknown

Henderson, Keith 1883–1982, *Sunlit Cliff, Arabian Desert*, donated by the artist

Henderson, Keith 1883–1982, *Harbour Crowd*, vendor Academy Exhibition

Henderson, Keith 1883–1982, *Ayios Varnavas, Cyprus; Monks with a Black Kid*, lender Mrs M. R. Brook

Henry, George F. 1858–1943, *Pastoral*, vendor Royal Exhibition

Hepple, Norman b.1908, *Sir Fredrik Stern OBE, MC*, donated by Lady Stern

Hill, Adrian Keith Graham 1895–1977, *The Estuary, Southport*, vendor Aldridge Bros.

Hitchens, Ivon 1893–1979, *Flowers in Hot Sun*, vendor Waddington Galleries Ltd, © Ivon Hitchens' estate/ Jonathan Clark & Co

Hobbema, Meindert (after) 1638–1709, *Landscape*, unknown

Hobby, M., *Sunflowers*, donated by Mrs Brice

Hodge, Francis Edwin 1883–1949, *The Reverend C. H. S. Runge*, donated by Lady Fish

Hodge, Francis Edwin 1883–1949, *Arthur Wimperis*, vendor Lady Fish

Holding, Edgar Thomas 1870–1952, *The Passing Storm*, unknown

Hornbrook, Thomas Lyde 1780–1850, *The San Josef*, donated by the executors of the late Harry Hargood

Hornbrook, Thomas Lyde 1780–1850, *'HMS Pallas' Entering Plymouth Harbour*, donated by the executors of the late Harry Hargood

Howard, Jennifer, *Salmon Heads*, vendor Mrs J. Howard

Hubbard, Eric Hesketh 1892–1957, *Derelict Ships*, donated by E. A. Sallis-Benny

Hughes, Talbot 1869–1942, *Garden Party at Milburn, Esher*,

donated by Mrs K. M. Napper

Humphreys, David b.1937, *Summer Landscape, Sussex*, donated by David Humphreys, © the artist

Hunt, William Holman 1827–1910, *Bianca*, vendor Leger Galleries

Jack, Richard 1866–1952, *The Flower Seller*, vendor Art Exhibition Bureau, © the artist's estate

Jamieson, Robert Kirkland 1881–1950, *The Roman Bridge at Lanark*, vendor the artist

King, K. A., *Gardener's Cottage*, donated by Mr H. D. Tribe

K. B. K., *Bradford Laundry*, vendor Derek & Ursula Powell

King, Yeend 1855–1924, *Early Autumn*, donated by Mr A. Lloyd

Knight, Laura 1877–1970, *Young Gypsies*, vendor Fine Art Society Ltd

Koekkoek, Hermanus the younger 1836–1909, *The Old Creek, Noorden, Holland*, donated by Mrs Cooper

Lessore, Thérèse 1884–1945, *Swainswick Valley, Bath*, donated by the Sickert Trust, © the artist's estate

Maitland, Paul Fordyce 1863–1909, *The Thames above Battersea Bridge*, vendor Leicester Galleries, London

Makinson, Trevor b.1926, *Drink Will Be the Death of Me*, donated by the artist

Malden, E. Scott active 1920, *Wind in the Trees, Wiston*, vendor Aldridge Bros.

March, *Herbert Lodge, Conductor of the Municipal Orchestra*, unknown

Marriott, Richard W. 1902–1942, *The Connoisseur*, donated by Mrs E. V. Mariott

Marriott, Richard W. 1902–1942, *Snow in London*, donated by Mrs E. V. Mariott

Marshall, Thomas Falcon 1818–1878, *Returning Health*, vendor Sothebys, Belgravia

May, Leonard, *Ernest G. Townsend, Town Clerk of Worthing (1941–1962)*, lent by Ernest G. Townsend

Meninsky, Bernard 1891–1950, *Young Woman*, vendor Belgrave Gallery, © the artist's estate

Merriott, Jack 1901–1968, *In the Sunshine with Esmeralda*, donation by the Jack Merriott Memorial Trust

Methuen, Paul Ayshford 1886–1974, *Dyrham, Gloucestershire*, donated by Lady Methuen

Middleton, James Godsell active 1826–1872, *Miss Mordaunt (Mrs Nisbett) as Constance in 'The Love Chase', Worthing Theatre, 21 September 1838*, donated by Worthing Art Development

Miles, Ella Cleevia 1910–1983, *Worthing's Town Hall*, donated by Stevie Field, © the artist's estate

Mills, Percy, *'The Rambler Inn', West Street, Worthing*, donated by the Sussex Room Collections

Minton, John 1917–1957, *Landscape*, donated by Mrs Wertheim, © Royal College of Art

Moody, John Charles 1884–1962, *The New Sluice*, donated by Mrs J. C. Moody

Moody, John Charles 1884–1962, *Autumn in the Pennines*, donated by Mrs J. C. Moody

Morris, Charles Alfred 1898–1983, *Miss Nancy Price*, donated by Miss Nancy Price

Morris, Charles Alfred 1898–1983, *The Old Town Hall*, donated by Mr C. A. Morris

Morris, Charles Alfred 1898–1983, *Percy Bysshe Shelley and Miss Phillips at Warwick Street Printery, Worthing, 1810*, vendor Derek & Ursula Powell

Morris, Charles Alfred 1898–1983, *Mary Bryan*, donated by Mrs L. M. Bryan

Morris, Charles Alfred 1898–1983, *Harry Riddles*, donated by Mrs P. Fishley

Morris, Charles Alfred 1898–1983, *Lambley's Lane, Sompting*, donated in memory of Colin Clive, by his family

Morris, Charles Alfred 1898–1983, *The Inherited Dress*, purchased from the artist

Morrison, William, *Baltic Flying Squadron*, unknown

Muncaster, Claude 1903–1974, *The Wye at Chepstow*, unknown, © the artist's estate

Nash, John Northcote 1893–1977, *Winter Evening*, vendor from R. A. Summer Exhibition, © the artist's estate

Nicholls, Bertram 1883–1974, *Chepstow Castle*, purchased from Aldridge Bros.

Nicholls, Bertram 1883–1974, *The Bridge*, purchased from the Cortis Bequest

Oppenheimer, Charles 1875–1961, *Early Morning, a Solway Port*, vendor Royal Asademy Exhibition

Orr, James R. Wallace 1907–1992, *Queen Street Gardens, Edinburgh*, unknown

Padwick, Philip Hugh 1876–1958, *Chichester*, vendor Aldridge Bros.

Padwick, Philip Hugh 1876–1958, *Landscape*, vendor Aldridge Bros.

Padwick, Philip Hugh 1876–1958, *Landscape and Rivers*, vendor Society of Sussex Painters

Padwick, Philip Hugh 1876–1958, *Town on a River*, donated by Mr & Mrs Bellin-Carter

Padwick, Philip Hugh 1876–1958, *Landscape with Cow*, donated by Mr & Mrs Bellin-Carter

Padwick, Philip Hugh 1876–1958, *River Landscape with Boat*, donated by Mr & Mrs Bellin-Carter

Padwick, Philip Hugh 1876–1958, *Landscape*, donated by Mr & Mrs Bellin-Carter

Padwick, Philip Hugh 1876–1958,

Town on the Arun, donated by Mr & Mrs Bellin-Carter

Padwick, Philip Hugh 1876–1958, *The Wharf*, donated by Mr & Mrs Bellin-Carter

Pelham, Thomas Kent active 1860–1891, *Still Life*, unknown

Philpot, Glyn Warren 1884–1937, *Master Jasper Kingscote*, donated by Mrs H. Nyberg, © the artist's estate

Philpot, Leonard Daniel 1877–1973, *Scabious*, donated by the Society of Sussex Painters

Pissarro, Lucien 1863–1944, *Cottage at Storrington*, purchased from Thos. Agnew & Sons Ltd, © the artist's estate

Pollard, Alfred R., *The Worthing Lifeboat Attending a Wreck*, vendor Derek & Ursula Powell

Pollard, Henry 1895–1965, *A Portrait*, donor or vendor Derek & Ursula Powell

Priestman, Bertram 1868–1951, *Blytheborough from Henham*, unknown

Procter, Ernest 1886–1935, *All the Fun of the Fair*, purchased from exhibition (unknown), Worthing Museum & Art Gallery/ © courtesy of the artist's estate/ www.bridgeman.co.uk, photo credit: www.bridgeman.co.uk

Prout, Margaret Fisher 1875–1963, *Stapleford Village*, vendor Aldridge Bros.

Redpath, Anne 1895–1965, *Spanish Street Scene*, vendor David Michie, Worthing Museum & Art Gallery/ © courtesy of the artist's estate/ www.bridgeman.co.uk, photo credit: www.bridgeman.co.uk

Rendle, Morgan 1889–1952, *Tramps Heritage*, vendor Aldridge Bros.

Roerich, Nicholas 1874–1947, *A Northern Sunset*, donated by Alderman J. Farquherson Whyte

Rowys, T., *Colonel Sergeant A. Cortis*, property of Town Hall, ownership passed to the museum 1994

Russell, Walter Westley 1867–1949, *The Jetty, Shoreham*, purchased through the Cortis Bequest

Sanders, Christopher 1905–1991, *Weymouth Harbour*, vendor C. Sanders, © Weymouth Museum & Art Gallery

Sedgley, Peter b.1930, *Warbel*, donated by Mrs H. Dandridge, OBE

Sharp, Dorothea 1874–1955, *Spring Morning, Sussex Downs*, vendor Godfrey Barclay

Sickert, Walter Richard 1860–1942, *Home Sweet Home*, vendor Messrs. Brown and Phillips, Leicester Galleries, © estate of Walter R. Sickert 2004. All Rights Reserved, DACS

Sillince, William Augustus 1906–1974, *Old Town Hall, Worthing*, donated by Mrs J. I. R. Tomlinson

Sillince, William Augustus 1906–1974, *Brickworks*, donated by Mrs J. I. R. Tomlinson

Sinden, Gordon P. b.1930, *Broadwater*, donated by Mr G. P. Sinden

Spear, Ruskin 1911–1990, *Mrs Maud Drysdale*, Diana King Bequest, Worthing Museum & Art Gallery/ © courtesy of the artist's estate/ www.bridgeman.co.uk, photo credit: www.bridgeman.co.uk

Spear, Ruskin 1911–1990, *Mr Drysdale*, Diana King Bequest, Worthing Museum & Art Gallery/ © courtesy of the artist's estate/ www.bridgeman.co.uk, photo credit: www.bridgeman.co.uk

Speechley, Gilbert b.1926, *Pier*, vendor Mr Gilbert Speechley, © the artist's estate

Spencer, Stanley 1891–1959, *The Furnace Man*, vendor Arthur Tooth and Sons Ltd, © estate of Stanley Spencer 2004. All Rights Reserved, DACS

Staples, Robert Ponsonby 1853–1943, *The Last Shot for the Queen's Prize, Wimbledon*, donated by Aldeman A. Cortis, © the artist's estate

Staples, Robert Ponsonby 1853–1943, *Queen's Prizemen*, bequeathed by Mrs Cortis, © the artist's estate

Starr, Sydney 1857–1925, *Miss Jane Cobden*, bequeathed by Mrs Cobden Unwin

Towner, Donald Chisholm 1903–1985, *Chalk Quarries, Amberley*, donated by Mr C. A. Humphrey, © the artist's estate

unknown artist 18th C, *James Francis Edward Stuart: The Old Pretender*, bequest of Mrs S. M. Jones

unknown artist, *Lieutenant (Later Admiral) William Hargood*, donated by the executors of the late Harry Hargood

unknown artist, *Mrs William Hargood (née Catherine Harrison)*, donated by the executors of the late Harry Hargood

unknown artist, *A Flood in South Street, Worthing*, unknown

unknown artist, *Alderman Alfred Cortis, First Mayor of Worthing*, donated by the Corporation by the Burgesses

unknown artist early 19th C, *Portrait of a Young Man*, donated by Miss G. Wilk

unknown artist 19th C, *Farm Scene*, donated by Miss Napper

unknown artist late 19th C, *Portrait of Unknown Lady*, unknown

unknown artist, *Sir Henry Stern*, bequeathed by Lady Stern

unknown artist, *Jan Cervenka*, donated by W. B. C. Community Services Department

unknown artist early 20th C, *Highworth House, Liverpool Road, Worthing*, ex-Sussex Room Collection

unknown artist, *Thomas J. Searle as Hamlet*, donated by Mrs M. Macwalter

unknown artist, *Moonlit Landscape*, bequeathed by Mrs K. M. Napper

unknown artist, *Charles Lee (1833–1910), Coxswain of Worthing Lifeboat, 'Henry Harris'*, ex-Sussex Room Collection

unknown artist, *When Poverty Enters the Door*, bequeathed by Mrs. E. A. T. Buckeridge

unknown artist, *Love Flies out of the Window*, bequeathed by Mrs E. A. T. Buckeridge

unknown artist, *Three Fishermen*, unknown

unknown artist, *A Portrait*, purchased from Derek & Ursula Powell

unknown artist, *Fields at Tarring, Sussex*, purchased from Derek & Ursula Powell

unknown artist, *Edwin Henty, DL, JP, FSA*, presented to the Worthing Corporation by Mrs Edwin Henty

unknown artist, *The Chain Pier at Brighton*, unknown

unknown artist, *Lady Hamilton as a Bacchante (after Joshua Reynolds)*, donated by Mr A. Leslie Clifford

Vaughan, John Keith 1912–1977, *The Trial*, vendor Thomas Agnes & Sons Ltd

Walker, Ethel 1861–1951, *Kathleen and Iris*, vendor Old Hall Gallery Ltd, Worthing Museum & Art Gallery/ © courtesy of the artist's estate/ www.bridgeman.co.uk, photo credit: www.bridgeman.co.uk

Ward, James 1769–1859, *Sheep on the Downs*, vendor Leger Galleries

Ward, James 1769–1859, *Sheep by a Stream*, donated by the late Mrs E. F. Dodsworth

Watson, F. active 1914, *At the Bedside*, unknown

Watson, F. active 1914, *Still Life*, unknown

Webb, James c.1825–1895, *Near Cologne*, donated by Cortis Bequest

Webb, James c.1825–1895, *A Calm Afternoon*, bequeathed by Mrs E. F. Dodsworth

Weiss, José 1859–1919, *Tranquil Pastures*, purchased from the Cortis Bequest

Wethered, Vernon 1865–1952, *The Manor Farm, Bury*, donated by V. D. Wethered

Wethered, Vernon 1865–1952, *Stopham Bridge*, donated by V. D. Wethered

Wiens, Stephen Makepeace 1871–1956, *Dorothy Primrose as Ophelia*, donated by Colin Henderson

Wiens, Stephen Makepeace 1871–1956, *Portrait of a Lady*, donated by Miss Nicoll

Wiens, Stephen Makepeace 1871–1956, *Miss Mordaunt (Mrs Nisbett), as Constance in 'The Love Chase', Worthing Theatre, 21st September 1838 (after James Godsell Middleton)*, vendor Derek & Ursula Powell

Wiens, Stephen Makepeace 1871–1956, *Edward John Trelawny*, purchased from Derek & Ursula Powell

Wiens, Stephen Makepeace 1871–1956, *Beach House, Worthing*, vendor Derek & Ursula Powell

Wiens, Stephen Makepeace 1871–1956, *Beach House, Worthing*, vendor Derek & Ursula Powell

Wijnants, Jan c.1635–1684, *Wooded Landscape*, donated by Cook Bequest

Wright, Henry 1823–1871, *The Duke of Norfolk's 'Prince'*, vendor Mrs C. Gotch

Collection Addresses

Arundel

Arundel Museum and Heritage Centre
61 High Street, Arundel BN18 9AJ
Telephone 01903 885708

Billingshurst

Billingshurst Library
Mill Lane, Billingshurst RH14 9JZ
Telephone 01403 783145

Chichester

Chichester City Council
The Council House, North Street,
Chichester PO19 1LQ
Telephone 01243 788502

Chichester District Museum
29 Little London, Chichester PO19 1PB
Telephone 01243 784683

Chichester Festival Theatre
Oaklands Park, Chichester PO19 6AP
Telephone 01243 784437

Chichester Library
Tower Street, Chichester PO19 1QJ
Telephone 01243 777351

Fishbourne Roman Palace
Salthill Road, Fishbourne, Chichester PO19 3QR
Telephone 01243 785859

Pallant House Gallery
9 North Pallant, Chichester PO19 1TJ
Telephone 01243 774557

Royal Military Police Museum
Roussillon Barracks, Broyle Road, Chichester PO19 6BL
Telephone 01243 534225

Royal West Sussex NHS Trust
St Richard's Hospital, Spitalfield Lane,
Chichester PO19 4SE
Telephone 01243 788122

University College Chichester, Otter Gallery
College Lane, Chichester PO19 6PE
Telephone 01243 816089

West Sussex County Council
The Grange, Tower Street, Chichester PO19 1RH
Telephone 01243 777100

West Sussex Record Office
County Record Office, County Hall,
Chichester PO19 1RN
Telephone 01243 753600

Crawley

Crawley Library
County Buildings, Northgate Avenue, Crawley RH10 1XG
Telephone 01293 895131

Crawley Museum Centre
Goffs Park House, Old Horsham Road, Southgate,
Crawley RH11 8PE
Telephone 01293 539088

Cuckfield

Cuckfield Museum
Queens Hall, High Street, Cuckfield RH17 5EL
Telephone 01444 473630

East Grinstead

Chequer Mead Theatre and Arts Centre Trust
De La Warr Road, East Grinstead RH19 3BS
Telephone 01342 325577

East Grinstead Town Council and
East Grinstead Town Museum
East Court, College Lane, East Grinstead RH19 3LT
Telephone 01342 323636

Hassocks

Hassocks Parish Council
The Parish Centre, Adastra Park, Keymer Road,
Hassocks BN6 8QH
Telephone 01273 842714

Haywards Heath

Princess Royal Hospital Arts Project
Lewes Road, Haywards Heath RH15 4EX
Telephone 01444 441881

Henfield

Henfield Museum
Henfield Parish Council,
The Henfield Hall, Coopers Way,
Henfield BN5 9DB
Telephone 01273 492507

Horsham

Christ's Hospital
Horsham RH13 0YP
Telephone 01403 211293

Horsham District Council: Horsham Museum
9 The Causeway, Horsham RH12 1HE
Telephone 01403 254959

Horsham District Council: Park House
North Street, Horsham RH12 1RL
Telephone 01403 215104

Lancing

Lancing Library
Penstone Park, Lancing BN15 9DL
Telephone 01903 753592

Littlehampton

Arun District Council
The Arun Civic Centre,
Maltravers Road,
Littlehampton BN17 5LF
Telephone 01903 731681

Littlehampton Museum
Manor House, Church Street,
Littlehampton BN17 5EW
Telephone 01903 738100

Petworth

Petworth Cottage Museum
346 High Street, Petworth GU28 0AU
Telephone 01798 342100

Petworth Parish Council
The Old Bakery, Golden Square,
Petworth GU28 0AP
Telephone 01798 344883

Rustington

Rustington Library
Claigmar Road, Rustington BN16 2NL
Telephone 01903 785857

Shoreham-by-Sea

Adur District Council
Civic Centre, Ham Road, Shoreham-by-Sea BN43 6PR
Telephone 01273 263000

Marlipins Museum
36 High Street, Shoreham-by-Sea BN43 5DA
Telephone 01273 462994

Steyning

Steyning Museum
Church Street, Steyning BN44 3YB
Telephone 01903 813333

West Hoathly

Priest House
North Lane, West Hoathly RH19 4PP
Telephone 01342 810479

Worthing

Worthing Hospital
Lyndhurst Road, Worthing BN11 2DH
Telephone 01903 285151

Worthing Library
Worthing Library, Richmond Road, Worthing BN11 1HD
Telephone 01903 212414

Worthing Museum and Art Gallery
Chapel Road, Worthing BN11 1HP
Telephone 01903 239999

Index of artists

Become a Friend of the Public Catalogue Foundation

If you have enjoyed this catalogue, you may be interested in becoming a Friend of the Public Catalogue Foundation.

As a Friend of the Foundation, you will be:

- Alerted to forthcoming publications in the series.
- Entitled to buy catalogues free of postage and packaging charges.
- Kept up-to-date with newsletters. These will keep you informed about the project's progress as well as reporting on anecdotes and points of interest that arise from cataloguing the nation's publicly owned oil paintings.

You can take out a year's subscription to become a Friend of the Public Catalogue Foundation for just £20. Alternatively, you can become a Friend of the project for life for £150. Please send a cheque payable to the Public Catalogue Foundation, to the address below, together with your name, postal address, email, and telephone number.

Friends of the Public Catalogue Foundation
St Vincent House
30 Orange Street
London WC2 H7HH

The Foundation has the following volumes of *Oil Paintings in Public Ownership* in preparation and expects to publish them in 2005:

Cambridgeshire: The Fitzwilliam, Cambridge
East Sussex (including Brighton and Hove)
Essex
Hampshire: Southampton
London: The Slade and UCL
Norfolk
North Yorkshire
Suffolk
Surrey
West Yorkshire

Catalogues will typically be priced at:

£20 for the softback
£35 for the hardback.

Public Catalogue Foundation Website

If you would like to find out more about the Public Catalogue Foundation, buy other catalogues in the series or become a Friend, you can do all three by visiting our website:

www.thepcf.org.uk

At present this offer is open only to residents of the UK. Please note that the price of Friends membership will be subject to change after 30th June 2005. Data collected will be used only in connection with the offer above and will not be released to any other organisation.